Ethno Music Gatherings

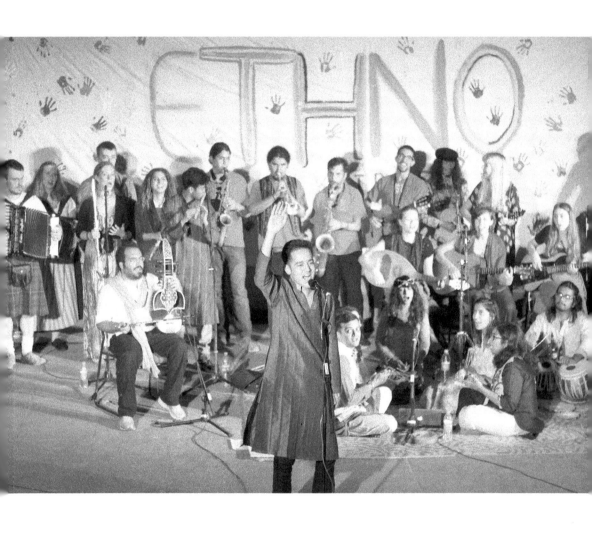

Ethno Music Gatherings

Pedagogy, Experience, Impact

EDITED BY

Lee Higgins and Sarah-Jane Gibson

Bristol, UK / Chicago, USA

Music, Community, and Education

Series Editor: Lee Higgins
Print ISSN: 2755-3302 | **Online ISSN:** 2755-3310

Music, Community, and Education is a focused monograph series that provides scholars and researchers with a platform for disseminating conceptually rich and empirically distinguished work that explores questions related to the impact music-making can have on those that participate and the cultural, political, and economic context through which it happens. To be accepted for publication, manuscripts must be judged as providing significant contributions to advancing cutting-edge research, promoting a wider discourse, and promoting the application of research and scholarship to policies and practices that improve our understanding of music, community and education. Monographs are intended to address their topic without being unduly narrow. They should be comprehensible to and engaging for, a general readership whilst valuable for scholars with shared research interests. Each book is expected to be written in a single voice even when it involves a collaboration between multiple scholars. Book proposals are welcome in any of the following areas that address questions relating to music-making; inclusivity, participation, social justice, democracy, power, community and pedagogy.

In this series:

Building Community Choirs in the Twenty-First Century: Re-imagining Identity through Singing in Northern Ireland, by Sarah Jane Gibson (2023)
Music Making and Civic Imagination: A Holistic Philosophy, by Dave Camlin (2023)
Ethno Music Gatherings: Pedagogy, Experience, Impact, edited by Lee Higgins and Sarah-Jane Gibson (2024)

First published in the UK in 2024 by
Intellect, The Mill, Parnall Road, Fishponds, Bristol, BS16 3JG, UK

First published in the USA in 2024 by
Intellect, The University of Chicago Press, 1427 E. 60th Street,
Chicago, IL 60637, USA

© Signed texts, their authors
© Rest of the book, the editors

The publication of this book was made possible through the generous support of JM International and Margaret A. Cargill Philanthrophies (MACP).

The electronic version of this work is licensed under the Creative Commons Attribution Non Commercial No Derivatives (CC BY-NC-ND) Licence. To view a copy of the licence, visit https://creativecommons.org/licenses/by-nc-nd/4.0/. Some rights reserved. Without limiting the rights under copyright reserved above, any part of this book may be reproduced, stored in or introduced into a retrieval system, or transmitted, in any form or by any means (electronic, mechanical, photocopying, recording or otherwise).

A catalogue record for this book is available from
the British Library.

Copy editor: MPS Limited
Cover designer: Tanya Montefusco
Cover image: Audrey Goforth
Frontispiece image: Courtesy of Ethno India
Production managers: Laura Christopher and Sophia Munyengeterwa
Typesetter: MPS Limited

Hardback ISBN 978-1-83595-036-4
Paperback ISBN 978-1-83595-035-7
ePDF ISBN 978-1-83595-038-8
ePUB ISBN 978-1-83595-037-1
Series (Print) ISSN 2755-3302 | Series (Online) ISSN 2755-3310

To find out about all our publications, please visit our website. There you can subscribe to our e-newsletter, browse or download our current catalogue and buy any titles that are in print.

www.intellectbooks.com

Contents

List of Figures	ix
Foreword	xi
Magnus Bäckström	
Acknowledgements	xv
Introduction	xvii

1. Ethno Pedagogy: Valuing One Another through Experiential Learning — 1
 Andrea Creech, Maria Varvarigou, Lisa Lorenzino, and Ana Čorić
2. Playing with Tradition: Personal Authenticity and Discourses of Traditional Music-Making at Ethno World Gatherings — 25
 Laura Risk and Keegan Manson-Curry
3. Music Making as Holistic Praxis — 43
 Dave Camlin and Helena Reis
4. Ethno World as a Site for Developing and Practising Musical Possible Selves — 76
 Maria Varvarigou, Andrea Creech, Lisa Lorenzino, and Ana Čorić
5. Marvelling at the Ethnoverse: Intercultural Learning through Traditional Music — 96
 Roger Mantie and Pedro Tironi
6. Carbon Footprints and Intercultural Exchange: Ethno as Sustainable Practice — 114
 Sarah-Jane Gibson
7. Ethno Online: An Analysis of Social Media Engagement on Facebook — 133
 Roger Mantie

8. Sharing Songs, Shaping Community: Revitalizing Time-Honoured Pedagogies at Ethno USA 148
 Huib Schippers
9. Reconceptualizing Ethno? Perceptions of the Ethno Gatherings in Bahia, Malawi, and the Solomon Islands 181
 Sarah-Jane Gibson

Notes on Contributors 201
Index 207

Figures

I.1	Musical engagement at an Ethno gathering.	xx
I.2	Meeting participants at an Ethno gathering.	xx
I.3	Group playing at an Ethno gathering.	xxi
I.4	Connecting with others at an Ethno gathering.	xxii
I.5	Empowering music making at an Ethno gathering.	xxiii
I.6	Respectful music making at an Ethno gathering.	xxiv
I.7	Enjoyment in full flow at an Ethno gathering.	xxiv
I.8	Learning new tunes at an Ethno gathering.	xxv
I.9	The creation of new music at an Ethno gathering.	xxvi
I.10	Performing at an Ethno gathering.	xxvii
I.11	Time to reflect at an Ethno gathering.	xxviii
I.12	Personal playing and thinking time at an Ethno gathering.	xxix
1.1	Modes of facilitation and dimensions of pedagogy.	5
3.1	Music in three dimensions (triad 1).	45
3.2	Identity (triad 2).	46
3.3	Self-determination (triad 3).	49
3.4	Social impact dyad.	53
3.5	Social impact grid.	53
3.6	Music in three dimensions (triad 1) – responses.	65
3.7	Identity (triad 2) – responses.	66
3.8	Self-determination (triad 3) – responses.	67
3.9	Social impact dyad – responses.	68
3.10	Social impact grid – responses.	68
4.1	Personal and professional development in and through Ethno.	80
8.1	The twelve-continuum transmission framework (Schippers, 2010, p. 124).	154

8.2	Balance between atomistic and holistic transmission within Ethno USA.	157
8.3	Balance between notation-based and aural transmission within Ethno USA.	158
8.4	Balance between tangible and intangible aspects of transmission within Ethno USA.	160
8.5	Degree of power distance within Ethno USA.	162
8.6	Balance between individual and collective at Ethno USA.	164
8.7	Balance between strongly gendered and gender neutral at Ethno USA.	164
8.8	Degree of embracing uncertainty at Ethno USA.	166
8.9	Long-term vs. short-term orientation at Ethno USA.	167
8.10	Approach to tradition at Ethno USA.	168
8.11	Approach to authenticity in Ethno USA.	169
8.12	Approach to the context at Ethno USA.	170
8.13	Approaches to cultural diversity at Ethno USA.	175
8.14	Twelve continuum transmission framework for Ethno USA.	175

Foreword

Magnus Bäckström
Uppsala, May 2023

> *It's something that has affected me deeply inside, and really kind of changed my whole being.**

Culture has the power to create change, but is also a source of discoveries and insights concerning us humans and the world. No form of culture or art is so closely bound to our sense of identity and affiliation as music. Our musical preferences and our making music are a part of our background, our times, our habitat, and the world around us. Music tells me who I am, and who you are.

Music is at the same time a part of our spirituality, our inner self. The art of music can reach the depths of our soul, convey thought far beyond words and intimately unite one person with another.

It is often said that music builds bridges between people and worlds. But music can also exclude. Some people's inclusion can be the exclusion of others. At worst, music can turn people against one another. It is up to us. Music and art are what we make of them.

The ability of music and culture to unite is often central to peace projects. We need these the most in our darkest days. In 1945, after a second devastating war, Jeunesses Musicales International (JMI) was founded, its vision being to use music to unite young people around the world. Its portal project, JM World Orchestra, was trailblazing and has been of great importance for thousands of young classical musicians from all over the world. JM World Orchestra was also honoured with the title of UNESCO 'Artist for Peace' in recognition of its humanitarian message.

World Orchestra was followed by JM World Youth Choir. UNESCO has awarded World Youth Choir with the 'Artist for Peace' title, acknowledging its success as a platform for intercultural dialogue through music.

* This quote is from comments made by participants in Ethno, extracted from the research reports.

These fantastic peace projects impressed, inspired, and moved an entire world of music. I was one of those moved and inspired, and an idea began to sprout inside me.

In my worlds of music – the worlds in which I belonged and where my passion was greatest – there was nothing similar: no platform of this kind for young people playing what we call folk music, the local traditional music cultures. We lacked a platform to bring together young people from these various cultures – a platform to inspire and to challenge them, to strengthen identity but also build bridges and broader perspectives. I wished to create such a platform. It became the international camp for folk music youth – Ethno.

Ethno was in other words created for young musicians from different worlds of music with completely different norms and traditions – varying aesthetics, ways of playing together, scales, rhythms, and instruments. Different expressions, different sounds. Nevertheless so close to one another in other respects and with so much more in common in other ways than in sounds. It might simply be a matter of attitudes to music and its playing. This unspoken, intuitive common ground draws us to one another.

As a folk musician I have often witnessed and taken part in cross-border meetings with such musicians and music cultures. I have also experienced this in my role as a festival producer, with hundreds of musicians from all kinds of music cultures from all over the world in one and the same place.

These cross-border meetings provided the basic structure of Ethno. Whereas a symphony orchestra or a choir rehearses a musical score with a conductor, with Ethno each individual youth musician was allowed to step forth, present their music culture, and, in a workshop, teach some of their music to others. What you yourself bring along takes centre stage, and is received and welcomed by others. Then you change roles, and you learn the traditions of others. Peer-to-peer learning. Musical worlds open up. You become a part of something greater, and your contribution is of value.

This giving and taking was and still is the core of Ethno. But a music camp is not a music camp without jam sessions, dance evenings, excursions, concerts, friendship, love. Ethno is all of this too.

I was confident that the young musicians would make the cultural meetings work. The greatest challenge was to persuade leaders and others to stay in the background, to trust in the music and musicians, to refrain from taking over and leading. I am grateful to the leaders in the first years who listened and understood the greatness of little things, striking a good balance between aiding and leading. This established a leadership culture which has remained with Ethno.

I also felt it important that Ethno would be part of JMI – that the worlds of folk music would stand beside, and be the equals of, JM World Orchestra and World

Youth Choir. JMI was approached on this matter from the first year, but was at the time more focused on western classical music. I was all the more happy when JMI later took Ethno under its wing. With JMI, Ethno has developed into the fantastic international project for peace and culture that it is today. I am impressed by, and grateful for, the engagement and conviction displayed by JMI and feel that Ethno is in the best possible hands.

To me it feels almost unreal that Ethno has now spread across the entire world, made such deep impressions and inspired thousands of young people – giving them life-changing insights and experiences. The testimonies regarding what Ethno has meant for many people are overwhelming and deeply moving.

Experiencing, playing, intuition, and passion have been central to the project, and have borne Ethno forward. The research project which results in this book adds yet another dimension.

The research team led by Professor Lee Higgins of York St. John University has approached Ethno in a wise and respectful manner. Viewing the project from the outside they have analysed, structured, formulated, and captured Ethno in a broader and deeper perspective. The result fashions a bridge between heart and thought, binding them into a new and greater whole.

*The world has opened up in such a great way.***

**This quote is from comments made by a participant in Ethno, extracted from the research reports.

Acknowledgements

A project like this relies on many people's contributions. Lee and Sarah-Jane would like to formally thank Matt Clark and Suchet Malhotra and all those working for the Ethno project at JM International's office in Brussels, particularly Nicky Tsianti, Martina Gerli, Blasko Smilevski, and Zak Hantout (the snack king). A big thanks must also go to the chair of the Ethno committee, Simon Voigt.

Thanks to all those who took part in this research, which is many hundreds of Ethno participants, mentors, and organizers past and present. To all those organizers who opened their doors to us, thanks for your hospitality, a special shout out to those who supported us through our pilot projects, Catalonia, Denmark, Estonia, Flanders, Portugal, and Sweden, and those with whom we formed close connections, New Zealand, France, England, and Sweden.

Thanks for the support we received from Magnus Bäckström, Peter Ahlbom, Eric Rask, and Lucile Jauffret.

The project could not have happened without a dedicated team of researchers: Roger Mantie, Dave Camlin, Andrea Creech, Maria Varvarigou, Ana Čorić, Catherine Birch, Helena Reis, Huib Schippers, Jason Li, Jo Gibson, Keegan Manson-Curry, Laura Risk, Linus Ellström, Lisa Lorenzino, Elise Gayraud, Lisandra Roosioja, Pedro Tirono, Ryan Humphrey, and Gabriel Harmsen.

The project certainly could never have happened without the coordination and administration excellence of Millie Raw-Mackenzie working from our base at York St John University.

Thanks to Jessica Lovett, Laura Christopher and Sophia Munyengeterwa from Intellect.

All images courtesy of: Kyra Aulani, Peter Ahlbom, Megan Blennerhassett, Audrey Goforth, Kertu Kruusla, Suchet Malhotra, Bhumanya Nehra, Daniel Quirino, and Andre Yamamoto.

Introduction

Ethno is JM international's programme for folk, world, and traditional music. Founded in 1990, it is aimed at young musicians (up to the age of 30) with a mission to revive and keep alive global cultural heritage. Present today in over 40 countries, Ethno engages young people through a series of annual international music camps as well as workshops, concerts, and tours, working together with schools, conservatories, and other groups of youth to promote peace, tolerance, and understanding. At the core of Ethno is its democratic, peer-to-peer learning approach whereby young people teach each other the music from their countries and cultures. It is a non-formal pedagogy that has been refined over the past 32 years, embracing the principles of intercultural dialogue and understanding. Ethno provides a unique opportunity for young people from across the globe to come together and engage through music in a manner that is characterized by respect, generosity, and openness.

(Ethno World 2021,[1] n.pag.)

An Ethno is a residential music gathering that lasts about ten days. Participants are asked to prepare a song or tune that reflects the culture they identify with. These are taught by participants during initial workshops, facilitated by an artistic mentor. Once songs and tunes are taught, participants begin to arrange the music for performance at public-facing events towards the end of the gathering. All the pieces are arranged so that the entire ensemble performs together, creating a large folk ensemble.

The first Ethno was held in Sweden in 1990. One hundred twenty participants from Sweden, Denmark, Finland, Estonia, Latvia, Lithuania, and the Shetland Islands attended the week-long event that took place before the Falun Folk Festival. Magnus Bäckström, who devised Ethno, wanted to create a space where young musicians could teach each other rather than 'just another music camp where adults teach young people' (Bäckström, interview, 2020).[2] Ethno was introduced in Estonia in 1997 followed by Flanders in 1999. Both of these Ethnos were organized by people who had attended Ethno Sweden and wanted a similar event in

their home countries. Ethno became part of JM International, in the year 2000. JM International is an international non-governmental organization (NGO) that comprises of a network of organizations that provide music opportunities for children and young people.[3]

From 2003, Ethno began to grow rapidly within Europe. Ethno Uganda was the first gathering outside Europe in 2009, soon followed by Ethno Australia in 2011. In 2019, with support from funding from Margaret A. Cargill Philanthropies, Ethno was able to hire a global coordinator and strengthen its infrastructure alongside organizers training, travel scholarships, and starting an Ethno gathering in the United States. Ethno research, the project from which this book flows, was part of this development. During 2019, there were eighteen Ethno gatherings, however, following support from Cargill and post-COVID-19 there has been a rapid increase in activity resulting in gatherings in over forty countries at the time of writing.[4]

What was Ethno Research?

Ethno Research was an international team of twenty researchers led by the International Centre for Community Music at York St John University.[5] The contents of this book reflect the majority of the research[6] carried out in response to the following question set by JM International: *Study the value and impact of the Ethno pedagogy and the related social process on the lives of the participating musicians over the last 30 years and its impact on society at large.*

As a collaborative team, which included Ethno participants and organizers, three lines of inquiry helped shape the investigation:

1. pedagogy and professional development,
2. participant experience,
3. reverberations (impact on people beyond the gatherings).

Our research design was initially articulated as ethnographic but the impact of COVID-19 in the second year of data collection meant that the approach needed some adjustment in order for us to meet deadlines set by the funder. This resulted in fewer site visits than initially expected with some interviews taking place remotely due to national lockdowns. Where possible the research team focused on the experiences people had at Ethno gatherings as we felt that it is within the 'stories', either as a participant, artistic mentor, or organizer, that the question could be faithfully responded to. Research findings were drawn from participant observation at eleven Ethno gatherings, over 330 interviews, online social media analysis, onsite and video

observations, surveys, and questionnaires. We saw our methodological approach as reflective of the ethos the Ethno project advocates. As a four-year project[7] exploring the subject of 'Ethno' we asked critical questions concerning claims regarding what it *does*. The claims reflect the context of its growth, its history, ethos, and philosophical ideals. Therefore, our purpose was to illuminate new understandings of what Ethno does to support future growth and development.[8]

The theoretical framework for Ethno Research was drawn up by Roger Mantie and Laura Risk (2020) and included discussions surrounding (1) globalization and culture, including heritage, revival and authenticity, cultural agency and production, and (2) intercultural music exchange encounters, exploring folk and traditional music programmes, musical nationalism, liminal spaces as sites for transformation, and pedagogic practices. Expanding upon this, we also used two further theoretical frameworks, communities of practice (Wenger, 1998) and intercultural competence (Deardoff, 2009).

The following section presents our key findings as they appeared in the final report (Gibson, Higgins, & Schippers, 2022). These twelve short statements are flanked by a quote and an image and have been designed to communicate with a wide and diverse audience. Whilst there are many ways to analyse the workings of Ethno, we feel that these twelve elements represent a transparent, insightful, and succinct way of illuminating the workings and success of the Ethno approach.

Key findings

An increasing number of young musicians from myriad cultures have been coming together in locations around the world for music residencies called Ethno gatherings. For all the diversity of cultures and places and participants, there are striking similarities in their lived experience. Many refer to it as 'magic', 'life-changing', or 'transformational'.

Engaging

Through the songs and the music you can understand how other cultures express themselves – it's a great way to understand others.

(Jaya)

Ethno attracts young musicians who are curious and open-minded, eager to learn unfamiliar music in new ways by engaging with fellow musicians from other styles and cultures. While representing different skill levels, they all arrive with a genuine passion to learn, play, and connect.

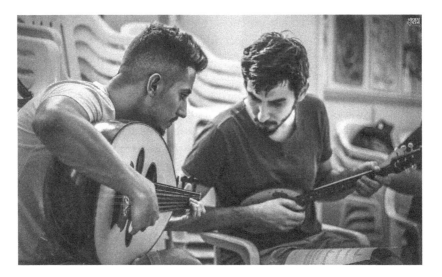

FIGURE I.1: Musical engagement at an Ethno gathering.[9]

Meeting

I think going through this world tour of music is actually a beautiful experience to travel sonically and have this open-mindedness about

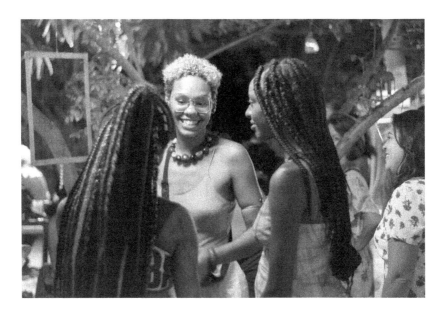

FIGURE I.2: Meeting participants at an Ethno gathering.

INTRODUCTION

taking down any barriers, any preconceptions or notions, and just getting into the music, in whatever language or style.

(Alicia)

Ethno offers encounters between diverse peoples, languages, and cultures in myriad ways. These encounters are predominantly harmonious and enriching, but also demand of the participants the will to negotiate difference and embrace dissonance, stretching skills and minds beyond their everyday comfort zones.

Playing

I'm there just to enjoy. I love music, I love playing.

(Jakob)

From the first moment participants arrive until the time the last one departs, there is music playing, from early morning until deep into the night: in the scheduled learning and performance settings, but also in the common rooms, in the kitchen, on the porch, on the bus … Everyone shares in the joy, the fun, the playfulness of making music for and with each other.

FIGURE I.3: Group playing at an Ethno gathering.

Connecting

Ethno creates a really strong feeling that the things that connect us are stronger and more important than the things that set us apart.

(keon)

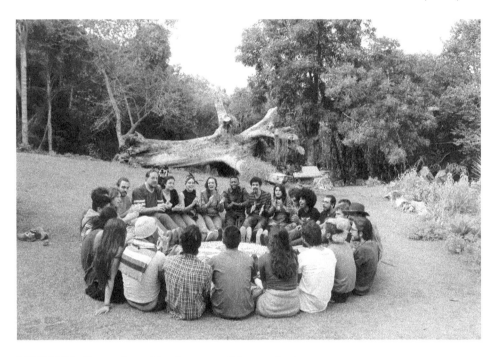

FIGURE I.4: Connecting with others at an Ethno gathering.

The intensity of the gathering leads to a strikingly quick sense of community, of family, of tribe. Most participants commented on how quickly close and selfless relationships develop at Ethno, and how they recognize more similarities than differences in a culturally diverse group. These connections reverberate long after the gathering forming a powerful global network through face-to-face encounters and digital platforms.

Empowering

Ethno has boosted my confidence massively and has been great for my personal development. I met many lifelong friends who believe in my music and accept me as I am. I feel respected and appreciated.

(Elsa)

INTRODUCTION

FIGURE I.5: Empowering music making at an Ethno gathering.

With its deliberate minimizing of hierarchical structures and distributed leadership, Ethno gives participants confidence, and a strong sense of agency, and empowers them. Everybody has their moment to shine: sharing a song from their culture, contributing a creative idea, or playing a solo on stage.

Respecting

There's not a moment I've felt like an outcast or anything just because I came from a different place and no one knows me.

(Jaden)

Ethno is structured in a dynamic way that is conducive to participants gaining a profound appreciation of people and their cultural backgrounds. This goes beyond limiting prejudice: it involves valuing others for who they truly are and being present with full attention. In that way, participants jointly build a learning community that will enable them to approach people and situations after the gathering with greater understanding.

FIGURE I.6: Respectful music making at an Ethno gathering.

Enjoying

There were a lot of happy, creative, interesting people. We did lots of fun things that everybody enjoyed.

(khadija)

FIGURE I.7: Enjoyment in full flow at an Ethno gathering.

Ethno is hard work and long hours. Despite exhaustion (and maybe partly because of the euphoria tiredness can cause), there is an overwhelming sense of joy among the group. First, there is the suspension from everyday concerns and the freedom to pursue a passion full-time. Second, there is the pleasure of creating something new with a group of like-minded musicians. Third, there is the sharing of new music and friendships with new audiences.

Learning

> *Ethno was a big change in my life. I developed leadership skills that I thought I didn't have, and now I enjoy helping other people to develop theirs too. It has been the best learning experience.*
>
> (LiHua)

Song sharing in a peer-to-peer setting is at the core of the Ethno experience. The sessions are structured, but quite distinct from formal music education: various participants take on a leading role in teaching a piece of music with cultural significance to them. Often, these are beyond the musical comfort zone of other

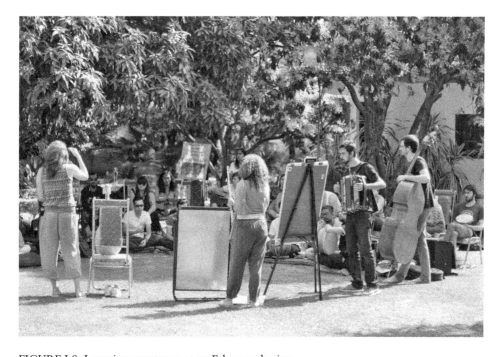

FIGURE I.8: Learning new tunes at an Ethno gathering.

participants, inviting them to stretch their musical skills and imagination to new levels. The artistic mentors gently guide the process with minimal interference, enabling group members to take charge.

Creating

We were playing a piece by the lakeside. Then people came in with their instruments. Everyone was improvising from their musical background the result was rather unique.

(Flora)

Ethno is not just about replicating existing pieces of music, it is about creating something new as a group: exploring possibilities, taking risks, and finding joint solutions. With the entire ensemble as the starting point, this leads to a distinct Ethno-sound, enabling individuals and instrument groups to put their stamp on the final product.

FIGURE I.9: The creation of new music at an Ethno gathering.

INTRODUCTION

Performing

I felt like, wow, I am a part of this big, awesome group performing at this festival, which I fell in love with.

(Linus)

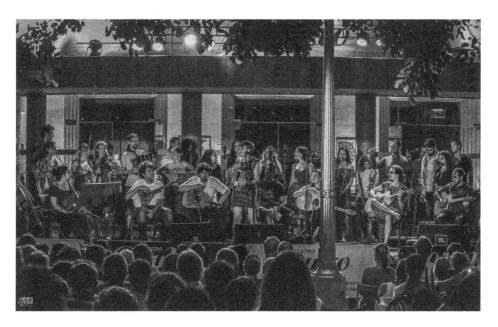

FIGURE I.10: Performing at an Ethno gathering.

Performing is a celebration of the sense of joy and togetherness Ethno creates, and an opportunity to share with local audiences. The preparations for the performances represent a major shift in the dynamics of the gathering. After leisurely sharing and learning songs and creating new interpretations and arrangements, the focus moves to the more product-oriented preparations for a festival performance, tour, or recording.

Reflecting

It's something that has affected me deeply inside, and really kind of changed my whole being.

(Tomas)

FIGURE I.11: Time to reflect at an Ethno gathering.

> *It changes your view on life.*
>
> (Carina)

Exposure to many cultures and ideas inevitably invites reflection on who you are, as a musician, a member of society, and as a human being. While there is little opportunity for dedicated reflection during the gathering, everyone leaves full of new impressions and processes these according to their time, ambitions, and disposition.

Growing

> *I know it has affected me a lot in the way I go into situations with people, the way I view the world and the world has opened up in such a great way.*
>
> (Kala)

Many participants have described their experience at Ethno as transformational or life-changing. Growth through Ethno ranges from gathering new repertoire and professional skills to increased intercultural understanding and a clearer picture of self, as well as personal and career choices.

FIGURE I.12: Personal playing and thinking time at an Ethno gathering.

Emerging questions

As a project that looked towards supporting the growth and development of Ethno gatherings, the research team chose to conclude the project by posing questions for further discussion and reflection. Drawn from the same meta-analysis that produced the final report, these questions are aimed at those in decision-making positions which includes Ethno organizers and those representing JM International. Although we shaped the questions, the substance emerged from the data and should be seen as wonderings from the people most invested in the programme.

- How big should Ethno get? As Ethno gatherings increase in size and number, how can the governance of Ethno respond best? And what are the optimal minimal and maximum numbers of participants for each gathering? Numbers of participants for each gathering?
- For whom are Ethno gatherings accessible? Who is excluded? What are the barriers to participation? How can these barriers be mitigated? What is needed to enhance accessibility, in terms of training and resources? For example, how have the mobility grants aided in addressing the issues above?
- As Ethno grows, how can the organization ensure that every participant feels respected and safe irrespective of issues of gender, sexuality, cultural, religious, and spiritual orientation? Reflective of global understandings of issues relating to equality, diversity, and inclusion, what agreed structures and policies does an international network need in place?
- How can Ethno contribute optimally to the practice and careers of emerging (neo-) traditional musicians during and after the gatherings?
- How does Ethno remain optimally respectful and open to – for instance, modal and Indigenous – music practices that have/not embraced chord structures?
- To what extent can Ethno pedagogy engage with participants who might not have an expressed openness or curiosity towards learning about different cultures? What are the mutually beneficial scenarios where JMI/Ethno could collaborate with formal and non-formal educational structures?

Ethno Research produced 23 reports that covered the gamut of activity across its 30-plus years. The twelve elements articulated above were designed to communicate our 'conclusions' in a succinct and accessible way. Mindful of our wide and diverse audience this report was animated in a 3-minute video. Two other animations were created including *Ethno Pedagogy* and *Ethno 2022: Exploring New Pathways*.[10] This edited collection represents another dissemination point and covers aspects of the research crafted as open access chapters.

INTRODUCTION

Chapter overviews

In Chapter 1, Andrea Creech, Maria Varvarigou, Lisa Lorenzino, and Ana Ćorić describe and theorize Ethno's pedagogical principles. Their findings reveal a foundational principle of 'valuing' one another through critical approaches to intercultural and experiential learning. This principle is articulated through frameworks such as non-formal learning and scaffolded expansive learning including activities such as learning by ear, peer self-directed, and situated learning. Chapter 2 considers the interplay between personal authenticity and traditional music-making within Ethno gatherings. Laura Risk and Keegan Manson-Curry consider how Ethno participants engage in traditional folk music, the relationship between traditional music and the presentation of national self-identity. They consider how participants' choice of repertoire to teach at an Ethno may occur through a framework of 'personal authenticity' wherein music that feels authentic to a person is by extension authentic to their nation.

Dave Camlin and Helena Reis consider the motivations of Ethno organizers in Chapter 3 and find that organizers are motivated by personal beliefs surrounding the 'transformational potential' of participatory music-making. Their research highlighted the value of 'communitas' achieved through shared music-making. Chapter 4, by Maria Varvarigou, Andrea Creech, Lisa Lorenzino, and Ana Ćorić, focuses on the personal and professional development experience of Ethno participants. The findings show how Ethno was transformational with regard to developing a life-long interest in music, changing the way participants think about music and communication, feeling recognized and valued, developing deeper self-knowledge, and acquiring transferable skills. The authors relate this to how the participant experiences within the gathering influenced their current and future musical possible selves.

In Chapter 5, Roger Mantie and Pedro Tironi investigate intercultural learning within the Ethno gathering, reflecting particularly on Allport's theories of intergroup contact and Appadurai's 'five dimensions of global cultural flow' (98). Sarah-Jane Gibson explores the relationship between the sustainability of Ethno and the climate emergency in Chapter 6. Based on research conducted during COVID-19 which impacted international travel, something heavily relied on by Ethno gatherings, this chapter focuses on three approaches Ethno could use in light of a climate emergency: drawing on local immigrant communities, incorporating Indigenous musical cultures, and holding online programmes.

In Chapter 7, Roger Mantie analyses social media engagement with Ethno on Facebook, interrogating how and why the Ethno community engages with one another on online platforms. Huib Schippers writes about the inaugural Ethno

USA and how the gathering relates to the twelve-continuum transmission framework, which focuses on what elements shape successful learning experiences across cultures in Chapter 8. The final chapter, by Sarah-Jane Gibson, draws on perceptions of Ethno's organized in Bahia, Malawi, and the Solomon Islands interrogating how a programme, which originated in the Nordic Regions and then developed in Central Europe could potentially be influenced and re-shaped by the epistemologies of music and culture in 'non-western' regions.

NOTES

1. As a descriptive term 'Ethno World' is not used by JMI when referring to the Ethno programme. Ethno is the preferred name to describe the programme as a whole. However, the term Ethno World was a commonly used nomenclature by our participants during the period of research and thus became part of the research data. Because of this, the term still appears within this publication. Ethno.world does continue to be used as the web address and the name Ethno World remains a signifier on a Facebook page at the time of publication.
2. Ethno Sweden has continued annually since 1990, apart from during the COVID-19 lockdown restrictions. This includes videos and participant narratives.
3. https://jmi.net/. See also https://ethno.world. Accessed 25 October 2023.
4. A timeline of all the ethnos from 1990 to 2020 can be found at the following address: https://www.tiki-toki.com/timeline/entry/1355245/Ethno-World#vars!date=1988-10-13_12:39:59! Accessed 25 October 2023.
5. https://www.yorksj.ac.uk/research/international-centre-for-community-music/. Accessed 25 October 2023.
6. Two pieces of research were not publicly published but rather discussed as internal documents: Catherine Birch's 'Protecting the experience and wellbeing of everyone: Safeguarding, consent, and trauma at Ethno World' and Gabriel Harmsen's 'Leading by example: Ethno Sweden's approaches to JMI's peacebuilding objectives.'
7. The project was initially to be completed within three years but an extension was granted because of the global pandemic.
8. The complete catalogue of research reports is available at http://www.ethnoresearch.org and https://www.yorksj.ac.uk/research/international-centre-for-community-music/projects/ethno-research. Both accessed 25 October 2023.
9. All figures in this introduction are courtesy of: Kyra Aulani, Peter Ahlbom, Megan Blennerhassett, Audrey Goforth, Kertu Kruusla, Suchet Malhotra, Bhumanya Nehra, Daniel Quirino, and Andre Yamamoto.
10. All three videos can be found at the following address: https://www.yorksj.ac.uk/research/international-centre-for-community-music/projects/ethno-research/. Accessed 25 October 2023.

REFERENCES

Deardoff, D. (Ed.). (2009). *The SAGE handbook of intercultural competence*. Sage.

Ethno World. (n.d.). About. Accessed 1 Feburary 2024, from https://ethno.world/about/

Gibson, S. J., Higgins, L., & Schippers, H. (2022). *Understanding the magic of Ethno: Key findings of Ethno Research 2019–2022*. Accessed 25 October 2023, from https://ray.yorksj.ac.uk/id/eprint/7888/

Mantie, R., & Risk, L. (2020). *Framing Ethno World: Intercultural music exchange, tradition, and globalization*. Accessed 25 October 2023, from https://www.ethnoresearch.org/wp-content/uploads/2020/06/Ethno-Research-condensed-Framing-report-.pdf

Wenger, E. (1998). *Communities of practice: Learning, meaning, and identity*. Cambridge University Press.

1

Ethno Pedagogy: Valuing One Another through Experiential Learning

Andrea Creech, Maria Varvarigou, Lisa Lorenzino, and Ana Čorić

Introduction

The question of whether Ethno World has a distinctive pedagogy has been debated among Ethno stakeholders. Notwithstanding differing perspectives, it may be said that Ethno World pedagogy is highly contextualized, shaped by specific contexts, cultural groups, different forms of musical knowledge, and individual needs. What is consistent across contexts is that through implicit and explicit communication about pedagogical values and beliefs, those in leadership roles create the conditions for awakening intercultural musical learning and exchange.

In Ethno World, responsibility for learning is distributed among the organizers, artistic mentors, and participants, with many participants rotating as leaders of the music workshops which function as the primary musical activity. Therefore, pedagogical leadership at Ethno could be described as distributed, manifest in the practice of participants taking on the role of workshop leader as well as the team-based approach of artistic mentors who share responsibilities in order to meet diverse needs.

> As an organizer you can try to build a team of leaders where you know that one is more procedures – oriented, another one very good in personal processes or giving energy to the group, and another one that is very good in arranging and getting the concert ready.[1]

In this chapter, we describe and theorize Ethno World pedagogical principles and processes in action, addressing the following questions: (1) What are the

underpinning values and beliefs that shape learning and teaching at Ethno World? and (2) How are these understood and enacted through pedagogical principles and practices? We frame our discussion with the idea of 'signature pedagogies' (Shulman, 2005), concerned with the implicit values and the explicit structures and practices that characterize discipline-specific pedagogies. Discussing the specific pedagogical principles and practices associated with Ethno World, we draw on a multifaceted model for the facilitation of experiential learning (Heron, 1999). Our discussion is evidenced by data from research that comprised a document analysis focused on Ethno World grey literature, a survey of 202 Ethno World artistic mentors, workshop leaders, and organizers, and in-depth interviews with ten Ethno World artistic mentors and organizers.

Our chapter begins with a brief account of the signature pedagogies framework, proposed by Shulman (2005). This is followed by a discussion of the implicit beliefs and values that our research suggested formed the foundation of pedagogical thinking in Ethno World. We then discuss the principal pedagogical frameworks and the core pedagogical practices that were, as evidenced in our research, characteristic of Ethno World. We conclude this chapter with a model of the signature pedagogies found in Ethno World, accompanied by some critical questions concerned with the link with the wider discipline of community music.

Signature pedagogies

Signature pedagogies reveal disciplinary culture, ethos, and particular 'ways' of knowing (Shulman, 2005). Originally conceptualized as a bridge between professions and professional training, the signature pedagogies framework has since been applied in a range of contexts, including education in the arts and humanities (Chick, Haynie, & Gurung, 2012).

Signature pedagogies are thought to be multidimensional and multi-layered, concerned with implicit, deep and surface structures that support learning how to think, how to perform, and how to behave with professional integrity. *Implicit-level* values, beliefs, or moral codes underpin *deep-level* frameworks and principles for learning and teaching, which in turn inform specific *surface-level* pedagogical practices Therefore, professional values and beliefs are made transparent through frameworks for learning and teaching and via specific activities that occupy learners and their teachers in particular disciplines.

According to the signature pedagogies framework, well-established, predictable, and enduring signature pedagogies can free learners to focus on learning complex skills without being distracted by *how* the learning can be achieved. However, rigid and repetitive ways of learning and teaching may risk perpetuating

redundant or irrelevant practices (Shulman, 2005). Thus, while Shulman did highlight the value of pedagogical consistency, the signature pedagogies framework also embraces the need for tolerance of uncertainty. For example, when students 'perform' professional roles this introduces unpredictability alongside accountability to peers or co-performers, as well as visibility (i.e. in the enactment of professional roles, students become both visible and vulnerable).

Two pedagogical approaches are characteristic of Ethno World: (1) participants rotate in taking on the role and responsibility of workshop leader, focused on facilitating learning by ear, and (2) jamming with peers. Both pedagogical practices require participants to enact 'professional' roles; in the former instance, it is as a community music facilitator, while in the latter it is as a musical artist. As the signature pedagogies framework suggests, these practices involve participants making themselves accountable to peers, visible, and vulnerable, as they learn habits of the hand, mind, and heart. In the following sections, we analyse the implicit beliefs and values, as well as the core pedagogical frameworks that form the foundation of these core pedagogical practices within Ethno World.

Implicit-level beliefs and values

Implicit-level beliefs about pedagogy: Theory and practice

Foundational implicit beliefs about Ethno World signature pedagogies focus on the 'facilitation' of learning. Contrasting with the idea of 'teaching' as a directive process requiring the controlled transmission of knowledge and skills from teacher to student, facilitation is premised upon creating an environment in which learners can 'encounter their freedom, can encounter the "call" to exist in the world in a grown-up way' (Biesta, 2017, p. 6). Within such a facilitative space, pedagogical practices focus on mediation, brokering access to resources and expertise (Lee & Tan, 2018), caring for (and responding to) student needs and interests (Heron, 1999), and guiding and scaffolding student-centred learning (Jacobs & Renandya, 2019).

Positioned within the 'facilitation' paradigm, Heron (1999) proposed a framework comprising three overarching modes (orientations to facilitating learning), each one reflecting distinctive leader–learner power relationships and approaches to pedagogical decision-making. First, a *hierarchical* facilitator takes decisions for others (the learners/participants). In contrast, an *autonomous* facilitator promotes self-directed learning through a non-interventionist approach where decisions are taken by participants and outcomes may be unpredictable and unknown. Finally, *cooperative* facilitators take decisions with participants, while

guiding and steering the group towards discovering for themselves the predicted, desired outcomes.

Cutting across each of these facilitation modes, issues emerge relating to power dynamics. In this vein, Heron proposed some specific facets of facilitator authority that may have consequences for the experience of learning within groups. First, tutelary authority refers to the facilitator's competencies (expertise, knowledge, skills, effective communication), as well as the capacity to respond to learners' needs, interests, rights, and duties. Second, political authority refers to the locus of decision-making (e.g. decisions made through direction, negotiation, or delegation), therefore having implications for planning, content, resources, activities, and so on. Finally, charismatic authority refers to the facilitator's presence, style and manner, flexibility, respect for learners, as well as a willingness to confront resistance to learning. Expert facilitation, Heron suggests, involves an awareness of the implications of different facets of tutelary, political or charismatic authority, as well as the capacity to engage with each one of the three facilitation modes (hierarchical, autonomous, cooperative) in a flexible manner.

The three modes of facilitation (hierarchical, cooperative, autonomous) in turn intersect with six dimensions of pedagogy. The former three of these dimensions – planning, structuring, and meaning – are concerned with establishing what will be learnt, how it will be learnt, and how this will be made meaningful. In contrast, the latter three dimensions of learning – confronting, feeling, and valuing – are concerned with interpersonal processes and dynamics amongst learners and facilitators (Figure 1.1).

For example, in the Ethno context, planning may include setting objectives, identifying specific musical content as well as social activities, identifying necessary resources, and anticipating necessary ground rules. Structuring is concerned with 'situational realities' which in the context of Ethno may be determined by time constraints, use of space, and pace of sessions. The meaning dimension is concerned with how participants acquire new knowledge and skills in ways that are personally relevant and deeply understood, for example through demonstration or explanation (a hierarchical orientation), negotiation (a cooperative orientation), or improvisation and exploration (an autonomous orientation). Turning to the interpersonal processes, the confronting dimension is concerned with how resistance or disruption may be transcended, while the feeling dimension concerns individual and group emotional well-being and dynamics. Finally, the valuing dimension encompasses the ways in which every participant can be included within a climate of respect.

Key to this framework is the idea that on any one of these six dimensions facilitators may adopt hierarchical, cooperative, or autonomous orientations to

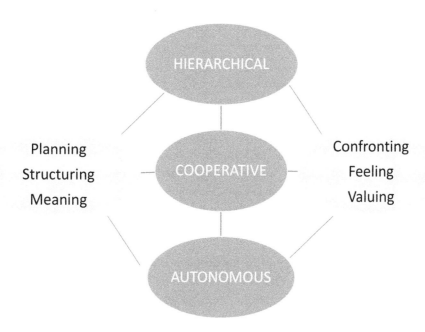

FIGURE 1.1: Modes of facilitation and dimensions of pedagogy.

pedagogy, and in any single context (or even within a single session) these orientations may shift dynamically as the music-making emerges and develops.

Within the multicultural context of Ethno World, an implicit belief in teaching as facilitation was found to encompass this full range of possibilities at the intersection of facilitator modes and dimensions of pedagogy (Heron, 1999). Thus, inclusive and highly contextualized practices required facilitators to take some decisions alone, to collaborate with groups on other decisions, and to allow participants the space to reach some decisions alone. Interviews with Ethno World artistic mentors reinforced the value accorded to an evolving, flexible, and differentiated pedagogy characterized by a continuum of orientations to facilitation.

> Depending on the participant, sometimes you need really, really tight frames to be creative […] some other participants they really like these wide frames […] the Ethno experience so far as I have experienced it, I think it has the flexibility to take care of both of them.

Accordingly, pedagogical choices were therefore related to the degree to which workshop leaders were guided by artistic mentors, supported by peers, or left to be entirely autonomous.

> We also have had the experience [...] in order to save some time [...] we propose something to the [workshop leader] on how they want to work. One option would be to have an arrangement, or at least the chords written down, help assisted by the artistic mentors. Sometimes it's a mixture of the artistic mentors [...] or sometimes even just one [peer] participant. Or [...] we even had the situation when we had a singer that brought a recording. We [artistic mentors] had to figure out everything of the recording, we didn't even have the chords [...] and nobody had the ability to be in the front and teaching the people how to do it. So what do we have to do? The most un Ethno thing which was to write down the arrangement in a traditional music score [...] it worked. In that context. It was what works. And everybody liked it, because at least they had clear instruction.

Notwithstanding the emphasis on flexibility and examples of hierarchical as well as autonomous practices, an overarching Ethno World pedagogical philosophy aligned strongly with a cooperative facilitation mode, premised upon the idea of guiding participants towards solutions. For example, pedagogical values articulated by Ethno leaders aligned with Heron's cooperative facilitation mode in the structuring and meaning dimensions, whereby decisions about how to communicate a piece of music and make it meaningful for one another would be taken *with* participants, not for them.

> The most important rule for the artistic mentors is that they are there in order to let the participants shine. They are their support system that kicks in when, whenever they are needed, and this might already start before the people have taught the tune to the group.
>
> The artistic mentors again, try to take as much of a backseat as possible until the workshop leader is either stuck somewhere or is not able to, to feel what the group is currently needing.

An autonomous facilitation mode, whereby decisions are taken by participants and the facilitator's role is as a fellow learner and collaborator, was also evident in the discourse concerned with the relationship between artistic mentors and workshop leaders. For some, this orientation to facilitation was a philosophical stance, while for others it was pragmatic.

> And then the people that have maybe studied the instrument say 'Oh, I don't need any help, thank you' [...] and then they lead it completely by themselves and then the artistic mentors they behave just like all the other participants, and they just learn the tune.

There could be tensions between a cooperative mode as a guiding principle and the demands that artistic leaders faced relating to any one of the task-based or interpersonal dimensions of learning, which in some instances were deemed to require hierarchical responses. In such instances, a hierarchical facilitation mode was deemed to be necessary to support planning and structuring the overarching progress towards group goals.

> Everyone who's been to an Ethno knows that there's a point when someone needs to make a call [...] people get really excited, and everyone wants to have ideas.
> And then at some point, you have to be like, 'well, it's all great, but this is what we do'.
> Sometimes you get people that are a little focused more on perhaps their own needs [...] of course I would have to set the boundaries, but, you know, I would at the same time, propose a solution.

On some occasions, despite the best efforts of all involved, the process broke down resulting in confusion, tension, and disappointment, for example when a hierarchical mode of facilitation did not serve the workshop leader's needs.

> I felt she wasn't happy because it didn't reflect her culture [...] that was a mistake from the leader because they didn't ask her 'Do you like this? Is the arrangement good? What do you feel?'

Implicit-level beliefs about how we learn: Experiential learning

Choices with regard to facilitation modes, discussed in the previous section, are typically made in service of supporting learning. In Ethno World, these choices focus on the facilitation of experiential learning, whereby learners gather, share, observe, imitate, reflect, and experiment, learning through repetition as well as through exploration and trial and error. Through an experiential cycle of affective experience, imaginative exploration, conceptual problem-solving and practical, task-oriented activity (Heron, 1999), Ethno World participants were thought to be empowered and guided in the development of their self-directed and co-regulated musical skills, the celebration of self and others, and progress in social competencies such as cooperation, communication, and interpersonal sensitivity.

According to this cyclical experiential model, affective learning forms the basis from which imaginal, conceptual, and practical learning emerge (Heron, 1999). While affective learning focuses on emotion and what can be learnt in the immediate moment of encounter, practical learning refers to how skills are acquired and physically carried out in action. Imaginal learning is concerned with metaphorical and evocative visualizations and exploration of new ideas, while conceptual

learning comprises criticality and cognitive understandings. Holistic, transformative change may occur when this full cycle of embodied experience, practical know-how, creative imagination, and critical reflection is complete.

Ethno participants depicted learning and development as a process of experiential exploration, trying new ideas, and being supported in taking risks within a failure-free environment. Learning was associated with going outside of one's comfort zone, expanding knowledge and skills, and trying new things even when it felt strange and different.

> You're allowed to make mistakes. And then you feel like you can try new things and maybe do it differently than you did before. And also contribute with new ideas.
>
> The full learning potential of embodied experiential music-making was perceived as being available to those who approached Ethno World with open hearts and minds.
>
> The only requirement would be to open yourself up to new experiences. Openness. Openness to learning and sharing, vulnerability, discovering what music has to offer and what music does to your soul. And doing this in a group. Openness to the experiment of trying new things.

At Ethno World, personal interest, motivation, and conceptual understandings (in and beyond music) flowed from the experience of one another's cultures through the medium of music. In this sense, meaning making was found to emerge from experiential learning rooted in intercultural exchange, being developed through affective engagement, imaginative, and practical activity and finally through new conceptual understandings. Through experiential learning supported largely by cooperative facilitation, Ethno World participants could make connections with – or 'unlearn' – prior musical and wider cultural knowledge and build new cultural understandings that were grounded in musical encounters.

Implicit-level values: Valuing one another through intercultural learning

A distinguishing feature of Ethno World was its perceived function as a space where shared understandings of one another's culture could be mediated through music. Intercultural learning was a consistent foundational value, involving honouring traditions through the reciprocal exchange of musical ideas as well as being open to adapting original material in order to be accessible for a multicultural group.

As discussed in the previous section, affective experience formed the basis of the full experiential cycle. In this way, affective insider knowledge of what the music

from cultures other than one's own 'feels' like was the foundation for intercultural learning – a cornerstone of Ethno World signature pedagogies.

Schippers (2010) was amongst the first to write about intercultural learning in music education, highlighting that those who teach the world's musical cultures need to carefully consider 'the position of different musics in society, the choice of musics to be taught; views on tradition, context, and authenticity; and approaches to methods of teaching' (p. 60). Similarly, Ibarretxe Txakartegi and Diaz Gomez (2008, p. 340) argued that modern-day societies are intrinsically intercultural, therefore the training of music educators should include 'the diverse range of existing music microcultures or subcultures' that reflect the music culture itself. They specifically maintained that a truly intercultural music education should encourage music makers to 'approach, understand, receive and even fuse with "other" music cultures' (p. 340) that could be distant in space and time from one another.

Participation in intercultural musical experiences reportedly has supported individual musicians and institutions in building networks that nurtured creative inspiration and knowledge transmission (Herbert & Saether, 2014). What is more, fusing musical cultures has reportedly helped musicians to make musical discoveries and brought to the surface tensions around creating individual vs. cultural musical identities as well as making explicit some concerns about the integrity of intercultural fusions.

Overall, participants valued Ethno World as a mutually respectful multicultural space, where music was the medium for intercultural exchange. As Ethno World participants noted:

> It's a way to get to know people from around the rest of the world as a beginning, but also through hearing them talk about their music or the songs that they're teaching you. You get to learn some important things about a culture [...] which makes you understand their situation way more than if you would not have gone an Ethno.
>
> The largest part of intercultural learning was extramusical. Yes, I did learn a lot about other musics, but to understand music from elsewhere takes way longer than one week. One week is however not bad to get to know and understand people from elsewhere.
>
> It feels like it's about breaking down those cultural barriers and just, you know, really creating a space for deepening understanding across, you know, religions across all these different beliefs, and in all these different, you know, cultural barriers really, and, it happens to be that the music is awesome.

Intercultural learning was furthermore valued in terms of Ethno World's response to global societal challenges, in particular those relating to the migration of people

across national borders, but also wider global challenges concerning cultural and gender identities and environmental issues.

> Ethno's view has grown to encompass society at large, we see that there is this great need for projects that are bringing people together, that are bringing greater understanding [...] as new communities of immigrants form, how do they get integrated into the societies where they are established [...] People are bringing environment to the table; gender diversity has been brought to the table.

Valuing one another meant adopting an inclusive approach to music-making, where all differences were welcomed and respected. An emphasis was placed on the 'valuing' dimension of learning, focusing on achieving this through trust and empathy.

> One of the main things that we ask [of] our leaders is 'Take care, that nobody's aside, that everybody can join.'
> These Ethno principles [...] it involves always listening to the other person [...] It's not very Ethno-like to say, 'I'm right and you're wrong.'

There were some critical issues relating to the implicit, foundational principles of facilitating intercultural learning. First, artistic mentors referred to a specific aesthetic – which they called the 'Ethno sound' – that emerged from the fusion of several cultural traditions.

> There tends to be this kind of like fusion, like Ethno sound that kind of goes into all the tunes. And I totally like that sound.

Overall, there seemed to be a shared view of the workshop leader as a 'culture bearer' who would have the 'final say' in matters concerned with the repertoire they had offered. This view of the 'culture bearer' in turn placed a responsibility with the workshop leader to critically reflect upon their own cultural identity, the material that was chosen to represent that culture and how it was presented, and whether that material was theirs to offer.

> There is a great deal of adherence to authenticity, and I don't think it happens in Ethno without the support of the culture bearer which of course, brings us to the question of that culture bearer also reflecting on his [sic] own traditions, quite sure.

The idea of fusion did not always partner easily with a wish to honour authentic musical traditions. Complex issues emerged concerned with cultural

identity, in particular questions relating to appropriating and sharing cultural traditions, colonization and the domination of a western perspective. Clearly, these issues were the focus of ongoing discussion and reflection among many Ethno leaders.

To summarize, the values and beliefs that were implicit in the Ethno World pedagogy were strongly rooted in the dimensions of learning concerned with valuing and feeling, in tandem with confronting potential resistance to new ideas and thinking critically about different perspectives (Heron, 1999). In the following section, we discuss the deep-level pedagogical frameworks that functioned as the spaces within which these dimensions of learning could be manifest in specific ways.

Deep-level pedagogical frameworks in Ethno World

The previous sections have discussed the implicit, values-based level of a signature pedagogy that in turn shaped the deep-level pedagogical frameworks that were characteristic of Ethno World. In this section, we discuss these deep-level principal pedagogical frameworks, which were identified as non-formal pedagogy and scaffolding. These were the frameworks for learning that reflected the foundational implicit values and beliefs as well as serving as the 'vessels' within which specific surface-level activities were developed.

Non-formal pedagogies

Non-formal pedagogies lie somewhere between formal (always organized and structured) and informal (never organized and with no set objectives) approaches (Creech, Varvarigou, & Hallam, 2020), and involve 'greater flexibility, versatility, and adaptability than formal education' (Coombs, 1976, p. 282). Non-formal music pedagogy has been aligned with facilitative approaches where teachers function as a musical model or resource to support learning, for example characterized by students learning in self-directed, independent friendship groups (e.g. see Hallam et al., 2011; Hallam et al., 2017). Classroom workshopping, where differentiated pedagogies can include modelling, coaching, and scaffolding, has also been associated with a non-formal pedagogical framework. Mok (2011) and Hallam et al. (2011) emphasize that one of the core characteristics of non-formal teaching is autonomy in the student's decision-making about the direction of the musical projects. Accordingly, attention has turned towards non-formal pedagogies that promote holistic, experiential learning (Hallam et al., 2017; Ruck-Keene & Green, 2017), with a specific interest in the ways in which imaginative and intuitive

learning intersect with cognitive understandings and procedural knowledge (Saetre, 2011; Muhonen, 2016).

In accordance with the conclusions of these previous studies cited above, the principal pedagogical framework for Ethno gatherings could be described as non-formal, characterized by a flexible and differentiated approach that reflected beliefs about learning as facilitation and the value accorded to a cooperative orientation.

> Ethno World facilitators explicitly use a non-formal pedagogical approach in their practice.
>
> In Ethno we do non-formal education and we want people to exchange and learn also in informal ways. For that we need a good group spirit and so we need to work on the process.

Survey responses reinforced the idea of non-formal learning as a principal pedagogical framework, with a specific emphasis on the non-formal structure of turn-taking in the workshop leader role. This 'co-teaching' approach was believed to be an important approach that fostered learning, for example through giving workshop leaders the latitude to explore and experiment with their own strategies in a self-directed manner, before suggesting ways of doing things differently. At the same time, artistic mentors and Ethno participants alike also favoured some oversight of learning, to ensure that the approaches suited the learners and that there was some shared responsibility for musical decisions. Therefore, the non-formal Ethno framework could be described as learning through self-directed experimentation, tempered with scaffolded guidance, support, and some oversight of aims.

Scaffolding: Supporting expansive learning

Scaffolding (Bruner, 1966) refers to support from a more knowledgeable other (e.g. teacher, peer) that makes it possible for learners to move beyond their 'comfort zone', closing the gap between their current capacity and what they aspire to achieve. For example, 'artful teacher scaffolding' (Wiggins & Espeland, 2012) describes the role that music teachers play in providing support, including stepping back to make space for learners' independence.

In the Ethno World context, scaffolding may include (1) strategies that align the attention of facilitator and learner, (2) marking critical features of musical material, (3) manipulating the difficulty level of the music through (for example) conducting, accompanying, singing or playing along, (4) modelling performance, (5) setting goals, and (6) providing support by engaging in dialogue intended to reduce frustration (Kennel, 2002) or creating a supportive environment characterized by

mutual respect, where learners are valued for their ideas and contributions and in control of their learning (Wiggins & Espeland, 2012). Within a cooperative facilitation mode, the type of scaffold adopted would be dependent upon the facilitator's perceptions of the reasons contributing to learner success or failure, a phenomenon Kennel labelled 'attribution scaffolding' (Wiggins & Espeland, 2012, p. 246).

Scaffolding emerged as a second key pedagogical framework for supporting the exploration of unfamiliar musical, personal, and professional territories, thus potentially playing a role in transformational learning. Accordingly, Ethno participants described being 'pushed out of [their] comfort zone', expanding their musical and personal boundaries. Scaffolded experiences included learning unfamiliar musical techniques or languages by ear, as well as creating, improvising, or jamming in peer groups.

In summary, two deep-level pedagogical frameworks were found to be characteristic of meaning-making in experiential learning at Ethno World, the first being 'non-formal pedagogies' and the second being 'scaffolding expansive learning'. These were the pedagogical frameworks which functioned as vessels for the core pedagogical practices that are discussed in the following section.

Surface-level pedagogical practices in Ethno World

As discussed above, implicit values and beliefs about learning underpinned the deep-level pedagogical frameworks that characterized Ethno World. Accordingly, specific surface-level core pedagogical practices, discussed in this section, were framed by non-formal pedagogies and scaffolding, which in turn were shaped by a foundational belief concerned with the facilitation practices that support valuing one another through intercultural, experiential learning. These core pedagogical practices included learning by ear, peer learning, and self-directed learning.

Learning by ear

Learning by ear was the prominent core pedagogical practice at Ethno gatherings, primarily achieved through call-and-response methods including imitation and repetition.

> It's all done by ear and so, you know, and from like a traditional cultural perspective, it's done by ear and you just sing it and you play it until you got it [...] This process of repeating until something is in your mind, but the feeling, it's always that you're going to forget everything.

Learning by ear contrasts with a notation-based approach to learning music where students are given notated material, often without prior exposure to the sound of the piece. Priest (1985, 1989) has argued that playing by ear can nurture advanced aural ability, but lamentably, this foundational music process has historically been undervalued in formal music education. Green (2002, 2008), Varvarigou and Green (2015), and Varvarigou (2017, 2019) have published extensively about learning music by ear from recordings, as an approach that can nurture personal and collaborative creativity, enhance aural development, and promote enjoyment through musical exploration.

Through playing by ear in groups, developing musicians enhance their listening and improvisation skills, learning to harmonize, and developing creative ideas (Varvarigou, 2017). Learning by ear can provide the scope for playful experimentation where groups 'mess around' with musical repertoire, arrange pieces for unconventional ensembles, and learn together by 'sticking with difficulty, daring to be different and tolerating uncertainty' (Spencer et al., 2012, p. 35 cited in Varvarigou, 2017, p. 173).

Thought to be integrally implicated in intercultural learning and exchange, learning by ear at Ethno gatherings was described as a 'beautiful but challenging approach to learning'. Perceived as being central in supporting peer learning, learning faster, and supporting memory retention, learning by ear was also depicted as an inclusive approach to learning that contributed to building confidence. In this sense, learning by ear was perceived as a pedagogical practice that could enable Ethno participants to experience ownership in music-making, irrespective of sight-reading skills.

> I've noticed learning tunes by ear is absolutely more inclusive than learning from notes.
>
> With regard to whether it is inclusive, of course some people feel more or less confident learning by ear. But I feel that the emphasis on ear learning at Ethno is a really important value, giving people a sense of ownership over the music they are teaching. It works against the experience that many have outside Ethno that you can only participate musically if you are a fluent sight-reader.
>
> Playing by ear is a way to really get to know the music, to understand music much better than playing it by score. You get the feeling of melody, harmony, tempo, rhythm. You get to know different music styles. You remember them way better than playing by score.

Notwithstanding the strong adherence to the predominant view among Ethno participants and artistic mentors that learning by ear was the most effective way to learn tunes, there was some ambivalence about whether notation could also

contribute to learning in some way. On the one hand, participants reiterated that aural learning 'sticks' in one's memory and is inclusive. On the other hand, participants made a distinction between music notation and lyrics, emphasizing that lyric sheets could be an important tool for retention, particularly when learning songs from multiple different languages.

> I read music fluently and learning by ear sometimes feels like a slower process, especially if the tune is in an unfamiliar musical style. But overall, the melodies will stick in my memory if learned by ear than just read on a score. Lyrics are a different matter, though, as I find it useful to see words spelled out to remember them, especially when learning a song in an unfamiliar language.
>
> When I was at Ethno [name] I had to learn lyrics in Estonian, Arabic, and other languages that I don't know or understand. The result was really different in between two ways of learning. (1) If I read the phonetics (how I would pronounce it in my birth language) or (2) if I heard and repeated the sound exactly as it comes. I think the best way is to first listen to it and be ready to also use visual memory and link those two ways of learning.
>
> Ethno does have a strong focus on aural transmission, but other aids are used when necessary. Western notation is pretty rare in my experience but chord and lyric charts, cheat sheets and Indian sargam systems have been used.

In summary, notwithstanding some acknowledgement that notation could play a role in supporting learning, Ethno participants identified learning by ear as a key musical skill and core pedagogical practice that was thought to help Ethno participants remember the music, to enhance their confidence when playing melodies, and to be an inclusive way of learning.

Peer learning

A distinctive surface-level signature pedagogy, characteristic of Ethno World, was peer learning. This core pedagogical practice included including peer-to-peer coaching, feedback, and interaction. As such, peer learning could be symmetrical (e.g. in jam sessions, side by side) or asymmetrical where peers took on the role of workshop leader or even artistic mentor.

> It's peer to peer, but we have artistic mentors. And I don't see that there is a conflict or a contradiction there.

Peer learning describes various ways that students learn from and with each other and is characteristic of non-formal pedagogy, contributing to relationship building

with fellow learners and the facilitator(s) (Creech et al., 2020). Peer learners interact and co-construct knowledge; this happens across a range of contexts and may manifest as collaborative projects, mentoring or coaching one another, or interaction in informal ways outside of guided learning tasks. Peer learning may be symmetrical, 'where interaction assumes relative egalitarian social and cognitive ability', or alternatively asymmetrical with 'defined roles for novice and expert', or 'helped' and 'helper' (Johnson, 2017, p. 164).

Whether symmetrical or asymmetrical, peer learning can enrich learning outcomes by providing a framework for cognitive challenge, the exploration of new ideas, and the co-construction of knowledge (Biggs, 2003; Topping, 2005). In music education, peer learning has been associated with positive achievement (Dakon & Cloete, 2018; Darrow et al., 2005; Goodrich, 2007; Johnson, 2017; Lebler, 2008), reflection and dialogue about musical development (Nielsen et al., 2018) as well as a range of wider benefits related to personal identity and motivation (Kokotsaki & Hallam, 2007). At its best, peer learning provides a framework where together learners may achieve an elaborate and deep understanding of the activities that they undertake.

One specific context for informal peer learning in music is 'jamming', referring to a process of informal musical exchange among musicians. Brinck (2017) explored the collaborative practice of jamming through the lens of situated learning. Collaborative peer learning, in this context, was deeply embedded in improvisational practices that embraced diversity and unpredictability. Specific processes by which collaborative peer learning could be nurtured were concerned with the 'communication of masterful standards' (Brinck, 2017, p. 221), through scaffolded interactions such as modelling and the use of dialogue (verbal or musical) for co-construction of knowledge. Such practices offered 'numerous possibilities for (changing) participation' for students and professionals alike (Brinck, 2017, p. 221).

In Ethno World, peer learning was expressed as 'room to help each other out': 'It is a shared process; I play this and I look and listen to my neighbour.'

> Everybody is here to answer your questions and help you. Everybody is enjoying sharing and learning.

Peer learning was made possible by a strong sense of community nurtured within Ethno gatherings. For example, Ethno gatherings were thought to enable participants to meet and experience a sense of union through music, without necessarily having a common spoken language and irrespective of musical ability or knowledge. Within that community environment, jamming – described as an inclusive space of intimate musical and social exchange – was thought to be an effective

way for learning with and from peers. Here, peer feedback and exchange were described as 'intense' and integrally bound up with the social bonds and trusting environment that developed at Ethno.

> I didn't get the feeling that people are shy expressing their feelings and when they feel somebody else is saying what they really think, then I can also say what I really think. And usually, the level of trust was there that we felt this was possible.

One Ethno participant described the heightened awareness of personal and social responsibilities within the community, which helped peer learning to function well. These responsibilities included being non-judgemental, mutually respectful, and supportive as well as being prepared to work towards resolution of conflicts when they arose. When these responsibilities were manifest in action, Ethno was an environment that was experienced as being personally and musically enriching, where friendships and learning flourished.

> You put musicians from all over the world together, they learn music from each other, they laugh, cry, dance, jam, eat together and they form a big bond through that interaction.
> It's also about responsibility, creating space for the other, helping each other and dealing in a sense with conflicts that might arise during that time.
> I have learned from and connected with so many people from all over the world because of it. I think one of the things the originally struck me about Ethno is the jamming and the non-judgement of musicians no matter the level […] there is always something to learn from another culture.

Nonetheless, some Ethno participants expressed the view that limits in musical skill could act as a barrier to peer-to-peer communication, interaction, and ultimately learning.

> I definitely feel musical ability is a strong factor in bringing people together; having that base ability allows for much easier and better music making especially in styles you're less familiar with, really enabling that bond.
> Musically I prefer people with a decently high level of music expertise. I usually can't learn or experience much with amateurs.

Likewise, jamming was not always perceived as being effective in supporting learning. Participants explained that jamming was fun, but could risk excluding some Ethno newcomers. The view was also expressed that jamming could be

experienced very differently, depending on factors such as technical expertise or leadership skills among peers.

> For me there is a difference between jamming and going to a workshop. At jams, you usually don't really learn anything, you just join and have a much fun as you can without annoying the others.
>
> Jamming is for fun, good practice and learning subconsciously. It's not a good place to learn something you have zero experience with.
>
> Jamming is not always the best way to learn from peers, the experience can be very different depending on musical learning abilities, knowledge of repertoire and technical background. It's also important which other musicians are playing and the way they communicate while playing. Lots of musicians are good at playing but not necessarily they are good at leading or sharing knowledge.

In summary, Ethno gatherings brought people from diverse cultures and backgrounds together and promoted opportunities for peer learning embedded in musical and social relationships. The experience of peer learning within Ethno was in some cases thought to be differentiated according to musical ability, musical knowledge, and language and cultural factors, although there was also a strong ethos of mutual respect and being non-judgemental. There were mixed views about jamming as a forum for peer learning. While it was for the most part described as 'fun', there was more ambivalence regarding whether jamming always supported learning and inclusion.

Self-directed learning

A third core pedagogical practice at Ethno gatherings was self-directed learning, for example including individual preparation or follow-up practising after workshops or jam sessions.

> It was all YouTube. All my experience is based on things I've picked up on-line.
>
> So, I got to a point where I was so passionate that every night at 3a.m. I would plead with people to borrow their violin and I would go to the basement and practise by myself, that's why I want to pick up the violin now.

With roots in humanistic theories of learning, a key idea underpinning self-directed learning is that learners have 'unlimited potential for growth' (Morris, 2019, p. 637). Early research was concerned with self-directed learning among adults in informal contexts, where self-directed learning was reportedly pragmatic and purposeful, often driven by an intention to solve real-world problems

within everyday lives (Tough, 1971). In this vein, Knowles (1975, p. 18) added that:

> Self-directed learning describes a process in which individuals take the initiative, with or without the help of others, in diagnosing their learning needs, formulating learning goals, identifying human and material resources for learning, choosing and implementing appropriate learning strategies, and evaluating learning outcomes.

According to Knowles (1975), adults have a deep psychological need for self-direction and learn best through personally meaningful real-world experience.

Notwithstanding the association between self-directed learning and informal contexts, Carl Rogers (1969) argued that self-directed learning could emerge from non-formal pedagogies where learners collaborate in setting objectives and where the learning environment is characterized by respect for divergence in opinions and attitudes towards the content. This, according to Rogers, provides the conditions where learners may construct meaning in differentiated ways and take ownership and responsibility for learning. Therefore, self-directedness emerges within a supportive and empowering context.

More recently, and in accordance with humanistic principles, self-directed learning has been reported to be motivated by curiosity, intrinsic interest, and an internal quest for self-improvement (Bonk, 2015). Similarly, Morris (2019) argued that self-directed learning is purposeful and may be transformational; with valued characteristics being 'the freedom to learn, an abundance of resources, as well as choice, control and fun' (p. 644). In the specific context of music learning, Creech et al. (2020) argued that self-directed learning, as a form of informal learning, promotes autonomy and supports learners to construct musical identities that connect directly with their real-world experience.

Self-directed learning in Ethno World was closely related to symmetrical peer learning. Indeed, instances of informal collaborative peer learning outside of the structured workshop sessions could be described as self-directed and situated learning, whereby the learning was an emergent property of the immersive and intense experience. Informal, autonomous learning was characteristic of activities outside the formal settings, in rooms, hallways, and informal gatherings.

> [A] lot of important teaching and learning happened outside the 'classroom'. In rooms, in hallways, sunrise jams, festival, some later gatherings of Ethno friend groups too.
>
> I was like staying up till like 6:30 every morning, learning tunes like all night but, you know, in a fun way, but I definitely was also learning. [...] For me personally, I felt like I was learning like almost all the time.

Overall, an autonomous orientation to facilitation was perceived to correspond with opportunities for self-directed learning. For example, Ethno participants indicated that it was both important and commonly experienced at Ethno to feel welcome to share their ideas and to contribute through negotiation and collaboration in creating music together. However, there was some ambivalence over whether Ethno artistic mentors should always be as hands-off as possible and that participants themselves had responsibility for 'making things happen'. In other words, self-directed learning was both valued and practised and was furthermore supported with some guidance and structure for learning. As one Ethno participant eloquently put it: 'The best organization is an organization that's hardly noticed by anyone, but still very much there.'

With regard to the facilitation of self-directed music learning during Ethno gatherings, the artistic mentors noted that it was important to allow those teaching the songs to be self-directed (the workshop leaders), to step back, and to find ways to welcome artistic input from participants. Yet, they also acknowledged the need to be flexible and provide 'good' facilitation when appropriate.

> There has to be room to allow participants to give some artistic and musical input. I like it very much to go in a conversation with the group about how they feel the tune and the arrangement. This conversation is not always possible in really big groups.
>
> Put a bunch of confident and experienced musicians together, and learning will happen. But in Ethno, you have a mixture of different levels of ability and experience. Therefore, good facilitation is essential. If the workshop leader is confident and has a strong arrangement, then the artistic leader can step back and leave it to the participant leading the tune. Usually, workshop leaders do a very good job in my experience [...] The best artistic mentors really listen to the workshop leader and try to help them achieve their vision [...] In a much smaller Ethno [...] the participants got to have a lot of input in the arrangements because it was a small group. This was a brilliant experience for me. I loved that the everyone in the band could suggest ideas and we could try them out together [...]. But when I later went to bigger Ethnos, [and] [...] I had to readjust my thinking of what Ethno was. In the large Ethnos, I discovered, the artistic leaders are in control. This is necessary because of the size of the group.

Therefore, while self-directed learning supported by autonomous facilitation was aspirational, this was sometimes tempered by logistics such as large groups, mixed abilities, and time constraints.

To summarize, at the surface level of Ethno World signature pedagogies, the dimensions of learning concerned with planning and structuring were expressed through pedagogical practices that were organized around self-directed, situated learning, aural learning, and peer learning.

Conclusions

Overall, the signature pedagogy found at Ethno World was underpinned by an implicit belief in teaching as a multifaceted form of facilitation, with the most highly privileged orientation to facilitation aligning with a cooperative facilitation mode. The 'signature' Ethno World experience was found to be intense, intimate, joyful, and fun. Within this intense, multicultural context, the deepest, foundational level of Ethno pedagogical principles and practices was found to be securely embedded in a commitment to valuing others through a critical approach to intercultural and experiential learning.

The principal frameworks that were found to be characteristic of Ethno pedagogies were informal learning and scaffolding of expansive and meaningful learning. Within an experiential approach, both informal (e.g. jamming) and non-formal learning (e.g. workshop sessions) were scaffolded around imaginative and practical exploration of familiar and unfamiliar ways of making music. Through experiential learning, Ethno participants could make connections with (or alternatively 'unlearn') prior musical knowledge and build new conceptual musical understandings grounded in practical knowledge and affective experience.

These foundational principles and frameworks underpinned the 'surface' level of Ethno pedagogical tenets that comprised what actually happened in Ethno gatherings. Here, core pedagogical practices were consistently found to be learning by ear, peer learning, and self-directed, situated learning. Although approaches to planning differed across a range of cultural contexts, some advance planning was generally considered to be crucial for the success of an Ethno gathering. That said, there could sometimes be tensions between the relative emphasis on planning vs. allowing the Ethno experience to unfold in a natural and holistic manner.

At each one of the implicit, deep, and surface levels of Ethno World pedagogies, practices and frameworks were found that reflected pedagogical practice in many other non-formal and formal music education contexts. For example, Creech et al. (2020, 2021) discuss a diverse range of music contexts where experiential learning, scaffolding, self-directed learning, peer learning, and learning by ear have been applied and explored extensively. Furthermore, leadership models such as distributed leadership as well as hierarchical, cooperative, and autonomous orientations to facilitation have been noted and discussed in non-formal community music settings as well as in formal music education (Barrett et al., 2021; Willingham & Carruthers, 2018). In that sense, it may be that it is context more than pedagogical practice that may be said to be the distinguishing feature of Ethno World.

In conclusion, the signature pedagogies found in Ethno World were fluid, flexible, and differentiated. While the predominant and aspirational guiding principle was aligned with a cooperative orientation to facilitation, a full continuum of orientations to facilitation was evident – and this was shaped by

context. Some characteristics were core, signature facets of Ethno World (i.e. the foundational principles and the core pedagogical practices) while others were more fluid and responsive to local needs, traditions, and perspectives.

We began this chapter by drawing attention to debates concerned with whether there is a distinctive pedagogy that can be said to differentiate Ethno World from the wider disciplines of music education and community music. We conclude by advocating a shift in focus from concerns about 'distinctiveness' to dialogue about how Ethno World achieves its objectives through pedagogical means. Our parting argument is that the social, intercultural, and musical aims of Ethno World rely on critical thinking with regard to manifestations of the multidimensional and nuanced pedagogical structure discussed in this chapter.

NOTE

1. Quotations that have come directly from the participants' responses to the interviews or survey questions appear throughout the chapter. These are either separated from the main body of the text and indented to the right or presented within quotation marks with italicized text in the main body of the text. To protect anonymity, no information on the participants responding is provided.

REFERENCES

Barrett, M. S., Creech, A., & Zhukov, K. (2021). Creative collaboration and collaborative creativity: A systematic literature review [Systematic review]. *Frontiers in Psychology, 12*(3137). https://doi.org/10.3389/fpsyg.2021.713445

Biesta, G. (2017). *The rediscovery of teaching*. Routledge and Taylor & Francis Group.

Biggs, J. (2003). *Teaching for quality learning at university*. Open University Press.

Bonk, C. J., Lee, M. M., Kou, X., Xu, S., & Sheu, F. R. (2015). Understanding the self-directed online learning preferences, goals, achievements, and challenges of MIT Open Course Ware subscribers. *Journal of Educational Technology & Society, 18*(2), 349–368.

Brinck, L. (2017). Jamming and learning: Analysing changing collective practice of changing participation. *Music Education Research, 19*(2), 214–225.

Bruner, J. S. (1968). *Toward a theory of instruction*. W.W. Norton & Co.

Chick, N. L., Haynie, A., & Gurung, R. A. R. (2012). *Exploring more signature pedagogies: Approaches to teaching disciplinary habits of mind*. Stylus Pub.

Coombs, P. H. (1976). Nonformal education: Myths, realities, and opportunities. *Comparative Education Review, 20*(3), 281–293.

Creech, A., Hodges, D. A., & Hallam, S. (Eds.). (2021). *Routledge international handbook of music psychology in education and the community*. Routledge.

Creech, A., Varvarigou, M., & Hallam, S. (2020). *Contexts for music learning and participation: Developing and sustaining musical possible selves*. Palgrave Macmillan.

Creech, A., Varvarigou, M., Hallam, S., McQueen, H., & Gaunt, H. (2014). Scaffolding, organizational structure and interpersonal interaction in musical activities with older people. *Psychology of Music*, *42*(3), 430–447.

Dakon, J. M., & Cloete, E. (2018). The violet experience: Social interaction through eclectic music learning practices. *British Journal of Music Education*, *35*(1), 57–72.

Darrow, A.-A., Gibbs, P., & Wedel, S. (2005). Use of classwide peer tutoring in the general music classroom. *Update: Applications of Research in Music Education*, *24*(1), 15–26.

Goodrich, A. (2007). Peer mentoring in a high school jazz ensemble. *Journal of Research in Music Education*, *55*(2), 94–114.

Green, L. (2002). *How popular musicians learn*. Ashgate Publishers.

Green, L. (2008). *Music, informal learning and the school: A new classroom pedagogy*. Ashgate Publishers.

Hallam, S., Creech, A., & McQueen, H. (2011). *Musical futures: A case study investigation*. Paul Hamlyn Foundation with Institute of Education, University of London.

Hallam, S., Creech, A., & McQueen, H. (2017). Teachers' perceptions of the impact on students of the musical futures approach. *Music Education Research*, *19*(3), 263–275.

Herbert, D. G., & Saether, E. (2014). 'Please, give me space': Findings and implications from an evaluation of the GLOMUS intercultural music camp, Ghana 2011. *Music Education Research*, *16*(4), 418–435.

Heron, J. (1999). *The complete facilitator's handbook*. Kogan Page.

Ibarretxe Txakartegi, G., & Diaz Gomez, M. (2008). Metaphors, intercultural perspective and music teacher training at the University of the Basque Country. *International Journal of Music Education*, *24*(4), 339–351.

Jacobs, G. M., & Renandya, W. A. (2019). Student centered cooperative learning: An introduction. In George M. Jacobs & Willy A. Renandya (Eds.), *Student centered cooperative learning: Linking concepts in education to promote student learning* (pp. 1–17). Springer Singapore.

Johnson, E. (2017). The effect of symmetrical and asymmetrical peer-assisted learning structures on music achievement and learner engagement in seventh-grade band. *Journal of Research in Music Education*, *65*(2), 163–178.

Kennell, R. (2002). Systematic research in studio instruction in music. In T. Colwell, & C. Richardson (Eds.), *The new handbook of research on music teaching and learning* (pp. 243–256). Oxford University Press.

Knowles, M. (1975). *Self-directed learning: A guide for learners and teachers*. Cambridge Books.

Kokotsaki, D., & Hallam, S. (2007). Higher education music students' perceptions of the benefits of participative music making. *Music Education Research*, *9*(1), 93–109.

Lebler, D. (2008). Popular music pedagogy: Peer learning in practice. *Music Education Research*, *10*(2), 193–213.

Lee, W. O., & Tan, J. P.-L. (2018). The new roles for twenty-first-century teachers: Facilitator, knowledge broker, and pedagogical weaver. In H. Niemi, A. Toom, A. Kallioniemi, &

J. Lavonen (Eds.), *The teacher's role in changing global world: Resources and challenges related to the professional work of teaching* (pp. 11–31). Brill and Snese Publishers.

Mok, O. N. A. (2011). Non-formal learning: Clarification of the concept and its application in music learning. *Australian Journal of Music Education, 11*(1), 11–15.

Morris, T. H. (2019). Self-directed learning: A fundamental competence in a rapidly changing world. *International Review of Education, 65*(4), 633–653.

Muhonen, S. (2016). Students' experiences of collaborative creation through songcrafting in primary school: Supporting creative agency in 'School Music' programmes. *British Journal of Music Education, 33*(3), 263–281.

Nielsen, S. G., Johansen, G. G., & Jørgensen, H. (2018). Peer learning in instrumental practicing. *Frontiers in Psychology, 9*, 339.

Priest, P. (1985). Playing by ear. *Music Teacher, 64*(3), 10–11.

Priest, P. (1989). Playing by ear: Its nature and application to instrumental learning. *British Journal of Music Education, 6*(2), 173–191.

Rogers, C. R. (1969). *Freedom to learn*. Charles Merrill.

Ruck Keene, H., & Green, L. (2017). Amateur and professional music making at Dartington International Summer School. In R. Mantie & G. D. Smith (Eds.), *The Oxford Handbook of Music Making and Leisure* (pp. 363–383). Oxford University Press.

Sætre, J. H. (2011). Teaching and learning music composition in primary school settings. *Music Education Research, 13*(1), 29–50. https://doi.org/10.1080/14613808.2011.553276

Schippers, H. (2010). *Facing the music: Shaping music education from a global perspective*. Oxford University Press.

Shulman, L. S. (2005). Signature pedagogies in the professions. *Daedalus, 134*(3), 52–59.

Topping, K. J. (2005). Trends in peer learning. *Educational Psychology, 25*(6), 631–645.

Tough, A. (1971). *The adult's learning projects: A fresh approach to theory and practice in adult education*. Ontario Institute for Studies in Education.

Varvarigou, M. (2017). Group playing by ear in higher education: The processes that support imitation, invention and group improvisation. *British Journal of Music Education, 34*(3), 291–304.

Varvarigou, M. (2019). Nurturing collaborative creativity through group playing by ear from recordings in formal music education. In P. Costes-Onishi (Ed.), *Artistic thinking in the school: Toward innovative arts in education research frameworks for 21st century learning* (pp. 175–193). Springer Series.

Varvarigou, M., & Green, L. (2015) The Ear-playing Project: Musical learning styles and strategies in the instrumental music lesson. *Psychology of Music, 43*(5), 705–722.

Wiggins, J., & Espeland, M. I. (2012). Creating in music learning contexts. In G. E. McPherson & G. Welch (Eds.), *The Oxford Handbook of Music Education* (Vol. 1, pp. 341–360). Oxford University Press.

Willingham, L., & Carruthers, G. (2018). Community music in higher education. In B.-L. Bartleet & L. Higgins (Eds.), *The Oxford Handbook of Community Music* (pp. 595–616). Oxford University Press. https://doi.org/10.1093/oxfordhb/9780190219505.013.9

2

Playing with Tradition: Personal Authenticity and Discourses of Traditional Music-Making at Ethno World Gatherings

Laura Risk and Keegan Manson-Curry

The Ethno World programme is an international network of youth camps (officially known as 'gatherings' within the Ethno organization) that are focused on traditional and folk musics, wherein participants teach each other repertoire associated with their respective home countries, arrange that repertoire under the guidance of 'artistic mentors', and then share the results of this collaborative work through one or more public-facing performances.[1] The programme was founded in 1990 in Sweden and is currently under the auspices of Jeunesses Musicales International (JM International).[2] Ethno gatherings are typically one to two weeks in length and attendance is limited to participants under the age of 30, with the lower bound of the age range varying by gathering. Participants go through a selection process, determined locally by the gathering organizer(s), and gatherings may range in size from one or two dozen participants to, as at Ethno Sweden, over one hundred participants. While Ethno World activities also include workshops, mentor trainings, and a touring group, the present chapter focuses on the program's core activity: the twenty-plus annual gatherings that take place in countries across the globe.

Discourses of 'folk' and 'tradition' have been central to the Ethno programme since its inception. The Ethno organization describes gatherings as sites of meeting and exchange for young musicians carrying the 'traditional music of their cultural background' (Ethno France, n.d., para. 1). Ethno World is JMI's 'program for folk, world and traditional music' (JM International, n.d., para. 1). And Ethno Mobility scholarships support 'folk, world, and traditional musicians' ages 16–30 (JM International, 2021, para. 1). Yet 'folk' and 'tradition' are freighted and highly

malleable terms in many contexts, including at Ethno gatherings. This chapter argues that, at these events, the notions of folk and traditional music extend well beyond that of a style and repertoire associated with a given locale and instead come to function as broad terms for nationally associated lived experience. As a result, participants' choices regarding traditional music not only shape their presentation of nation-based self-identity but also redefine traditional music in ways specific to the Ethno context.

This chapter is based on arms-length research conducted under the auspices of Ethno Research, a multi-year project headed by Lee Higgins at York St. John University and funded by Margaret A. Cargill Philanthropies. The authors of this chapter were part of the Arts and Culture team of Ethno Research. Primary sources for this chapter include attendance by the lead author at Ethno France 2020; a post-hoc analysis of 114 Ethno Research interviews conducted between 2019 and 2021; and fourteen additional interviews with Ethno organizers and artistic mentors conducted by the Arts and Culture team. Though some of these interviewees have been involved with Ethno for many years, we note that our data does not sufficiently account for activity and experiences from the program's first decades, due to difficulties in contacting attendees from that earlier period. This focus on more recent attendees biases our findings towards the experiences of younger musicians who might still be seeking a career direction, meaning that the impact of Ethno on participants' professional careers may also be underrepresented in our data.[3] While beyond the scope of this chapter, it is important to note that young musicians who work as professional traditional or folk musicians may have a very different relationship to traditional and folk ecosystems than those who participate in these communities as amateurs.

As musical practices defined by discrete ethnic, geographic, class, and national identities, traditional and folk are relatively recent genre terms, with meanings varying from one locale to another, particularly outside Europe and North America. Ethno World's goal of engaging folk and traditional musics to promote intercultural dialogue and understanding might be understood as motivated by a set of highly western beliefs that hold that modern industrial life has caused westerners to become alienated from other people and from 'culture' more broadly, and that a deeper understanding of one's own place in traditional culture may be an antidote to this alienation and disconnectedness. As one artistic mentor put it, 'it's really a Western way of thinking to be not connected deeply with traditional music' (Interview #20022).[4]

Prior to each gathering, Ethno organizers ask attendees to prepare a piece of music from the tradition of their home country (or region). This is often a collaborative process, as all the participants from a given locale are typically asked to work together to select one or two repertoire items to bring to a gathering. This request presumes that: (a) each individual, or group of individuals, will claim

affiliation with one country or region according to birthplace and/or nationality, and will represent that country or region at the gathering; (b) that each country or region has a distinct traditional music that may serve as its cultural representation; and (c) that an individual or group of individuals is, by virtue of their nationality, qualified to teach the traditional music associated with their country or region to others. Ethno Research interviews indicate that Ethno organizers, artistic mentors, and participants are well aware of the problematic nature of these assumptions and many interviewees actively challenged them. Not all Ethno attendees have a clear national identity that they feel comfortable representing. In addition, musical repertoires and individual constructions of identity do not always align neatly with geopolitical political borders. Although this vision of traditional music does not withstand scrutiny, it does provide a reference point – a *point de repère*, as one artistic mentor put it (Interview #20022) – for the conversations on sameness and difference that are woven into the fabric of Ethno. Indeed, as later sections of this chapter demonstrate, the strength of the Ethno model as a locus for intercultural exchange derives in part from the problematic nature of this nation-based model. As participants negotiate the constraints of a system within which they are asked to represent their home countries or regions through traditional music, they critically reflect on identity and the nature of national belonging.

This chapter begins with a brief review of scholarly literature on the intersecting topics of revival, tradition, and authenticity, and then locates Ethno gatherings in the context of North American and European traditional/folk music camps and workshops. We propose a framework of 'personal authenticity' for Ethno gatherings, wherein music that feels authentic to a person is by extension considered representative of their nation, and examine links between Ethno and local traditional/folk music scenes. Ultimately, this chapter examines the complexities of sharing one's national heritage via traditional music in the Ethno context and asks how understandings of traditional music are constructed during and after Ethno gatherings by the Ethno community. In recognition of their meanings within the Ethno context, we use the terms *traditional* and *folk* in tandem, except when citing an author or interviewee who has specifically used one or the other.[5]

Tradition and authenticity

Filene (2000), Miller (2010), and others historicize folk music as the product of (a) the commercial recording industry of the early twentieth century and the financial success found in categorizing records according to ethnic or racial identities, and (b) the rise, in the late nineteenth and early twentieth centuries, of folklore as an academic discipline that could provide easily digestible units of discrete cultural

practices to the growing middle class. As Bendix (1997) aptly recounts, early academic interest in practices of the 'folk' were concerned with assigning labels of authenticity or inauthenticity to traditions based on their perceived uniqueness from other practices. In turn, these labels were used to strengthen the perception that each 'authentic' tradition was composed of unique elements associated with a given people and place. Music revivals in particular drew on discourses of 'authenticity' that placed great value on 'historical continuity and organic purity of the revived practice' and often built on notions of the 'folk' as a 'mythical people living in a land and time far removed from modern society' (Livingston, 1999, pp. 74–75). Though the modern academy has broadly relegated discourses of authentic vs inauthentic to the 'intellectual dustheap' (Born & Hesmondhalgh, 2000, p. 30), the professional folk or traditional musical ecosystem, as well as scholars of folk or traditional practices, often continue to define folk and traditional musics as discrete practices belonging to discrete peoples from discrete regions.

Although the reach of Ethno World today extends well beyond Europe, a particularly European set of beliefs about the connection between folk music and national identity remain foundational to the programme. In his 2004 monograph, *The Music of European Nationalism*, Philip Bohlman describes how Europe came to see itself as both a singular continent and a set of discrete nations, each represented by its own national musical tradition (Bohlman, 2004, p. 35). In this European framing, folk musics carry a universal human heritage but also promote the heritage of each individual nation. Ethno extends this vision outward to include non-European traditional/folk musics. The Ethno format, wherein participants bring a nationally associated song or tune to the group but also learn traditional repertoire contributed by other participants, builds towards a universal folk/traditional music culture even as it celebrates the distinct nations that exist within this whole.

In *The Invention of Tradition* (1983), Hobsbawm and Ranger remind us that the term 'tradition' is often applied to the result of deliberate acts that promote and advance certain practices that make reference to historical precedent – regardless of the actual veracity of these historical claims. Put differently, the connection between tradition and cultural heritage is constructed to promote particular cultural values and activities as important to and representative of a people (*ethnos*). That traditions are 'invented' means that they are political: some activities must be selected as more important for continuation – that is, more authentic – than other activities.

Placed in a wider context, authenticity can be understood as an imaginary. As Hill and Bithell emphasize, authenticity is a 'quality ascribed to representations' rather than 'an essence inherent in an object' (2014, p. 20). In the context of a revival, authenticity is ascribed by way of a two-part process: first, via the 'highly selective and subjective identification of particular aspects or elements in a music-culture', and second, via the decision that those aspects or elements 'should

be [valued and] perpetuated' (Hill and Bithell, 2014, p. 20).[6] Hill and Bithell describe three types of criteria for determining authenticity: *product-oriented* (e.g. manuscripts, scores, historical instruments), *person-oriented* (e.g. culture-bearers), and *process-oriented* (e.g. mode of transmission, creation, reception) (2014, pp. 20–23). The present chapter focuses primarily on the second of these and specifically on the ways in which Ethno positions participants as culture bearers for their home country or region. We argue that this presumption of individual-as-national-representative generates a framework of 'personal authenticity'.[7]

Traditional/folk music camps and workshops

In the post-Second World War decades, North American and European folk revivals generated a new class of professional folk/traditional musicians and an accompanying infrastructure of festivals, record labels, specialty magazines, and so on. While many of these commodity-driven changes also mark a shift from a participatory to a presentational paradigm with larger financial incentives (Turino, 2008) – a move from the kitchen to the stage, as it were – others, like camps and workshops, signal new modes of participatory music-making and new sites for community music transmission. Like the western music revivals by which it was initially inspired, and in spite of highly visible presentational outputs including carefully orchestrated final concerts, Ethno's official discourse emphasizes these more participatory, egalitarian aesthetics. In this section, we locate Ethno gatherings within a transnational – though primarily North American and European – ecosystem of traditional/folk music camps and workshops that variously target young musicians, adult amateurs, pre-professional and young professional musicians, or any combination thereof.

The musical landscape of traditional/folk music camps in North America and Europe has exploded in recent decades, from a handful of events in the 1970s[8] to the over one hundred 'fiddle camps' listed in Hargreaves (2017, pp. 125–131). These events are themselves just one part of a larger trend towards the formalization of community-based structures for the transmission of traditional musics in many locales (Risk, 2013, pp. 437–438). In Scotland, for instance, Miller notes 'a proliferation of educational events and classes run by local and national organizations' since the 1960s, with the number and popularity of such events and classes greatly increasing with the Scottish cultural renaissance of the late 1980s and 1990s (Miller, 2007, p. 289). Although community-based sites for the learning of traditional musics offer numerous social benefits, including as training grounds for music teachers, as repositories 'of experience and potential for music learners of all ages and abilities', as 'sites of social and musical participation and performance',

and as 'cultural resource[s] for building and maintaining communities', they are notably understudied in the scholarly literature (Miller, 2018, pp. 30–31).

As at Ethno, participants at other traditional/folk music camps typically leave the realities of day-to-day living and spend anywhere from several days to several weeks learning music in group settings, playing in late-night jam sessions, and preparing for final public performances. Inclusive opportunities for music-making are prioritized and many camps offer a variety of levels and modes of musical participation. Repertoire is often taught by ear using a call-and-response approach, though typically by designated instructors rather than by the participants themselves, as is the case at Ethno gatherings. While some traditional/folk music camps focus on a single musical tradition, many introduce students to a variety of different musical practices, though typically with more options for in-depth study than at an Ethno gathering.[9] Attendees are usually housed together and share meals, and contribute in a variety of ways to the 'co-creation' of the event, from informally sharing music with peers, to organizing dances, concerts, talent shows or other evening events, to stacking chairs and assisting in the kitchen. In short, traditional/folk music camps offer participants a suspension from the everyday and near-immediate entry into a community that, for many, feels life-changing (Dabczynski, 1994, p. 223; Hargreaves, 2017, p. 96).

Hargreaves notes that the participants at North American and European fiddle camps are overwhelmingly white, middle class, heterosexual, and cisgendered (Hargreaves, 2017). By contrast, Ethno purposefully draws its participants from as many identities and backgrounds as possible, although attendees from what may be loosely described as the Global South typically remain underrepresented. The low cost of Ethno gatherings and the recent addition of Mobility Grants for participants may further expand Ethno's demographic reach, however.

Three elements set Ethno gatherings apart from other traditional/folk music camps: (1) the emphasis on 'peer-to-peer learning', rather than a one-way flow of musical information from teacher to student, (2) the potential for a more ethnically and socially diverse group of participants, and (3) Ethno's narrow age range (most folk and traditional music camps are all ages and target primarily adult amateurs). By targeting musicians under age 30, Ethno attracts participants who may be not only in the formative stages of their musical development, but also still developing a sense of individual identity. For these young musicians, Ethno gatherings propose nationally associated musical repertoire as one means of claiming identity both as a musician and as an individual.

The following sections draw on the ethnographic and interview data collected by Ethno Research to examine the place of traditional/folk repertoire at Ethno gatherings, beginning with what we term a framework of 'personal authenticity'. We also consider Ethno participants' relationships to local traditional/folk music scenes and to their nationally associated musical repertoires.

Personal authenticity

When asked what happens if a participant brings a piece of music that is not considered folk or traditional enough by mentors and other attendees, some Ethno Research interviewees rationalized repertoire selection at the gatherings as follows: each person represents a nation, therefore what feels authentic to that person – including musical style – is representative of that nation. For the purposes of this chapter, this framework is termed 'personal authenticity'. To some extent, the personal authenticity framework functions as a practical solution to categorizing the range of musical material taught at an Ethno. Participants are associated with a national place of origin upon arrival at an Ethno gathering, meaning that any repertoire they share is typically connected both to them and to their place of origin. Put another way, the conflation of individual and nation blurs the line between individual style and repertoire and nationally associated musical traditions.

Ethno Research interviews suggest that when national authenticity comes into conflict with personal authenticity, the latter wins out. As one long-time artistic mentor said, 'Of course, you represent a country, but you represent mostly yourself in the way you are. You should be able to be yourself' (Interview #20153). In the following exchange, an interviewee who is both organizer and artistic mentor explores these questions of national and personal authenticity:

INTERVIEWER: *How important do you feel learning music from other parts of the world is to the experience?*

INTERVIEWEE: I think it is important [...] but it needs to be authentic. I think that's number one.

INTERVIEWER: *Authentic personally, for the people – the individuals – or authentic culturally? Or both?*

INTERVIEWEE: Probably for the people. I guess you could be [...] born in a culture but identify more with something else. [...] One year in Sweden, we had this Japanese guy [... but Japanese music] is not his thing. He was playing Irish music [...] He didn't want to have this connection to a country. He had another musical [identity ...] So mostly authentic in terms of people, and what they feel like they are.

(Interview #20141)

One interviewee suggested that national authenticity may in fact be a construct and that personal authenticity is the only true measure of identity: 'If [a person sees]

themselves as being from a certain place and it's important to them, then that's completely valid and there doesn't need to be any other qualification' (Interview #20042). Similarly, an organizer gave the example of an Australian who lived in the Czech Republic and played Balkan songs, arguing that 'people have a musical identity that they built, which is not necessarily their background'. Curiously, however, she said that when this participant finally taught an Australian song at an Ethno, there was 'a little spark'. Ultimately, she noted, the repertoire that a participant chooses to teach must be 'something from the heart' (Interview #20148).

Key to the focus on personal authenticity seems to be an understanding that all musical traditions are already hybrid. One Portuguese interviewee emphasized that his national music was by nature an amalgam of other traditions:

> There are some purists who do tradition the way that they were taught and they are not going to move it. But this is, in my opinion, completely wrong, because tradition is not about perpetuating or conserving a thing. Tradition exists for the well-being of the community. When a new culture appears, it mixes with that [and] that's going to affect the future [...] In some areas of Portugal, you have a lot of Arabic influence, for example, or a lot of Spanish, because we're close countries [...] Tradition is an evolving thing.
>
> (Interview #20025)

'You're not gonna find authenticity [at Ethno]', stated another interviewee (Interview #20042). Other interviewees emphasized that traditions are always evolving: 'When I present some song, it's my interpretation of the song, and somebody who lived 100 years ago, 200 years ago, probably presented a totally different way' (Interview #20041). It is worth noting that there are limits to what is considered an appropriate musical and personal expression for Ethno, however. Although one organizer supported attendees bringing songs that represented themselves, he also noted that popular music, in the commercial, often electronic sense, would not fit the Ethno approach (Interview #21016).

The framework of personal authenticity appears to be based in part on an assumption that 'traditional music' is an umbrella term that may encompass everything from twentieth-century popular songs (e.g. 'it's music that we like and that we identify with') (Interview #20025) to songs unique to one's family, such as a lullaby sung by a participant's grandmother (Interview #20037). Many Ethno interviewees expressed discomfort with rigid boundaries between traditions and cultures, seeing the gatherings as sites to break down those boundaries. A number of interviewees felt that traditional music was open to interpretation in a way that other musical repertoires were not and used this as a justification for the interpretive liberties common to Ethno gatherings. Said one participant,

'I loved that you could play tunes from a country without [...] being told it's wrong and you should play it like that because it's a tune from there [...] We just played it without [...] thinking about the styles' (Interview #20131).[10] One artistic mentor explained that he works from the assumption that 'traditional music should be always free. If it's not what you want to hear with traditional music, just don't listen to it' (Interview #20022).

Some interviewees whose primary musical focus is on a folk or traditional genre did describe the surface-level engagement with traditional music at Ethno gatherings as discomforting, however. One participant, who described herself as 'play[ing] trad music quite seriously' found the Ethno approach to traditional music problematic.

> I feel like it's a bit wrong playing this trad music without having listened to it lots and researched it and knowing how to correctly play it. When people are suggesting, 'With this Chinese piece, let's do this', I'm going: But what if that's just how you think Chinese music should sound? I don't want to do it wrong [...] If I was going to properly play Chinese music, I'd spend three or four months solidly listening to the tradition [...] It feels a little bit dodgy, really sort of [like] cultural appropriation to me [...] It's fine to just play it for fun but to perform it that way feels bad.
> (Interview #20017)

Another interviewee, whose musical background included two years in Sweden studying traditional fiddle music, described a tension 'between cultural meeting and engaging with cultural difference [at Ethno ...] where appreciation borders on appropriation'. He pointed out that participants cannot return home after an Ethno and play the music learned 'in all its idiosyncrasies' (Interview #20079). Other interviewees suggested, however, that Ethno gatherings may encourage dedicated players of traditional musics to expand their musical vision. Said one interviewee, 'I don't think we all need to be on the search for authenticity. I think there's room for experimentation. There's room for crossover' (Interview #20042).

While many of these critical conversations about authenticity can be valuable, it must be noted that there remains a potential for harm here. Attendees are granted authority to share a piece of folk or traditional music not as a member of a community that practices that music but rather as the representative of a nation or region associated with that music; there is no stipulation that participants have engaged with practitioners of the tradition they are bringing to Ethno. This may allow access to and use of the music of whichever cultural 'others' participants choose, including from certain minorities in Europe, like the Roma people, despite having little to no relationship with those communities.

Ethno World and local traditional/folk music scenes

Ethno gatherings are rooted in the folk revivals of the later twentieth century – the programme has its origins in the Swedish revival of the 1970s and 1980s – and many present-day Ethno gatherings are linked to local folk or traditional music festivals. Ethno New Zealand, for instance, performs at the Auckland Folk Festival, while Ethno England shares an umbrella organization – the Tandem Collective – with the Tandem Festival.[11] At the same time, some Ethno Research interviewees (all from the Global North) intentionally set themselves apart from folk revivalists, noting a lack of ethnic and racial diversity among the latter. One organizer remarked that when Ethno performed at his local folk festival, the group 'stood out very strongly' because the festival was 'just generally older and whiter' (Interview #21013).

This same organizer noted that his local folk festival had changed in recent years, hiring a more diverse line-up of artists and adding 'cultural advisors' to its team. While this organizer was reluctant to name Ethno as an outright 'agent of change' for the festival, he noted that a 'dialogue' had taken place wherein there was 'an acknowledgment [on the part of the festival] that changes needed to happen, and I think we've participated in being part of that change' (Interview #21013). Statements such as this suggest that Ethno may encourage local traditional/folk music scenes and events to reflect on their own whiteness and to work towards increased ethnic and racial diversity.[12]

Some interviewees described a symbiotic relationship between Ethno gatherings and local traditional/folk music scenes, wherein the former might pique a young musician's interest in a given repertoire and style and the latter might then provide additional opportunities, such as traditional/folk music workshops, to further that newfound interest. One organizer pointed out that most attendees at his Ethno were not, in fact, traditional musicians and that the goal of the gathering was not to transmit traditional styles:

> A rock musician will not come to Ethno because they want to learn from a musician from a village in Croatia how to play that traditional music. But maybe they will come to Ethno and of those 20 tunes, they will really like that song from Croatia and then they will get in touch with that person that they met at Ethno, and then maybe they will go to that village and learn more about that traditional music.
> (Interview #20023)

In this framing, Ethno sees itself as separate from local traditional/folk music scenes but finds them a useful resource. A participant from Sweden described how attending both Ethno and local folk music workshops eventually inspired

her to research and learn her own regional tradition in Halland (in southern Sweden):

> Friends had this tradition [from another region in Sweden] [...] I went to those workshops [...] But I lived in the northern part of Halland actually, just by the border to Västergötland, give or take [...] I wanted something of my own.
>
> (Interview #20135)

Meanwhile, some interviewees (all from the Global North) described Ethno events as fundamentally different from local traditional/folk scene events. One contrasted a Nyckelharpa course in Uppland, Sweden with an Ethno gathering:

> [At the course,] everyone stayed more or less to themselves [...] But at Ethno, it's like everyone has to face something else, something new – which means that you have to take a step out of yourself or towards someone else [...] Everyone has to do it and that meeting becomes much more powerful, much more potent [... whereas] if I meet people from the Nyckelharpa course in Österbybruk, then it is just: 'Hello, nice to see you'.
>
> (Interview #20140)

As this passage suggests, Ethno gatherings foreground self-discovery via the discomfort of intercultural interaction. This approach to music learning differs noticeably from traditional/folk music camps and workshops that encourage participants to study one or, at most, a few traditions.

We detected a tension between Ethno World's espoused and enacted values regarding the learning of traditional musics in that the programme promotes a cursory knowledge of many different musical practices in order to better understand oneself and one's relationship to others in the world, rather than in-depth study of a tradition. We understand Ethno gatherings as working from a presumption that participants are already culture bearers – either because they have studied their national tradition or simply because they are citizens or residents of a particular nation – and therefore gatherings function as sites of meeting and exchange rather than intensive study. The degree to which participants have in fact studied a traditional music in depth prior to attending a gathering seems to vary widely. By design, Ethno gatherings are not concerned about following often rigidly defined contemporary folk or traditional music practices.

In sum, the Ethno community appears to see itself as complementary to local traditional/folk music scenes rather than competing with them. Both musical communities share an interest in the teaching and learning of traditional musics but Ethno ultimately stands apart due to its emphasis on musical interactions

with multiple traditions rather than a deep and concentrated focus on a single tradition. 'It's about awake[ning] curiosity', stated one organizer, recalling his own first Ethno:

> The only thing I learned was that there's other things that exist [...] I didn't know anything about Arabic music when I left Ethno. But I knew it existed [...] I knew these people so if I want[ed] to learn I ha[d] somewhere to start.
> (Interview #21016)

We note the limitations of our data in this regard, however. As stated above, our analysis is based primarily on interviews conducted with recent Ethno attendees and with current or recent organizers and artistic mentors; that is, most of our interviewees have been active in Ethno during the program's recent explosion in popularity and at a time when it has emphasized diversity, inclusion, and exposure to a variety of different cultural perspectives over preservation or reconnection to one's 'own' culture. Our findings suggest that, where early Ethnos tended to emphasis the aesthetics of looking backward in order to build a deep relationship with a pre-existing tradition, contemporary Ethnos are oriented much more towards individual expression and a wider exposure to multiple traditions. Our interview data biases towards the latter point of view, meaning that there may well be more criticisms of this approach than we have included here.

Sharing one's national heritage

Although Ethno World prides itself on fostering sites of intercultural musical exchange where attendees learn about other cultures, numerous interviewees pointed to Ethno as a catalyst for learning about their own national or regional traditional music (e.g. 'Ethno is one more motivation to learn music from my country' [Interview #20096]). A participant from Italy, for instance, stated, '[I decided to dive] a little bit more inside some tunes I know but [that] I'm not used to practic[ing]'. She ultimately chose to teach a tarantella from southern Italy even though she wasn't from that region and hadn't grown up with that music (Interview #19076). Other interviewees echoed this sentiment. As one stated,

> I started to really research what [I] have in [my] country. So, OK, what do we sing in the south and in the north, you know? So now when I want to bring a tune or song, I search for songs that are really traditional [...] not 20th century.
> (Interview #19070)

Said another:

> It makes you look into your own code, your own culture, your own musical tradition a bit more deeply and find something that maybe you hadn't found before [...] I was the only Irish participant [at an Ethno ...] It's a bit of responsibility, you know – how am I going to portray my vast musical tradition?
>
> (Interview #20042)

Ethno not only encourages participants to explore their nationally associated traditions but inspires them to take responsibility for carrying those traditions. Some attendees go so far as to launch new initiatives along the same model – such as a new Ethno, or other community music events. A few interviewees noted the importance of being partnered with others from their own country, even though the ensuing intra-cultural negotiations could be potentially challenging:

> If you teach together, you need to find [...] how you see the place where you come from, and how the other one sees. It can be different [...] even if they come from the same place but they learned it differently.
>
> (Interview #20041)

Some participants describe searching for repertoire that will represent some aspect of their national culture while also sharing something of themselves at a profound level. A Cantonese speaker from China described her process as follows:

> I just asked myself, 'What is the thing that first jumps to my mind, that really speaks my own heart, my own roots?' [...] Because a lot of Mandarin tunes are taught at schools [...] but that is not something that I really [relate to], I would say, so finally I choose that [Cantonese] song because this is definitely the one thing that really comes to my heart.
>
> (Interview #19087)

A Turkish participant who shared a song written by a composer who died in the 1993 Sivas massacre emphasized the relevance of the song to his own lived experience, stating that,

> In Turkey I feel outside of society, and these people who died there were also like me [...] I am not Muslim [but] I grew up with a Muslim culture there, and I tried to understand different cultures [...] That's why I feel connected to [the song].
>
> (Interview #19071)

This same participant noted that 'when I'm in Istanbul in Turkey, I don't feel like Turkish, but when I go abroad, after some time I start to feel Turkish, and I feel Turkish here in Ethno' (Interview #19071). As this example demonstrates, Ethno seems to allow participants to claim a strong sense of national identity on their own terms and outside of right-wing nationalist or xenophobic movements – to both represent a nation or region singlehandedly (or as part of a small group) and to feel, as this interviewee put it, 'absolutely [at home]' (Interview #19071).

The emotional relationship that interviewees reported having with their nationally associated traditional music varied widely. Some spoke with pride and underscored the beauty of their national repertoire: 'Our patrimony […] has survived centuries […] It's a culture that belongs to us and it's super beautiful' (Interview #19028). For others, however, the traditional music of their country was a fraught topic. An artistic mentor and organizer offered a list of countries from which attendees often struggled to find repertoire: 'I'm thinking about Germany, about Belgium, about the [United] States, about Australia […] In Belgium, you [want to] play Flemish traditional music? It's very connected to hardcore nationalistic movements' (Interview #20148). The 'problematic' nations mentioned were typically settler-colonial countries, those with strong right-wing nationalist movements, and/or those with a history of associating traditional music with racist or xenophobic politics. Some Ethno attendees described a lack of connection with their own traditional music and their subsequent turn to minority or subcultural musical traditions as a solution. One German interviewee said she felt 'not German', in part because she had often been told that she did not physically look German, and described an 'inner confusion about origins, or inner longing for something […] Identity probably' (Interview #20024). Another German interviewee at the same Ethno said of traditional German music, 'It's very kitschy and […] it's way too sweet […] The foreigners love it but we hate it' (Interview #20027). Together, these two participants chose to share a Sinti (Roma) song. Conversely, Ethno can also be a way of coming to terms with a difficult national heritage. One interviewee said she had 'started to be a little bit proud to be Flemish, Belgian' after discovering 'a lot of nice songs in Flemish and in Belgium' at Ethno (Interview #20148).

One interviewee argued that, while participants are called upon to represent their countries of origin at Ethno, it is not 'in a nationalistic way. You will not see flags of all the countries represented in an Ethno at the end of the last concert, which is something that does happen in meetings of folk dance groups, for example' (Interview #21002). Rather, Ethno participants represent their nation simply by being themselves, including, for some, sharing the complexity of their transnational lives:

> At Ethno, it is more like, I come from Chile. I wear jeans. I wear a T-shirt that says Ireland because I went to Ireland once. And that's me. This is how I dress at home,

and this is how I dress here in Chile. Only if I want, I might wear a more fancy or typical shirt for the last concert. If I don't want to, it is okay. Nobody is going to tell you anything.

(Interview #21002)

Conclusion

At Ethno, 'folk' and 'traditional' do not simply describe styles and repertoires derived from singular peoples and places, but instead are musical concepts that are continually redefined, in part according to each participant's own individual experiences and aesthetic desires. Intentionally or not, by asking participants to represent their nationally associated musical traditions, Ethno World provokes a questioning of the nature of traditional music and of the complexity of relationships between a repertoire labelled 'folk' or 'traditional' and the people from a given locale. In this chapter, we explored varying discourses of traditional/folk music and music-making among members of the Ethno community and proposed a framework of 'personal authenticity', wherein music that feels authentic to a person is by extension representative of their nation. This chapter also explored how Ethno participants engage in local traditional/folk music and documented the complex relationships of Ethno participants to their nationally associated traditional/folk music.

Many aspects of Ethno World call the reification of tradition into question. Though Ethno was initially inspired by revivalist beliefs (including concerns about modernist alienation and the potential loss of cultural diversity), its current form is very much focused on playing with tradition and on mixing elements from a variety of traditions together. Notably, Ethno gatherings – like many other traditional/folk music camps – frame folk and traditional musics as available to all, even without prior knowledge of those traditions. While this approach seems to be relatively innocuous in the context of Ethno gatherings, we note that this vision of tradition has a strong connection to a liberal knowledge economy in which people feel that they have the right to whatever knowledge they happen to be interested in, and that this approach may not be appropriate to all musical traditions, especially those that have faced colonialism or other kinds of violence.

Ethno can be understood as a community with threads that extend outward into various facets of life, and gatherings have lasting impacts that go well beyond studying a variety of nationally associated repertoires. Ethno is an opportunity for a diverse group of young musicians to meet, share music, exchange ideas, and build relationships on which they might draw for years to come, irrespective of their continued engagement with folk or traditional music. Arguably the most significant impact of the Ethno World programme on the global music ecosystem

is the contact network it provides for attendees during their travels beyond Ethno gatherings. As one participant put it,

> This is the Ethno thing. You have people everywhere. You have people in India, you have people in New Zealand, you have people in, I don't know, Germany, and if you go there, if you connect with them again, call them or whatever, write to them [...] Maybe they can, you know, show you around [...] It's a beautiful thing [...] It's cool to have people everywhere.
>
> (Interview #20008)

In such a context, sharing nationally associated repertoire at an Ethno gathering is the foundational step in building this global network.

NOTES

1. 'Gathering' and 'artistic mentors' are the preferred terms of the Ethno World programme. Portions of this chapter are drawn from the white paper *Framing Ethno World* (Mantie & Risk 2020) and the final report of the Ethno Research Arts and Culture team, 'The Complexities of Intercultural Music Exchange' (Mantie et al. 2021). The authors express their thanks to the Ethno Research Team based at York St John University and to their colleagues on the Ethno Research Arts and Culture team at the University of Toronto: Roger Mantie, Pedro Tironi, Jason Li, and Alison de Groot. This chapter would not have been possible without their contributions. We also thank all Ethno Research interview participants for generously sharing their time and experience.
2. Ethno | JMI.net. Accessed 9 January 2022, from https://jmi.net/programs/ethno
3. Of 114 Ethno Research interviewees for which there is complete socio-demographic data, only 23 listed performing musician/artist as their primary source of income, and only 19 others listed performing musician/artist as work that they had done in the past. The numbers of interviewees primarily employed as music teachers ($n = 25$), and other music industry workers ($n = 9$), were similarly low. In other words, only about one-fifth of the interviewees were professional performers and only half were professionally involved with music or the arts in some capacity. We note that many Ethno Research interviewees were under age 30 and still exploring various career pathways.
4. To maintain anonymity and confidentiality consistent with research ethics norms and requirements, research participants in this chapter – all of whom have signed 'informed consent' forms – are cited only according to an interview research code (e.g. Interview #20021). By their nature, pseudonyms carry ethnicity connotations that could inadvertently identify interviewees, and were thus avoided. Specific dates of interviews have not been provided to avoid inadvertent attribution (i.e. dates that align with specific Ethno

5. gatherings). The master codebook linking interviewees and their interview number is under the management of the research leads of Ethno Research.
5. See Mantie and Tironi (this volume) for additional details regarding the analytical methodologies used by the Arts and Culture Team.
6. Sweers (2014) argues that revivalist processes have removed various folk musics from their oral, 'peasant', and rural contexts by notating and recording them (thus standardizing and commodifying them), and by placing them in academic and institutional contexts (p. 467).
7. Interestingly, this person-oriented discourse has much in common with many western notions of individual expression and the realization of self; see ethnomusicological analyses of the 'individual' by Stock (2010) and Ruskin and Rice (2012).
8. This includes the Willie Clancy Summer School (founded 1972) in Ireland, and the Festival of American Fiddle Tunes (1977) and Ashokan Music and Dance Camp (1980) in the United States.
9. For instance, Lark in the Morning in Mendocino, California. Accessed 9 January 2022, https://www.larkcamp.org/
10. This is similar to the history of the genre of world music which, under the guise of promoting traditions from across the globe, may ultimately serve as a space for westerners to use elements from others' traditions for their own personal or professional gain (Feld 2004).
11. https://ethno.tandemcollective.org/about/ (accessed 9 January 2022)
12. The authors note that Ethno World similarly challenges us to reflect on the historic complicity of our disciplines (Musicology and Ethnomusicology) in constructing 'folk' and 'traditional' musics along racial and ethnic lines.

REFERENCES

Bendix, R. (1997). *In search of authenticity: The transformation of folklore studies*. University of Wisconsin Press.

Bohlman, P. V. (2004). *The music of European nationalism: Cultural identity and modern history*. ABC-CLIO.

Born, G., & Hesmondhalgh, G. (Eds.). (2000). *Western music and its others: Difference, representation, and appropriation in music*. University of California Press.

Dabcynski, A. H. (1994). *Northern week at Ashokan '91: Fiddle tunes, motivation and community at a fiddle and dance camp* [Doctoral dissertation]. University of Michigan.

Ethno France. (2021, December 9). 10 days left to apply for Ethno France 2022! Ethno World. Accessed 9 January 2022, from https://ethno.world/10-days-left-to-apply-for-ethno-france-2022/

Feld, S. (2004). A sweet lullaby for world music. *Public Culture*, 12(1), 145–171.

Hargreaves, T. (2017). 'That one time at fiddle camp…': The emergence of the fiddle camp phenomenon and its influence on contemporary American fiddle music [Senior undergraduate thesis (Division III)]. Hampshire College.

Higgins, L. (2020). Case study: Ethno Portugal. Crossing the threshold. *Ethno Research Pilot Case Studies*. York St. John University: Ethno Research. Accessed 26 January 2024, from https://www.ethnoresearch.org/publication/ethno-portugal/

Hill, J., & Bithell, C. (2014). An introduction to music revivals as concept, cultural process, and medium of change. In J. Hill & C. Bithell (Eds.), *The Oxford handbook of music revival* (pp. 3–42). Oxford University Press.

Hobsbawm, E. J., & Ranger, T. O. (1983). *The invention of tradition*. Cambridge University Press.

JM International. (n.d.). Programs: Ethno. JM International. Accessed 9 January 2022, from https://jmi.net/programs/ethno

JM International. (2021). Ethno Mobility 2021 – Open call. mubazar. Accessed 9 January 2022, from https://www.mubazar.com/en/opportunity/ethno-mobility-2021-open-call

Livingston, T. E. (1999). Music revivals: Towards a general theory. *Ethnomusicology*, 19(2), 20–25.

Mantie, R., & Risk, L. (2020). *Framing ethno-world: Intercultural music exchange, tradition, and globalization*. JM International.

Mantie, R., Risk, L., Tironi, P., Manson-Curry, K., Li, J., & de Groot, A. (2021). *The complexities of intercultural music exchange: Ethno World as cultural change agent*. JM International.

Miller, J. L. (2007). The learning and teaching of traditional music. In J. Beech, O. Hand, F. MacDonald, M. A. Mulhern, & J. Weston (Eds.), *Scottish life and society: A compendium of Scottish ethnology. Volume 10: Oral literature and performance culture* (pp. 288–304). John Donald.

Miller, J. L. (2018). A sense of who we are: The cultural value of community-based traditional music in Scotland. In S. McKerrell & G. West (Eds.), *Understanding Scotland musically: Folk, tradition, and policy* (pp. 30–43). Routledge.

Risk, L. (2013). The chop: The diffusion of an instrumental technique across North Atlantic fiddling traditions. *Ethnomusicology*, 57(3), 428–454.

Ruskin, J. D., & Rice, T. (2012). The individual in musical ethnography. *Ethnomusicology*, 56(2), 299–327.

Stock, J. P. (2010). Toward an ethnomusicology of the individual, or biographical writing in ethnomusicology. *The World of Music*, 52(1/3), 332–346.

Turino, T. (2008). *Music as social life: The politics of participation*. University of Chicago Press.

3

Music Making as Holistic Praxis

Dave Camlin and Helena Reis

Introduction

In their white paper report *Framing Ethno World*, Mantie and Risk (2020, p. 53) include several research questions relating to the role of Ethno Organizers:

1. What are the self-reported motives of Ethno camp organizers?
2. In what ways do organizers conceptualize and enact their relationships and obligations to their local communities? To what extent do organizers make ethical and pragmatic decisions in response to local conditions and expectations?
3. In what ways do organizers conceptualize and enact their obligations to attendees and artistic leaders? To what extent do considerations of race, gender, class, and geopolitical representation factor into decision-making?
4. In what ways are local decision-making processes constrained or influenced by JMI and Ethno World?

It is to these questions that this project directed its attention, to explore the experiences of Ethno Organizers in relation to these areas of inquiry. Recognizing the geographical and cultural diversity of Ethno Organizers' practices, we set out to understand their experiences through the perspective of their personal narratives, taking a broadly phenomenological approach, that is to say, to understand 'the perception [of experience] in terms of the meaning it has for the subject' (Gallagher & Zahavi, 2012, p. 7). We were also interested in whether there were any similarities between those different experiences, which might point towards a more collective sense of shared values underpinning the organization of Ethno activities. To that end, we deployed a multi-strategy approach, using a software app Sensemaker to collect individual stories, which also requires respondents to 'interpret' the significance of their story via digital mark-making at the point of collection.

Review of literature

In this section, we set out an overview of literature pertaining to the enquiry, including a justification of the Sensemaker method as well as setting out key parts of the conceptual framework used to collect, analyse, and interpret data.

The justification of Sensemaker as a primary method for data collection is chiefly to do with its affordances for capturing and interpreting complex sociocultural phenomena. Sensemaker collects narrative accounts of individual experiences alongside respondents' own interpretation of the significance of those experiences through a process of digital mark-making against a series of conceptual geometric frameworks pre-determined by the researchers (Cynefin Company, n.d.). This approach therefore draws on both more subjective and more objective conceptions of knowledge to generate a rich set of data, locating personal experience within a predetermined framework of categorization. The Sensemaker app is a stable software platform used in many research sites around the world. It has become a valued and established research tool in the context of sustainable development (Mausch et al., 2018; 2021), including recent use by Oxfam (2018) and the UNDP (United Nations Development Programme 2020) as well as in contexts of human displacement (Bakhache et al., 2017) and peace building (Eggers, n.d.). Sensemaker has considerable potential to 'reposition first-hand, individual experience of arts and culture at the heart of enquiry into cultural value' (Crossick & Kaszynska, 2016, p. 7), by involving respondents in the critical interpretation of their own experiences rather than having such interpretation imposed upon them.

From the questions in the white paper, several conceptual themes were highlighted to both frame the enquiry and develop categories for the Sensemaker software environment. These included: the idea of music as a 'holistic' practice encompassing aesthetic, participatory, and paramusical dimensions of experience; the ways that music making interacts with notions of personal and collective identity; the centrality of self-determination (competence, autonomy, relatedness) in underpinning leadership; the social impact of music making (SIMM).

Some of the research tools used in the Sensemaker app are triadic, requiring respondents to interpret the significance of the narrative they shared by making a digital mark within a triangle of complementary dimensions (see section on geometric data analysis). In the sub-sections which follow, we outline how we constructed the various frameworks for the Sensemaker app by connecting them to the themes outlined above through concepts derived from pertinent literature.

Music as a holistic praxis

One such framework developed for a previous music research project using Sensemaker centred on a consideration of music as a 'holistic' praxis (Camlin, 2016;

2023) where a creative tension between aesthetic and participatory dimensions of music supports the emergence of 'paramusical' outcomes (Camlin et al., 2020) (see Figure 3.1).

The historic philosophical tensions between aesthetic and participatory musical traditions have been explored extensively by a number of theorists (Elliott [Ed.], 2009; Elliott & Silverman, 2014; Regelski & Gates, 2009; Small, 1996; Turino, 2008). Some of these tensions are resolved by appeals to unifying concepts such as: 'music(k)ing' (Elliott, 1995; Small, 1998) as a verb, where 'to music is to take part, in any capacity, in a musical performance, whether by performing, by listening, by rehearsing or practicing, by composing, or by dancing' (Small, 1998: 9) or by appeals to view music as an 'ethical praxis' (Elliott et al., 2016) or a 'praxical' endeavour (Regelski, 2021); or by emphasizing the 'paramusical' dimension of musical experience (Stige et al., 2013, p. 298). Specifically, in this instance we draw on theories of musicking which emphasize its polyvalent complexity (Camlin et al., 2020, p. 2), where music

FIGURE 3.1: Music in three dimensions (triad 1).

is literally about the 'performance' of human relationships (Camlin, 2021c; 2022; 2021b; Small, 1998, p. 13; Trevarthen & Malloch, 2017) as much as it is about the performance of musical 'works'.

Identity (me, my people, my place)

Some of the signification frameworks available to a Sensemaker research project are referred to as 'polymorphic', in that they are available for use in multiple Sensemaker projects across a wide range of research fields, to provide a means of comparing results between research projects in very different settings. One such polymorphic triad used in previous Sensemaker research into musical experiences (Camlin et al., 2020) lent itself to exploring the relationship between personal (me), collective (my people), and situated (my place) identities (see Figure 3.2).

This previous study found that greater significance was attributed by respondents to the collective (my people) dimension of identity achieved through collective

FIGURE 3.2: Identity (triad 2).

musicking, and that the situated (my place) dimension did not compete for attention, but rather was seen as a resource which enriched and amplified the collective (my people) joyful experience of 'communitas' (Turner, 2012), i.e. the 'magic moments' (Pavlicevic, 2013a, p. 197) of transcendence through collective musicking commonly experienced as deeply profound and transformational. Given the very particular geographical and cultural situatedness of Ethno gatherings worldwide, we were interested to see what difference – if any – these intercultural situations made to the significance people attached to their experiences, which would therefore help us to develop insights into our second and third research questions.

Notions of identity also build on the complex ways in which identities are nurtured, developed, challenged, re-imagined, and transformed through musical participation, both in terms of the roles that people take in musical activities (e.g. performer, composer, singer, improviser, educator, community musician) referred to as Identities-in-Music (IIM), and in the role that music has in shaping individual and collective identity, referred to as Music-in-Identities (MII) (MacDonald, Hargreaves, & Dorothy [Eds.], 2002; MacDonald, Hargreaves, & Miell [Eds.], 2017). Both kinds of identity transformation are at play within participatory musicking, where participants and leaders alike re-invent themselves in response to new experiences, both in terms of the different roles they take on within musical contexts, and the ways in which they subsequently see themselves in relation to these transformed roles.

Self-determination theory

Self-determination theory (SDT) is a comprehensive set of theories developed by Richard Ryan and Edward Deci which provide insights into some of the psychological dimensions of human behaviour and personality, including motivation and autonomy (Ryan & Deci, 2000; 2018). A consideration of the various dimensions of SDT would enable us to consider the extent to which both 'intrinsic' and 'extrinsic' motivations shaped Ethno Organizers attitudes towards their leadership responsibilities. Intrinsic motivation is to do with the 'primary and spontaneous propensity to develop through activity – to play, explore, and manipulate things and, in doing so, to expand competencies and capacities' (Ryan & Deci, 2018, p. 123). By contrast, 'extrinsic' motivation is to do with behaviours which are 'done to achieve consequences that are operationally separable from the behaviour' (Ryan & Deci, 2018, p. 102) such as financial reward, qualifications, increases in social status, or other gains which result from activities.

For performing musicians and students of musical performance, the development of a more educational or 'socially-engaged' identity in music (e.g. music teacher/facilitator, community musician) can sometimes be a more extrinsic

motivation, arising from the need to supplement income from performance activities (Camlin, 2021a; Freer & Bennett, 2012). However, this more transactional approach to facilitating musical experiences for others can be less effective than one where there is a genuine alignment of personal values and beliefs – e.g. music as a resource for social impact and/or social justice – with the broadly emancipatory aims of socially engaged artistic practice (Camlin, 2018; Helguera, 2011). A professional practice characterized by more humanistic values of empathy, cultural humility, and respect can therefore lead to greater 'veritable authenticity' (Chan, Hannah, & Gardner, 2005) as a leader/facilitator, and consequently higher levels of intrinsic motivation, where musicians commit to this kind of work for more altruistic purposes other than purely for personal capital gain (Camlin & Zeserson, 2018). Therefore, by exploring the self-reported motivations of Ethno Organizers and directly addressing our first research question, we reasoned that we might also be able to draw inferences about the alignment of organizers' personal values with the espoused aims of the Ethno programme to create opportunities for 'young people from across the globe to come together and engage through music in a manner that is characterized by respect, generosity and openness' (JM International, n.d., para. 2).

Within the conceptual framework of SDT, 'autonomy literally means "self-governing" and connotes, therefore, regulation by the self. Its opposite, heteronomy, refers to regulation by an "other" (heteron) and thus, of necessity, by forces experienced as other than, or alien to, the self' (Ryan & Deci, 2018, p. 51). Viewing the experiences of Ethno Organizers from the perspective of autonomy would help us develop insights into our fourth research question, and the extent to which organizers felt able and empowered to make local decisions independently from JMI as the host institution. It is perhaps to be expected that in any large trans-national programme with local partners developing projects which respond to local situations, there would be some negotiation of autonomy, in order to preserve both local and trans-national identities and considerations. We were therefore interested in understanding the extent to which these negotiations of autonomy and identity – as well as competence, the third 'dimension' of SDT – were experienced in practice (see Figure 3.3).

Social impact of music making (SIMM)

Threaded through all the various Ethno World activities is a belief that the programme has an impact which goes beyond the immediate experience of participation, which aligns with ideas about the social and cultural value of participating in Arts activities. The UK publication of the *Use or ornament* report in 1997 established the enduring idea that (1) participation in the arts brings

FIGURE 3.3: Self-determination (triad 3).

social impacts; (2) benefits are integral to the act of participation in the arts; and (3) the resulting social changes can be planned for and evaluated (Matarasso, 1997). While the relationship between artistic interventions and planned-for social changes are more complex than this simple argument allows (Belfiore & Bennett, 2007, 2008; Perry, 2013), cultural policy in the United Kingdom has centred around debates concerning the cultural value of the arts for some time (Crossick & Kaszynska, 2016), despite the apparent lack of equality of provision of funds to bring about anticipated social changes (Neelands et al., 2015) and calls for more a more culturally democratic distribution of resources (Cultural Policy Collective, 2004; Gross et al., 2017; Hadley & Belfiore, 2018; Hunter et al., 2016).

There is now a secure evidence base for the various ways in which music can achieve positive impacts on individual health and well-being (MacDonald, Kreutz, & Mitchell, 2013), and the rise of Community Music (CM) as an academic discipline (Bartleet and Higgins [Eds.], 2018; Higgins, 2012; Higgins & Willingham, 2017; IJCM, n.d.; Veblen et al. [Eds.], 2013; Willingham, 2021) highlights

the growing interest in the potential of collaborative musicking to make a positive contribution to people and society, even with reservations about the overly institutionalized and prescriptive nature of some approaches (Camlin, 2021a). A significant global research project was established in 2019 to investigate the social impact of music making (SIMM) world-wide (Pairon & Sloboda, n.d.; Guildhall School of Music and Drama, 2019), drawing together an extended community of practitioners and researchers to develop a stronger theoretical understanding of the field in a global context.

Methodology

The approach taken is broadly Constructionist in recognizing that 'meaning comes into existence in and out of our engagement with the realities in our world. Subject and object emerge as partners in the generation of meaning' (Crotty, 1998, p. 8). It emphasizes the importance and potency of personal narrative, where 'stories offer multiple opportunities for individual interpretations which can allow [respondents] to examine their own [experiences] through this process of mutually negotiated meaning' (Crawford et al., 2015, p. 126). It might also be described as a 'mixed methods' or 'multistrategy' (Williamon et al., 2021, pp. 42–52) approach in that the Sensemaker process requires respondents both to share a story from their own perspective, and subsequently to interpret that story through a series of digital mark-making against a predetermined set of geometric shapes – in this instance triads of complementary dimensions, scales, and grids. The resulting data were examined through both qualitative and quantitative means – using Interpretative Phenomenological Analysis (IPA) (Smith, Flowers, & Larkin, 2009) to examine the narrative data, and geometric analysis to interpret the geometric and numerical data arising from the digital mark-making. A rich picture of experience can be established through attending to both kinds of data, in turn leading to a greater validity of findings.

Research design

The Sensemaker method has two related stages in a coherent sequence (i) story sharing and (ii) story interpretation/self-signification. In the initial story sharing stage, respondents share a story via a software app which can be downloaded to their digital device or web browser. The story can be shared in multiple formats – text, audio, image, video – to enable responses from a wide range of communication and creative media, although in this instance, all received responses ($n = 22$) were text. The app was 'skinned' in two languages – English and Portuguese – to facilitate responses in respondent's first language where possible. The app

instructions were translated from English to Portuguese by the second researcher, who is a native Portuguese speaker. Three 'prompt' questions were used to facilitate responses:

1. A new Ethno Organizer has come to you for advice; what story would you share with them which highlights the pitfalls, pleasures, and/or privileges of organizing an Ethno event?
2. Imagine you're catching up with other Ethno Organizers informally after a major Ethno event – what story would you share which illustrates how your experience of Ethno has changed over time?
3. You've been asked to write a 'think piece' for a national magazine about how you came to think differently, or more deeply, about the Ethno experience – what story would you share?

Respondents can choose not to respond to any of these questions, but instead to tell a story based purely on their own interests and concerns. Having shared their story, they then give it a title, and indicate via a 5-point Likert scale whether their story represents a positive or negative experience.

In the subsequent story interpretation/self-signification phase, respondents place a digital mark – representing the story they have just shared – in relation to a series of geometric shapes representing concepts drawn from the literature (see Literature Review). In the Sensemaker environment designed for this study, there were five such geometric frameworks to respond to, relating to concepts of connection, quality, self-determination, and social impact.

Sensemaker triad frameworks

For each of the three triad frameworks in Sensemaker, respondents place the digital mark representing their story within a triangle of complementary dimensions, in response to a prompt. The triad frameworks were designed with the above literature in mind – music as a holistic praxis; identity, self-determination – resulting in three frameworks (see Table 3.1 and section 'Analysis of Geometric Data').

Sensemaker social impact frameworks

To examine issues surrounding social impact, we developed two frameworks for the Sensemaker environment, based around (unpublished) conceptions of social impact outlined by John Sloboda at an SIMM research conference in Antwerp in

TABLE 3.1: Summary of triad frameworks.

No.	Title	Prompt	Dimension 1	Dimension 2	Dimension 3
1	Music in Three Dimensions	The story I shared is about …	Making a good sound for others to listen to (aesthetic)	Enjoying making music together (participatory)	More than just the musical (paramusical)
2	Identity	The story I shared is about developing (or losing) a sense of connection …	To oneself/identity (me)	To other people (my people)	To a particular place (my place)
3	Self-Determination	The story I shared mostly relates to me (or someone else) …	Exercising and developing skills (competence)	Having the freedom to make and implement decisions (autonomy)	Working as part of a team (relatedness)

2019 (Sloboda, 2019). The first of these was a dyadic scale where respondents place the digital mark representing their story within a continuum between two dimensions, in response to the prompt, 'the impact of this story was on …' (see Figure 3.4).

A second framework was a more complex grid exploring the interplay between 'inwards' or 'outwards' social impact on the one hand (*x*-axis), and 'individual' or 'group' impact on the other (*y*-axis), in response to the prompt 'the impact of the experience I shared was to do with …' (see Figure 3.5).

Some respondents fed back that they did not really understand what they had to do in order to respond to this question, and especially because the data appeared to be inconclusive, we chose to discount it from any further analysis. The complexity of making three independent marks against two complementary dimensions may have been too confusing for participants, or it may have been that the number of respondents was simply insufficient in generating clusters of meaning, but we concluded that any future research should rethink how to approach collecting this kind of important data.

The final questions in the app collect additional data to contextualize the narratives, including how common respondents think their experience is, how they feel about the story they shared, who they think should know about it, and identifying characteristics for monitoring purposes which are subsequently anonymized (name and name of Ethno). Some sociometric data are also collected

The individuals involved in the activity Society in general

FIGURE 3.4: Social impact dyad.

FIGURE 3.5: Social impact grid.

to enable comparison against variables, namely the gender and age of those involved in the story shared.

Procedure

Responses were sought from 39 individuals on a current email distribution list of Ethno Organizers managed by JMI, via a personal email invitation from the Ethno Research team. Potential respondents had previously given their consent to participate in the Ethno Research programme through a process approved by York St John Ethics Committee on 10 June 2020. Because of the situated nature of organizers' experience, anonymity could not be guaranteed as individuals might be identifiable from the content of organizers' stories. However, every effort was made to

anonymize the data, including using numerical identifiers rather than names/project names, and anonymizing biographical information where necessary. Initial responses were low, so an online workshop was set up with the Ethno Organizers team to explain the Sensemaker process and answer any questions. Subsequently, a total of 22 stories were shared by eighteen Ethno Organizers who responded to the invitation from fourteen different countries in Europe, Africa, South America, and the Indian subcontinent, representing *c.* 46 per cent of the total population of Ethno Organizers.

Data analysis

The resulting data were prepared for analysis in several ways. First, stories told in Portuguese ($n = 3$) were translated by the second researcher. One further story was shared in Italian, which was translated by the second researcher and then the translation verified by a native Italian speaker. Both researchers then immersed themselves in the data, to become familiar with the stories and to build up an impression of emergent themes. Organizers' stories were then analysed initially using IPA, involving a process of (a) identification of emergent themes, (b) clustering of emergent themes into interim subordinate themes, and (c) grouping of subordinate themes into superordinate themes. Analysis of the narrative data was conducted by the authors independently to improve validity, with interim themes combined into a final set of four superordinate themes with dependent sub-themes.

Subsequently, organizers' digital mark-making of the significance of their stories against the set of signification frameworks was analysed through a geometric analysis of the 'clustered' responses, initially through visual immersion in the data to identify general patterns of signification. Each digital mark also generates numerical data based on where the mark was made in relation to each of the frameworks. These numerical data were exported using Sensemaker Analyst software into a Microsoft Excel spreadsheet, where further statistical analysis could be undertaken, including comparison of the data with that of a larger ($n = 167$) previous study of group singing (Camlin et al., 2020).

Findings

The narrative data were analysed prior to any geometric analysis of self-signification data (digital mark-making) to build up an 'emic' (participants' perspective) impression of themes emerging from organizers' stories. Subsequently, analysis of the geometric patterns in the self-signification data helped to establish a more 'etic' (external) perspective of those experiences. The full meaning of organizers' experiences was therefore considered to emerge in the interplay

between 'emic' and 'etic' perspectives. One story was considered to be a 'neutral' experience, with the remaining 95 per cent ($n = 21$) of responses considered to be either 'positive' or 'very positive'.

Thematic analysis of narrative data

As described, both authors examined the data independently using Dedoose software to code individual stories, group these codes of emergent themes into subordinate themes and subsequently into interim superordinate themes with dependent sub-themes which represented the full dataset. Author 1 settled on the following four superordinate themes: leadership; communitas; experiences; identity. Author 2 settled on the following four superordinate themes: community; liminality; communication/relationships; purpose. Through discussion between authors, a final four superordinate themes with dependent sub-themes were agreed, which enabled us to categorize the full dataset collectively. These final four themes were: communitas; paramusical; identity; leadership. Both authors then undertook a final collaborative analysis of the data, to interpret the organizers' stories against this final set of themes and dependent sub-themes, to ensure that the whole dataset had been included in our analysis. In the rest of this section, we summarize this analysis in relation to the final themes, and include participants' narratives as 'thick' description of these themes.

Communitas

We refer to the first superordinate theme as Communitas, a concept conceived as 'moments of collective joy' (Turner, 2012). In relation to musicking, we use it to describe the 'magic moments' (Camlin et al., 2020, pp. 10–11; Gabrielsson, 2011, p. 746; Pavlicevic, 2013b; Stige et al., 2013, pp. 109–110) where a 'peak flow' is achieved which participants experience as transcendental. We use the term to describe the way that profound social connections are established and nurtured through the act of participatory musicking, becoming an inseparable imbrication of social connection through music.

Some respondents suggested that musical experiences enabled a different kind of communication to occur between participants, following the adage 'where words fail, music speaks', and the idea expressed in some of the literature that music is a medium of communication for sharing emotion and social intent (Cross & Woodruff, 2009; Mithen, 2007) – a universal 'language' that brings together people from different ages and backgrounds: 'So who needs [an] interpreter when there is music around – the universal language' (P01).

Music works as the 'connective tissue' at Ethno camps, the communicative medium used to bring people together: 'In that first edition, I discovered the

anthropological value of the Ethno Gathering experience: true meeting points between distant people, the universal value of music as a common language' (P05).

Some stories contained powerful examples of music as the tool that facilitates human social connections:

> She was standing there in front of the whole group, people from all over the world, and they started to play [the song she had taught them] and it sounded amazing. This energy built up and halfway through the song she stopped singing but everybody else continued singing the song and she started to cry.
>
> (P08)

How exactly intercultural music exchange works at an Ethno camp is related to the people, the day-to-day activities, the physical space and the expectations that both participants and artistic leaders bring to the camp [Mantie & Risk, 2020, p. 27]. In this sense, the sharing occurs in both a musical and cultural aspect.

> Ethno is a mix of good energy and great moments. An exchange through music and through culture.
>
> (P15)

The whole Ethno experience is seen as something which transcends the music – almost as if the Ethno experience works as a catalyst that de-emphasizes individual experience and allows participants to experience a collective spiritual identity through the music: 'I dissolved and connected to something bigger than myself and my earthly needs were irrelevant. I had never experienced anything like that before' (P08). However, participatory musicking can represent a significant disruption to ways of thinking about music for those trained primarily in the perfectionist aesthetic of the conservatoire (Camlin, 2022). In the context of Ethno, some organizers steeped in the Western Classical Music (WCM) tradition see the experience as an opportunity to develop new skills, while others describe it as a more radical alternative approach to music training.

> Ethno was very awkward for me because the pedagogy did not involve didactic material, books or workbooks and the music was all learned by ear without the need of formal music notation.
>
> (P06)

Several Ethno participants have studied music in conservatoire or university, mostly in WCM or, less commonly, jazz (Mantie & Risk, 2020, p. 28). And this also appears to be common to the organizers: 'I am mostly classically trained so I am used to reading music from sheets, so learning by ear was a new experience

that I was not confident at' (P14). However, even though participatory musicking might be a heterodox practice for these musicians, the move towards a more holistic understanding of music's impact was not something that was difficult for them to accommodate: 'I work mostly with the promotion and communication in social networks so I quickly learned the Ethno values: sharing and participating' (P09); 'I feel more humane [sic] and much more free/released to enjoy music' (P06). In these settings, the sense of acceptance is high, and one has the opportunity of being 'seen' as a unique musical person, maybe for the first time: 'The sense of being seen. Having come to a place, where people really want to hear you and are amazed by what maybe is most natural to you' (P04).

This heightened sense of being more relationally 'present' allows oneself to learn in a different way:

> With Ethno I learned a new way of doing music and I learned to share musical feelings and different impressions – not mattering the technique and the high level of music education. All that matters is sharing and inspiring each other.
>
> (P06)

Paramusical

What these accounts point towards is our second superordinate theme, namely the 'paramusical', which Stige et al. describe as 'the "more-than-musical" phenomena which are often justified as therapeutic outcomes – be these individual, relational, social, or political phenomena' (2013, p. 298). The experience of communitas itself might be considered a paramusical phenomenon, indicating as it does a sense of transcendence in and through the music, and the roots of this transcendence are fundamentally social.

It is clear from the stories told by the organizers that music is what brings people together, and is the reason why people go to Ethno camps; at the same time, the whole experience is about something else beyond music:

> It gave me the chance to breathe, do exercise, and connect with the rest of the participants in a different way, and showed me the importance of creating bonds between people and having fun, beyond worrying too much about preparing 'the perfect concert'.
>
> (P18)

The intensity of the experience allows for trust and friendship to become a solid ground for future partnerships: 'This intimate experience can create a very strong baseline of trust, that builds the foundation for a successful gathering and beginning of new friendships and collaborations' (P04).

The Ethno experience is characterized by a general sense of social acceptance, in and through the music: 'We danced holding each other's hands, we sang and laughed happily, the most important thing was that it didn't matter from which part of the world you were from, the smiles were shared equally among everyone' (P07).

The sense of community thus generated, here in the sense of 'my people', is one of the most important aspects of the Ethno experience mentioned by participants – as highlighted in previous research – and the organizers themselves: 'I finished the first Ethno much more aware of the importance of taking care of the participants at a human level, of generating for them a welcoming, friendly context and atmosphere in which they feel secure and appreciated' (P05).

It is a recurrent concern for organizers that the participants feel welcomed and supported: 'As an organizer, you watch [the participants] and you feel the happiest and proudest person on earth; so grateful to see "your" group, "your" Ethno. And you know: Ethno did it again. We did it again' (P10).

In order to consistently achieve this welcoming and supportive environment, the international structure and network that supports Ethno has an important role to play in reinforcing a sense of a common purpose, as mentioned by one of the organizers:

> It can be difficult to keep up the spirit when you are working a whole year for only 10 days in the summer. That's why the international meetings are a great boost. Especially when I felt alone in the start of my project leading 'career' meeting the experienced leaders from around the world would give me a lot of energy and vision, as I could feel that I am being part of something much bigger than myself or our own Ethno camp.
>
> (P04)

This sense of community, of belonging, feels like a family for some: 'Folk musicians needed a proper promotion and introduction to a multicultural community, like the Ethno Family' (P12).

And it can feel like a responsibility for others: 'I was also the team leader of my country's team which added more responsibility to the need of doing well and representing our country in a good way' (P14).

The notion of community is, by itself, a polymorphic concept that can assume different conceptualizations depending on the subject of research. Gathering participants are usually housed together with the organizers sharing meals and contributing in a variety of ways to the 'co-creation' of the camp. This suspension of everyday life and near-immediate entry into a new, emergent community feels life-changing for many (Mantie & Risk, 2020, p. 36).

The impact of the Ethno experience on both participants and organizers alike, can be quite profound, with one organizer describing it as 'above all an intense experience of mutual care' (P05) which resonates beyond the immediate experience. Being a social event Ethno has at its core a deep level of social impact but not just for those who take part of it. The multiculturality of the experience can extend beyond the Ethno camps as, for example, during the final concerts:

> But what was the most amazing and what I actually keep in mind (I'll always remember that day for sure!), was the sociology of this venue: it was full of people from various origins, families, teenagers, elderly people, friends [...] half of them you would never meet in such a place.
>
> (P11)

The concerts are an important part of the experience because they are the 'goal', so to speak, of the Ethno camps. They represent the final presentation of the work developed during the residence: 'And because it makes sense for local partners (and their audience) to welcome the Ethno orchestra, we manage to [sell] out concerts [...] and it also allows us to develop more and more Ethno inspired local project[s]' (P11).

Sometimes this impact can contribute to life-changing experiences on a more personal level: 'I have participated in more than 10 Ethno[s] as [a] participants and seen many people [have] changed their life differently because Ethno [is] not just a music event; it's beyond that!' (P16).

Leadership

A third superordinate theme is therefore to do with the complex nexus of leadership responsibilities which organizers hold – for organization, for the music, for everyone's well-being – and how they enact these responsibilities. Leadership concerns centre around management, relationships, and communication. In some of the stories there are several challenges and difficulties mentioned by the organizers. Such challenges are perhaps to be expected as an intrinsic part of the complex web of human relationships, but how do Ethno Organizers address and overcome them? First, there is the logistic challenge of organizing an Ethno event that means a whole-year planning something that will happen in just ten days:

> Organizing an Ethno can be a tough process. So many practical things need to be done. For almost a whole year you're working mostly on the computer to get everything ready; to find money, to reach out to participants, to communicate with venues, volunteers, artistic leaders etc. There is very little music in there. The stress

raises for the concerts. The tiredness kicks in. You have to keep motivating your team to be happy and energetic.

(P10)

Then, because of the intensity of the experience, there are physical and psychological challenges:

> For the participants it is a very intense experience, with a very close coexistence, long days of rehearsals, little sleep, little personal space, etc. [...] People of very different ages, cultures and different perceptions, at very different moments in their lives.
>
> (P05)

> I felt overwhelmed and guilty since I had taken all the responsibility on myself and didn't manage to reach out for help. It took a long time to build a more sustainable structure, with a lot of changes in group members.
>
> (P04)

There are also social, historical, and cultural tensions between different people of very different origins:

> The relations with the Sami and the Swedish society are tense to say the least and has a very dark history and we were a bit nervous about how she would experience Ethno, especially with what we saw at the start. After that workshop day she totally changed the way she interacted with others, she learnt all the songs and we saw her running down to the beach with others and that song became the most powerful song in the public concerts that we gave with Ethno that year.
>
> (P08)

The Ethno experience is not always an easy process of integration and connection for everyone: '[One participant] wouldn't open to anybody, to explain what he's feeling and what are his needs. We realized then that he had spent the whole ethno camp without really connecting to anybody' (P13).

Organizers also need to keep a balance between the more local demands and the global guidelines set by JMI:

> Organizing an Ethno is both exciting while at the same time challenging considering the diverse nature of the participating musicians, its global nature, the need to standardize your needs as an organization but being in tandem with the Ethno world guidelines. So being aware of the requirements of the standards of Ethno

organization, we have had the challenge as to where to start from as a national Ethno that makes sense to the local people for them to appreciate the global nature and impact of traditional music.

(P03)

However, overall, there is a sense of feeling supported:

> We encouraged them to go on, how to do the first steps, to gather a strong group of organization, to write projects for sponsoring and so on.
>
> (P02)

> Everyone comes up to you, gives supporting feedback and advice on how to perform in whatever.
>
> (P14)

> Another thing that helped me is the support I received whenever I seemed doubtful of my performance as a player, as a team leader or as a presenter of our tunes.
>
> (P14)

This support is experienced at both a local and an international level:

> By building this local network (with local partners) in the same spirit that we are working at international level (no formal-education, peer to peer exchange and kindness) we can find an echo to the work that the orchestra is doing.
>
> (P11)

Here is also a clear emphasis on the human, well-being, and social aspects of the whole experience alongside the didactic activities:

> I give a lot of importance to the 'extra activities' surrounding an Ethno, and while I still [give] a lot of attention into rehearsing and having good concerts, I know I can't miss having at least one 'fun activity', since it can improve substantially the quality of the experience for the participants and everyone involved.
>
> (P18)

> I am happy therefore that as a network we are more and more starting to put structures into place that allow addressing personal challenges and contemplative practices during the camps, like noise-less areas, listening volunteers, smaller groups, story-telling and other non-musical activities, etc.
>
> (P04)

Overall, there is a sense of privilege at being an active part of something 'bigger than myself':

> It's a privilege to be part of that network and form our greater visions. I can't really imagine giving it up, as it has become a sort of way of life with a mindset that is applicable in all aspects of life.
>
> (P04)

In turn, the experience has a direct impact on the organizers' 'sense of self':

> It's also a moment when we start to reflect on our own identity being foreign to others. Reflection about identity happens. How is it to be the other and how does this affect my sense of self (pride, acceptance, curiosity).
>
> (P04)

Identity

The question of identity is complex and multi-faceted. Ethno camps occur within a transnational ecosystem of folk/traditional music camps and workshops – primarily North American and European – that variously target young musicians, adult amateurs, and pre-professional and young professional musicians (Mantie & Risk, 2020, p. 36).

> I got to know people from India, China, Scotland, or a Turk from Germany, and socialize with all of them, for 10 days, in the most positive environment, and see them through the 'veil' of music, being free of issues, that they might have made it difficult for them coexisting inside their own family, society, and country.
>
> (P12)

It is not just that the multicultural environment of Ethno gatherings creates a sense of 'no borders', but that the musical activity opens up a different kind of environment where participants can encounter each other in ways that are qualitatively different to the experience of their everyday lives – as 'cosmopolitan' (Appiah, 2007; Goldberg-Vååg, 2018) citizens in a collective identity formed in and through music: 'I'm telling this story quite often because it tells about what is Ethno for me: gathering people that would never have met, in a nice atmosphere, to share a moment in music (no more borders!!)' (P11).

How intercultural music exchange works at an Ethno camp is related to the people, the day-to-day activities, the physical space, and the expectations that

both participants and artistic leaders bring to the camp (Mantie & Risk, 2020, p. 27):

> The energy was really good and the place very rustic in the middle of the forest, only with the fire light. It was one of the most striking nights of those days we stayed there. A combination of the place, of people from different places in the world and a lot of music.
>
> (P15)

Participants come to Ethno camps with a strong sense of national identity – perhaps stronger than usual. Participants put up their own boundaries of national and cultural identity and search out the boundaries of others, in full knowledge that these boundaries will be broken down over the course of the camp (Mantie & Risk, 2020, p. 33): 'Ethno changes you not only as a musician, but as a person' (P12).

These disruptions to identity can be experienced in a very personal way:

> When I participated at the first concert at Ethno Brazil, it was as if a light had been lit up around classical music and my musical life was completely transformed.
>
> (P06)

> I am mostly classically trained so I am used to reading music from sheets, so learning by ear was a new experience that I was not confident about.
>
> (P14)

The experience of Ethno can also impact on organizers' professional identities:

> Being able to join the Ethno programme as a participant, gave me the choice to evolve as a musician, outside of my country's borders, and learn about other cultures.
>
> (P12)

> As an executive producer, I took on the challenge of coordinating all this just a few days before its celebration, focusing above all on the professional aspects of the production.
>
> (P05)

> To my mind, an album was a tangible product that showed the collaborative nature of Ethno, while highlighting the musicians that participated, thereby enhancing their careers and professional prospects.
>
> (P17)

Many participants describe their experiences at Ethno camps as life changing. Entering the Ethno space is, for some, akin to a transformative ritual that alters one's experience of the world and deepens one's own self-understanding (Mantie & Risk, 2020, p. 27):

> Although I was very scared in the camp, I was not talking to the people but everybody was so nice and beautiful! I opened up magically and became part of the group. That was a totally different world for me which has changed my life over the years and now I am an organizer of Ethno!
>
> (P16)

There's a strong sense of curiosity that draws one's attention towards the 'unknown': 'I find it quite fascinating that although I felt extremely challenged and awkward at the camps at times, I knew that this was something I had (to) go through and figure out' (P04).

This movement towards what organizers are curious about perhaps brings them closer to a deeper sense of themselves which is only just emerging: 'I was very curious with all these novelties and indeed I did not know what was expected of me in terms of results' (P06).

In this section, we have outlined our thematic analysis of Ethno Organizers' stories. We now move on to discuss the significance they attached to those stories.

Analysis of geometric data

The first stage of analysing geometric data generated by Sensemaker is to visually examine the emerging patterns in the signification frameworks, to look for any apparent 'clusters' or trends of signification. In each of the triad frameworks, the position of each individual mark is triangulated against three dimensions, and returns a score between 0 and 100 for each dimension. Hence, a score of greater than 33.3 indicates an emphasis on that dimension. Taken together, the mean response for each triad gives an overall impression of the relative collective significance of each dimension to the respondents.

Triad 1 – Music in three dimensions

Respondents placed their mark against a triad of three complementary dimensions (paramusical; aesthetic; participatory) in response to the prompt 'The story I shared is about' (see Figure 3.6).

In this triad, the paramusical dimension is strongly emphasized, while the participatory dimension is de-emphasized, and the aesthetic dimension is strongly de-emphasized.

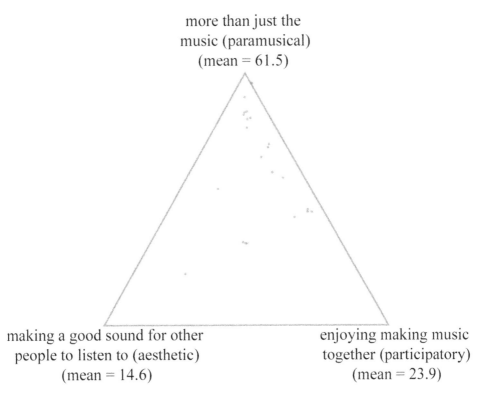

FIGURE 3.6: Music in three dimensions (triad 1) – responses.

Triad 2 – Identity

Respondents placed their mark against a triad of three complementary dimensions (me; my people; my place) in response to the prompt 'The story I shared is about developing (or losing) a sense of connection …' (see Figure 3.7).

In this triad, both 'me' and 'my people' are emphasized, while 'my place' is de-emphasized.

Triad 3 – Self-determination

Respondents placed their mark against a triad of three complementary dimensions (autonomy; competence; relatedness) in response to the prompt 'The story I shared relates mostly to me (or someone else)' (see Figure 3.8).

In this triad, the dimension of 'relatedness' is emphasized.

These results support the findings in the thematic analysis, that organizers' concerns are to do with the relational and social aspects of musicking, even though

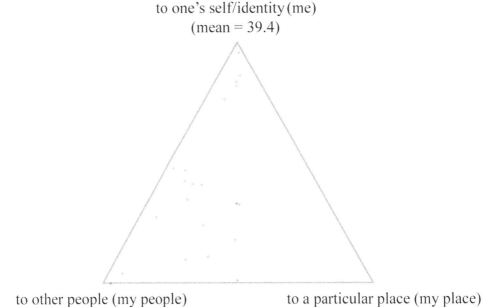

FIGURE 3.7: Identity (triad 2) – responses.

many of their stories are centred around highly presentational experiences of musical performance.

Comparison with previous study

Because the first two triads were also used in a previous study (Camlin et al., 2020) it is also possible to compare the findings of both studies. To that end, one-sample *t*-tests were undertaken on the numerical data, the results of which are summarized in Appendices i and ii. Regarding Triad 1 (Identity), of note is that there was a very similar pattern of signification between this study and the previous one in relation to the dimension of 'my people', suggesting that the social dimension of music making was similarly emphasized, reinforcing the idea of 'communitas' through collective musicking as a resource for social bonding. Furthermore, in relation to the dimension of 'My Place', a one-sample *t*-test revealed a significant difference between Ethno Organizers signification data around the importance of place and the mean score reported in a previous study of group singers (Camlin et al., 2020), with a medium effect ($t_{21} = 2.66$, $p = 0.01$, $d = 0.52$), such that the importance of place among Ethno Organizers was lower ($M = 17.88$, $SD = 13.94$) than among group singers ($M = 25.78$).

Having the freedom to make and
implement decisions (autonomy)
(mean = 27.7)

Exercising and developing
skills (competence)
(mean = 27.8)

Working as part of
a team (relatedness)
(mean = 44.5)

FIGURE 3.8: Self-determination (triad 3) – responses.

Regarding Triad 2 (Quality), the 'paramusical' dimension was similarly emphasized over the other two dimensions. However, a one-sample t-test revealed a significant difference between Ethno Organizers signification data around the paramusical aspects of musicking and the mean score reported in the previous study of group singers (Camlin et al., 2020), with a medium effect ($t_{21} = 2.69$, $p = 0.01$, $d = 0.48$), such that the importance of paramusical experiences among Ethno Organizers was higher ($M = 61.5$, $SD = 21.9$) than among group singers ($M = 48.96$). In other words, the emphasis on the paramusical was significantly more present for Ethno Organizers than the group singers in the previous study.

Dyad 1 – Social impact

In the dyad framework, respondents placed their mark against a continuum of two dimensions (individual; society) in response to the prompt, 'the impact of this story

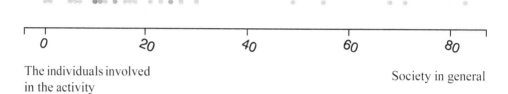

FIGURE 3.9: Social impact dyad – responses.

was on …' returning an individual score between 0 (wholly individual impact) and 100 (wholly societal impact) for each dimension (see Figure 3.9).

The mean score in response to the question of social impact was 26.8, suggesting a positive skew towards the impact on the individual but with data otherwise normally distributed – 71 per cent of the data fell within one standard deviation of the mean, and 95 per cent within two standard deviations.

Grid 1 – Social impact 2

The grid framework returned inconclusive results, with respondents' marks distributed more evenly across all quadrants of the grid (see Figure 3.10).

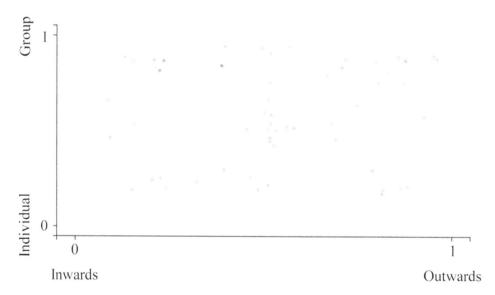

FIGURE 3.10: Social impact grid – responses.

Discussion

The results of the geometric analysis broadly confirmed what emerged from the thematic analysis, that Ethno Organizers are most concerned with the human relationships which are facilitated and supported through the whole of the Ethno experience. The two statistically significant differences in the data surprised us, as they suggest that Ethno Organizers are particularly focused on the affordances for social connection which their events entail, even though a significant part of their experience must be – we assumed – about organizing events where musical quality matters a good deal. It might have been reasonable to expect a corresponding emphasis on both the aesthetic and geographically situated aspects of their experiences, and while these were very present in their stories, the collective significance attached to these stories suggests a strong focus on how their events can unite people from very different cultural backgrounds, creating spaces outside of everyday life where – through musicking – participants can explore different personal and collective identities which contrast with the ones they inhabit outside of the Ethno 'bubble'.

The themes which emerged from a thematic analysis of Ethno Organizers' stories – communitas, the paramusical, leadership, and identity – suggest a strong 'ethical praxis' of action and reflection with regard to the socio-musical dimensions of musicking. That is to say, the organizers appear collectively to be 'deeply committed to making art that reflects their own critical perspectives on their places and spaces' (Elliott et al., 2016, p. 8) and 'conceive of and engage in [their endeavors] with a view to the particular social "goods" they embody or nurture' (p. 5).

Coming predominantly from a WCM background, Ethno Organizers share a strong sense of curiosity and resilience in their approach to leadership. Belonging to a broader community of reflective practice facilitates a common ground for undertaking transformational identity work in music, as well as developing capabilities of self-determination in the supportive context of emergent personal and professional networks. Among the logistical challenges of planning large-scale events, managing the social and cultural tensions that might arise and the physical demands of leadership, the well-being of participants is foregrounded through structuring activities which promote 'paramusical' outcomes as well as musical ones. Whilst maintaining a somewhat delicate balance between more local demands and the global expectations of the host institution JMI, the multicultural environment of Ethno gatherings creates a sense of 'no borders' – an adaptive and interdependent complex of place, people, and music – that can have a life-changing impact on organizers' musical and personal lives.

In the discussion that follows, we return to the questions on which this study was formulated to consider the extent to which we have been able to address them.

In relation to the self-reported motives of Ethno Organizers, we hope that our approach has been able to illuminate some of the complexities surrounding this issue. Far from a more transactional approach to participatory musicking – for primarily capital gain, say – the organizers in this study appear to be motivated by more ethical and emancipatory concerns, often working beyond the expectations of their contract to deliver transformational experiences for their participants. Our study suggests that Ethno Organizers are motivated by often deeply held personal beliefs about the transformational potential of musicking, often stemming from personal experiences, and sometimes from their own histories of participation in previous Ethno events. This translates into a strong 'ethical praxis' which celebrates the power of music to facilitate deep social connections and personal transformations.

There is a clear sense of organizers' pride in their local heritage, culture, and musical traditions, and how musicking can not only preserve local cultural identities but also lead to transformations in those identities by exposing them to intercultural dialogue where new cosmopolitan identities can be negotiated and experienced. While Ethno gatherings are deeply rooted in the places where they occur, there is less of a sense of cultural and/or national identities being promoted *in competition with* others, but rather that ways of integrating those more localized identities can become co-constituent in the negotiation of new transnational and/or cosmopolitan identities. The musical encounter is at the heart of this discourse, forging interpersonal and intercultural alliances and connections which are sustained beyond the duration of the gathering, and often lie at the heart of organizers' own personal and professional identity.

Similarly, Ethno Organizers manifest their obligations to attendees and artistic leaders in the way they establish the Gathering as a site for individual and collective identity transformation. Often drawing on their own transformational experiences of musicking – and many with histories of participation in the Ethno programme itself – they seek to create the conditions where attendees can experience similar disruptions, epiphanies, and personal insights to the ones they underwent themselves, in order to facilitate *everyone*'s development as musical human beings in a world of plurality and difference.

JMI and Ethno World provide a vital role in creating the conditions for this transformational work to be undertaken, but the sense from the organizers' perspectives is that this is not done in overly prescriptive ways, with local gatherings allowed and encouraged to develop their offers in diverse ways that are most suitable to their local situation. The institutional infrastructure around Ethno Organizers' activities clearly provides peer-led practical support, advice, and problem-solving, but the Ethno culture also goes deeper than this. In response to some of the questions raised about intentionality in the white paper (Mantie & Risk,

2020, p. 45, 53), our sense is that the broadly humanistic values – e.g. empathy, patience, tolerance, acceptance – which underpin the programme are not simply 'espoused' values (Argyris & Schön, 1992, p. 6), but ones that are very much 'in-use' within the fabric of organizers' peer discourse, in the development of their leadership capabilities, and in the stories they share of their experiences.

There are several limitations to our findings. Principle among these is the extent to which current Ethno Organizers may feel constrained by their professional relationship to JMI to present a positive impression of their experiences. While their stories point to a good degree of personal autonomy in the fulfilment of their leadership responsibilities, this cannot be taken as evidence of full impartiality, and perhaps we should not expect it to. The findings themselves are not considered to be generalizable, representing as they do a rich set of insights into the personal and situated experiences of a small group of people. Organizers were also slow to respond to the call to participate in the research, and this may be because of time constraints, research fatigue, suspicions about the process, or several other reasons. While organizers were not coerced into participating, it required some organizations to establish a suitable platform for participation, and this process may have affected their responses.

Conclusions

The study represents a rich understanding of the experience of Ethno Organizers. The self-motivation of organizers to facilitate events which create the conditions for identity transformation suggests that the 'values-in-use' within the Ethno programme go beyond mere espousal, but rather are held in very personal ways by the organizers of Ethno activities. We think that the main themes to emerge from this study – communitas, the paramusical, leadership, identity – provide some scope to broaden the literature to frame the Ethno experience. The findings broadly support the findings of previous research that 'paramusical' outcomes are what drives musical participation, in particular the resulting affordances for deep social bonding. It confirms Ethno gatherings as valuable sites for identity work, not just in relation to personal identities *in* music, but more broadly in relation to the development of more cosmopolitan identities *through* musicking.

REFERENCES

Ansdell, G. (2013). Belonging through musicing: Explorations of musical community. In *Where music helps: Community music therapy in action and reflection* (pp. 39–61). Ashgate.

Argyris, C., & Schön, D. A. (1992). *Theory in practice: Increasing professional effectiveness.* Jossey-Bass.

Bakhache, N., Michael, S., Roupetz, S., Garben, S., Bergquist, H., Davison, C., & Bartels, S. (2017). Implementation of a SenseMaker® research project among Syrian refugees in Lebanon. *Global Health Action, 10*(1), 1362792–1362792. https://www.tandfonline.com/doi/full/10.1080/16549716.2017.1362792

Bartleet, B.-L., & Higgins, L. (Eds.). (2018). *The Oxford handbook of community music*. OUP USA.

Belfiore, E., & Bennett, O. (2007). Rethinking the social impact of the arts. *International Journal of Cultural Policy, 13*(2), 135–151.

Belfiore, E., & Bennett, O. (2008). *The social impact of the arts: An intellectual history*. Palgrave Macmillan.

Camlin, D. A. (2016). *Music in three dimensions* [Doctoral thesis]. University of Sunderland.

Camlin, D. A. (2018). Assessing quality in socially engaged musical performances. *Paper presented at the reflective conservatoire conference: Artists as citizens, 20-23 February 2018* [Unpublished]. Guildhall School of Music & Drama. Accessed 2 February 2023, from https://www.researchgate.net/publication/323573653_Assessing_Quality_in_Socially_Engaged_Musical_Performances

Camlin, D. A. (2021a). Mind the gap! In L. Willingham (Ed.), *Community music at the boundaries* (pp. 72–95). Wilfrid Laurier University Press. Accessed 2 February 2024, from https://www.wlupress.wlu.ca/Books/C/Community-Music-at-the-Boundaries

Camlin, D. A. (2021b). Organisational dynamics in community ensembles. In R. Timmers, F. Bailes, & H. Daffern (Eds.), *Together in music* (pp. 24–34). Oxford University Press.

Camlin, D. A. (2021c). Recovering our humanity – What's love (and music) got to do with it? In K. S. Hendericks & J. Boyce-Tillman (Eds.), *Authentic connection: Music, spirituality, and wellbeing* (pp. 293–312). Peter Lang UK.

Camlin, D. A. (2022). Encounters with participatory music. In *The chamber musician in the 21st century* (pp. 43–71). Oxford University Press.

Camlin, D. A. (2023). *Music making and the civic imagination: A Holistic Philosophy*. Intellect.

Camlin, D. A., Daffern, H., & Zeserson, K. (2020). Group singing as a resource for the development of a healthy public: A study of adult group singing. *Humanities and Social Sciences Communications, 7*(1), 1–15. https://doi.org/10.1057/s41599-020-00549-0

Camlin, D. A., & Zeserson, K. (2018). Becoming a community musician: A situated approach to curriculum, content, and assessment. In B.-L. Bartleet & L. Higgins (Eds.), *The Oxford handbook of community music* (pp. 711–733). OUP Oxford. Accessed 2 February 2024, from https://www.oxfordhandbooks.com/view/10.1093/oxfordhb/9780190219505.001.0001/oxfordhb-9780190219505-e-7?rskey=4wPQqK&result=1

Chan, A., Hannah, S. T., & Gardner, W. L. (2005). Veritable authentic leadership: Emergence, functioning and impacts. In W. L. Gardner, B. J. Avolio, & F. O. Walumbwa, (Eds.), *Authentic leadership theory and practice: Origins, effects and development* (pp. 3–42). Emerald.

Crawford, P., Brown, B., Baker, C., Tischler, V., & Abrams, B. (2015). *Health humanities* (2015 ed.). Palgrave Macmillan.

Cross, I., & Woodruff, G. E. (2009). Music as a communicative medium. In B. Rudolf & C. Knight (Eds.), *The prehistory of language* (pp. 113–144). Oxford University Press.

Crossick, G., & Kaszynska, P. (2016). *Understanding the value of arts and culture: The AHRC cultural value report*. Arts & Humanities Research Council. Accessed 2 February 2024, from https://ualresearchonline.arts.ac.uk/id/eprint/15973/1/Kaszynska%20-%20AHRC%20Cultural%20Value%20Project%20Report.pdf

Crotty, M. J. (1998). *The foundations of social research: Meaning and perspective in the research process*. Sage Publications Ltd.

Cultural Policy Collective. (2004). *Beyond social inclusion, towards cultural democracy*. Accessed 2 February 2024, from https://www.culturaldemocracy.net

Cynefin Company. (n.d.). *SenseMaker®*. Accessed 8 November 2019, from https://cognitive-edge.com/sensemaker/

Eggers, K. (n.d.). *Peace Engineering Lab*. Accessed 17 August 2021, from https://carterschool.gmu.edu/research-impact/carter-school-peace-labs/peace-engineering-lab

Elliott, D. J. (1995). *Music matters: A new philosophy of music education*. OUP USA.

Elliott, D. J. (Ed.). (2009). *Praxial music education: Reflections and dialogues*. OUP USA.

Elliott, D. J., & Silverman, M. (2014). *Music matters: A philosophy of music education*. Oxford University Press.

Elliott, D., Silverman, M., & Bowman, W. (2016). *Artistic citizenship: Artistry, social responsibility, and ethical praxis*. Oxford University Press.

Freer, P. K., & Bennett, D. (2012). Developing musical and educational identities in university music students. *Music Education Research*, 14(3), 265–284. https://doi.org/10.1080/14613808.2012.712507

Gabrielsson, A. (2011). *Strong experiences with music: Music is much more than just music*. Oxford University Press.

Gallagher, S., & Zahavi, D. (2012). *The phenomenological mind* (2nd ed.). Routledge.

Gross, J., Wilson, N., & Bull, A. (2017). *Towards cultural democracy*. Kings College. Accessed 29 June 2017, from https://www.kcl.ac.uk/cultural/resources/reports/towards-cultural-democracy-2017-kcl.pdf

Guildhall School of Music and Drama. (2019). *Guildhall School of Music & Drama awarded £984,000 to lead 3-year international research project on the social impact of making music*. Accessed 22 August 2021, from https://www.gsmd.ac.uk/about_the_school/news/view/article/guildhall_school_of_music_drama_awarded_pound984000_to_lead_3_year_international_research_project_on/

Hadley, S., & Belfiore, E. (2018). *Are we misunderstanding cultural democracy?* Accessed 21 September 2018, from https://www.artsprofessional.co.uk/magazine/article/are-we-misunderstanding-cultural-democracy

Helguera, P. (2011). *Education for socially engaged art: A materials and techniques handbook*. Jorge Pinto Books.

Higgins, L. (2012). *Community music: In theory and in practice*. OUP USA.

Higgins, L., & Willingham, L. (2017). *Engaging in community music: An introduction*. Routledge.

Hunter, J., Micklem, D., & 64 Million Artists. (2016). *Everyday creativity*. 64 Million Artists. Accessed 21 August 2016, from http://64millionartists.com/everyday-creativity-2/

IJCM. (n.d.). *International Journal of Community Music*. Accessed 12 June 2014, from http://www.intellectbooks.co.uk/journals/view-journal,id=149/

JM International. (n.d.). Ethno. JMI.net. Accessed 22 August 2021, from https://jmi.net/programs/ethno

MacDonald, R., Hargreaves, D., & Dorothy, M. (Eds.). (2002). *Musical identities*. Oxford University Press.

MacDonald, R., Hargreaves, D. J., & Miell, D. (Eds.). (2017). *Handbook of musical identities*. OUP Oxford.

MacDonald, R., Kreutz, G., & Mitchell, L. (2013). What is music, health and wellbeing and why is it important? In *Music, health and wellbeing* (pp. 3–11). OUP Oxford.

Mantie, R. and Risk, L. (2020). *Framing Ethno-World: Intercultural music exchange, tradition, and globalization*. University of Toronto Scarborough.

Matarasso, F. (1997). *Use or ornament? The social impact of participation in the arts*. Comedia.

Mausch, K., Harris, D., Dilley, L., Crossland, M., Pagella, T., Yim, J. & Emma, J. (2021). Not all about farming: Understanding aspirations can challenge assumptions about rural development. *The European Journal of Development Research*, 33(4), 861–884. https://doi.org/10.1057/s41287-021-00398-w

Mausch, K., Harris, D., Heather, E., Jones, E., Yim, J., & Hauser, M. (2018). Households' aspirations for rural development through agriculture. *Outlook on Agriculture*, 47(2), 108–115. https://doi.org/10.1177/0030727018766940

Mithen, S. (2007). *The singing Neanderthals: The origins of music, language, mind, and body*. Harvard University Press.

Neelands, J, Belifore, E., Firth, C., Hart, N., Perrin, L., Brock, S., Holdaway, D., Woddis, J., & Knell, J. (2015). *Enriching Britain: Culture, creativity and growth*. University of Warwick. Accessed 17 November 2023, from https://warwick.ac.uk/research/warwickcommission/futureculture/finalreport/warwick_commission_report_2015.pdf

Oxfam. (2018). *How decent is decent work? Using SenseMaker to understand workers' experiences*. Accessed 17 August 2021, from https://policy-practice.oxfam.org/resources/how-decent-is-decent-work-using-sensemaker-to-understand-workers-experiences-620476/

Pairon, L., & Sloboda, J. (n.d.). *Social impact of music making*. Accessed 22 August 2021, from http://www.simm-platform.eu/

Partti, H. (2014). Cosmopolitan musicianship under construction: Digital musicians illuminating emerging values in music education. *International Journal of Music Education*, 32(1), 3–18. https://doi.org/10.1177/0255761411433727

Pavlicevic, M. (2013a). Between beats: Group music therapy transforming people and places. In Raymond MacDonald, Gunter Kretz, & Laura Mitchell (Eds.), *Music health and wellbeing* (pp. 196–212). Oxford University Press.

Pavlicevic, M. (2013b). Let the music work: Optimal moments of collaborative musicing. In *Where music helps* (pp. 100–123). Ashgate.

Perry, J. (2013). *Social impact measurement: time to admit defeat?* Accessed 7 May 2013, from http://www.guardian.co.uk/social-enterprise-network/2013/apr/11/social-impact-measurement-defaeat

Regelski, T. (2021). Musical value and praxical music education. *Action, criticism, and theory for music education.* https://doi.org/10.13140/RG.2.2.11819.57121

Regelski, T., & Gates, J. T. (2009). *Music education for changing times: Guiding visions for practice.* Springer.

Ryan, R. M., & Deci, E. L. (2000). Intrinsic and extrinsic motivations: Classic definitions and new directions. *Contemporary Educational Psychology, 25*(1), 54–67.

Ryan, R. M., & Deci, E. L. (2018). *Self-determination theory: Basic psychological needs in motivation, development, and wellness.* Guilford Press.

Sloboda, J. (2019). *Research into social impact of music making.* Keynote Speech. Accessed 17 November 2023, from https://youtu.be/d82LYl-ICq4

Small, C. (1996). *Music, society, education.* Wesleyan University Press.

Small, C. (1998). *Musicking: The meanings of performing and listening.* Wesleyan University Press.

Smith, J. A., Flowers, P., & Larkin, M. (2009). *Interpretative phenomenological analysis: Theory, method and research.* SAGE Publications Ltd.

Snowden, D. (2016). *Ethnography Part II.* Accessed 1 March 2018, from http://cognitive-edge.com/blog/ethnography-part-ii/

Stige, B., Ansdell, G., Elefant, C., & Pavlicevic, M. (2013). *Where music helps: Community music therapy in action and reflection.* Ashgate.

Trevarthen, C., & Malloch, S. (2017). The musical self: Affections for life in a community of sound. In R. MacDonald, D. J. Hargreaves, & D. Miell (Eds.), *Handbook of musical identities* (pp. 155–175). OUP Oxford.

Turino, T. (2008). *Music as social life: The politics of participation.* University of Chicago Press.

Turner, E. (2012). *Communitas: The anthropology of collective joy.* Palgrave Macmillan.

United Nations Development Programme. (2020). *The impact of COVID-19 through people's narratives and perceptions.* Accessed 17 August 2021, from https://www.md.undp.org/content/moldova/en/home/library/inclusive_growth/the-impact-of-covid-19-through-peoples-narratives-and-perception.html

Veblen, K. K., Messenger, M. S., & Elliott, D. J. (Eds.). (2013). *Community music today.* Rowman & Littlefield Education.

Williamon, A., Ginsborg, J., Perkins R., & Waddell, G. (2021). *Performing music research: Methods in music education, psychology, and performance science.* OUP Oxford.

Willingham, L. (2021). *Community music at the boundaries.* Wilfrid Laurier University Press.

4

Ethno World as a Site for Developing and Practising Musical Possible Selves

Maria Varvarigou, Andrea Creech, Lisa Lorenzino, and Ana Čorić

Introduction

Ethno is committed to reviving and keeping alive global cultural heritage amongst youth. Ethno gatherings function as spaces where young musicians, both professional and non-professional, can come together to share the traditional musics of their own countries. They also function as spaces for professional networking and connections founded upon shared repertoire (Ellström, 2016; Gayraud, 2016; Mantie & Risk, 2020; Roosioja, 2018). Our research has suggested that through signature pedagogies, including informal learning and scaffolding rooted in the pedagogical practices of learning by ear, peer learning, self-directed, and situated learning (see Chapter 3, this volume), Ethno participants expanded their comfort zones through experimenting with multi-dimensional professional roles such as performing musician, workshop leader, artistic leader, organizer, and mentor, taking them into previously unknown musical worlds (Čorić, 2024; De Bonte & Dokuzović, 2015). What is more, by engaging in the exploration of diverse musical genres and traditions, and the ways in which those could be mixed and developed as 'hybrids', Ethno participants nurtured a range of musical and organizational skills that have contributed to the development at personal as well as community levels (Creech, 2014).

With a particular focus on how Ethno may support the participants' professional development, Gayraud (2016) noted that, upon completion, many Ethno participants expressed the desire to pursue careers as professional folk musicians in their own countries, as well as within Ethno. This goal was supported in two principal ways. First, Ethno facilitated opportunities whereby participants could

forge international connections with other musicians, typically founded upon shared knowledge of a common repertoire of songs 'jammed' at Ethno gatherings and transferred to other folk music-making contexts. Second, Ethnofonik was the formal training pathway within Ethno, aimed at providing future artistic leaders the tools to facilitate cultural exchange through music to different audiences. De Bonte and Dokuzović (2015) explained that being an artistic leader required the development of skills to fulfil different roles such as being a musician, youth worker, organizer, citizen artist, and reflective practitioner. Each role involved acknowledging the multi-faceted contribution that Ethno could have in societies around the world – as sites for learning, for socializing through music; as well as for building Ethno participants' careers in music-making, music leadership, and artistic citizenship.

Accordingly, the term 'professional development' as used in this chapter, aligns with the academic literature on music learning and development (Creech, 2014; Hargreaves & Lamont, 2017; Smilde, 2018; Varvarigou & Creech, 2021) aiming to explore the ways that Ethno experiences supported personal or professional learning and change. As it emerged in our research, within Ethno, personal and professional development were integrally linked often leading to transformational changes in the ways that Ethno participants thought about music and communication. For instance, their motivation to continue as lifelong learners in music was attributed in part to the feeling of recognition and personal value derived from Ethno. In addition, motivation to participate in Ethno had fostered a deep self-knowledge as well as life skills that could be transferable to other contexts.

The two research questions addressed in this chapter are:

- How do the Ethno professional development structures develop, and how are they reinforced?
- What are the practices that are perceived as being transformational, within the context of Ethno?

In addressing these questions, we analysed 108 documents, including previously undertaken interviews with Ethno participant-musicians (many of whom had taken on the role of workshop leader), artistic mentors, and organizers; 202 responses to a survey distributed via Ethno networks, developed by extracting concepts and text from the document analysis; and ten in-depth semi-structured interviews with an Ethno mentor, an Ethno workshop leader, four participant-musicians, three organizers, and a mentor/organizer (for a detailed account on the methodology, including sampling see Creech et al. [2021]). The model of 'musical possible selves' (Creech et al., 2020; Freer, 2010) has been used to frame our analysis and discussion of personal and professional development through Ethno experiences.

Overall, our research revealed that Ethno could be significant in supporting both personal and professional development leading to transformational experiences for participants. An analysis of these transformational experiences may serve as a point of reflection that could contribute to the ongoing evolution of Ethno, within the wider discipline of music education.

Musical possible selves

The concept of 'possible selves' (Markus & Nurius, 1986) refers to ideal and hoped-for selves or alternatively selves that are feared and dreaded. Possible selves are domain specific, guiding action and influencing our decisions with regard to what to expend effort on and what to abandon (Smith & Freund, 2002). Two key dimensions characterize our possible selves: (1) *salience*, referring to personal investment in the possible self and the extent to which an individual is engaged with the associated goals, and (2) *elaboration*, referring to the vividness, detail, and emotionality of the narrative individuals can generate when asked about their possible selves (King & Hicks, 2007; Rossiter, 2007). Highly elaborate and salient possible selves are constructed through the observation of role models, experimentation, and evaluation of new possible selves against internal and external standards (Leondari, 2007). Possible selves are also dynamic and are reframed in response to life transitions (Cross & Markus, 1991). At the same time, possible selves offer coherence in our lives, linking past, present, and future experience (Erikson, 2007). These personal narratives represent an 'insider perspective' located within social and cultural contexts fashioned by the way we experience the world.

'Musical possible selves' (Freer, 2010) are musical self-stories or narratives representing 'how, when, where, and with whom we make music' (Creech et al., 2020, p. 18). Freer (2009) suggested that musical possible selves are shaped by two overarching phases of conceptualization and realization. While conceptualization involves the stages of discovering, thinking, and imagining, realization comprises reflecting, growing, and performing. During the conceptualization phase, musicians discover possible selves as recollections of early musical experiences in the home, as well as some 'pivotal' early musical experiences in school. They may ask themselves questions concerned with their strengths and interests, identity, aims and expectations, and fears. Answers to these questions will shape emergent possible selves. Similar to discovering possible selves, 'thinking' possible selves is a stage involving role models, for instance, parents, siblings, teachers, and peers, as sources of inspiration for musicians' thinking about their potential musical interests and activities. Questions asked in this stage might focus on the source of personal musical interests, musical preferences, and goals. Role models may also

have a significant impact in the 'imagining' possible selves stage, during which musicians identify desired strengths and interests. Questions asked in this stage might be: *What are my possible musical selves? What can I be?*

During the realization phase, musicians evaluate and reflect on how they have arrived at where they are, how they are doing, and what can possibly be in the future. These processes result in some musical possible selves becoming 'lost', others being rediscovered, and others becoming further elaborated. To begin with, in the 'reflecting' stage, individuals focus on how they have developed musical skills and competencies, as well as on making explicit their learning strategies. The goal of this stage is to identify the obstacles towards achieving musical possible selves and to determine whether they are fixed or changeable. Questions that lead the reflecting stage are concerned with an evaluation of what musical possible selves could be achieved, leading to establishing musical priorities. 'Growing' musical possible musical selves responds to the question *How do I get to my musical goals?*, encouraging the development of action plans for learning and achieving musical goals. Finally, 'performing' musical possible selves refers to the refinement of action plans based on progress towards musical goals. The question leading this stage is: *How am I doing on my journey towards my possible musical goals?*

The following sections demonstrate how intercultural learning in Ethno was perceived to have fostered learning experiences that shaped the conceptualization and realization of new musical possible selves while also providing opportunities for reframing previously dominant musical possible selves.

Personal and professional development in and through Ethno

Through contributing to the conceptualization and realization of musical possible selves, Ethno appeared to play a significant role in the personal and professional development of its participants. Our data suggested that personal and professional development were integrally linked. Figure 4.1 shows the relationship of these two spheres of development, intersecting in the formulation of musical possible selves. It is important to recognize that not all Ethno participants had joined Ethno with specific *musical* goals in mind. This has also been reported in studies with adult learners engaging in musical experiences in non-formal settings (Creech et al., 2014; 2020). Some participants wanted to improve their knowledge and skills in music, while others wanted to create friendships and/or professional networks, or to experience personal growth and challenge. With regard to personal development, our research revealed that Ethno had supported participants in ways that extended beyond musical skills and knowledge, for example, fostering enhanced confidence or supporting the development of stronger beliefs in one's own potential.

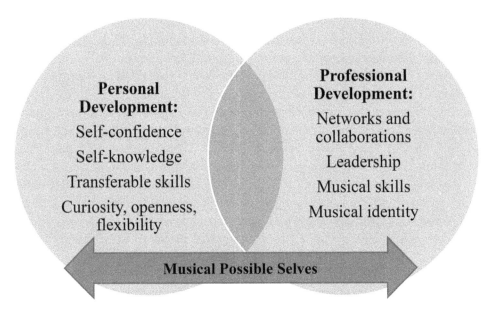

FIGURE 4.1: Personal and professional development in and through Ethno.

> Ethno has always pushed me out of my comfort zone, actually resulting in better confidence in myself and doing things I would not have thought I could e.g., singing alone in front of an audience.
>
> It's unmeasurable for me. As I've commented before, Ethno had and always will have a very important role in my own personality and world view. My first camp was at a time when all this was very important – to learn about my own potential, to get new friends and encouragement etc.
>
> I improved as a person […] You start coming out of your shell and you start accepting everyone […] that's a great, great thing for every musician.

Moreover, Ethno was perceived to have deepened and expanded the participants' self-knowledge. This included a heightened awareness of cultural identity, as well as personal growth and life skills, such as reacting in situations where they did not know anybody and in coping with insecurities in such situations – skills that were potentially transferable to other parts of the participants' lives.

> I'm speaking of course of my personal perspective now, that you come to a camp, expect to learn all those other things but what you probably learned most about is who you are in that context, and learning about 'oh, this is how I'm situated in the

world and in my culture' and seeing yourself clearer and the contrast of the other cultures.

I learnt how to meet people (musically and in other ways) from other cultures/with other languages. It never feels like a problem to me, quite the opposite, and I think I have Ethno to thank for this! In groups/situations, I am often the one who has the easiest to meet people from other cultures.

My level of openness has definitely increased. As has my curiosity. But also, the ability to improvise in situations where you are presented with something unexpected, and just accept that 'ok, this is how it is now, I'll try this.'

Finally, some participants reported that they had gained a sense of value and recognition in their endeavours as musicians, which they attributed to Ethno. In these instances, the creative, musical work undertaken at Ethno was recognized as being of high quality contributing to feelings of self-efficacy, and of being valued.

> The recognition that you get for who you are [...] Ethno also gives you a recognition that you have something to offer, you have something to teach, and it does make you feel very very good and very valued.

With regard to professional development, Ethno offers a framework for the development of professional networks around the globe that is founded upon trust and deep social connection, while focused on the shared interest and love for folk music. In particular, participants often managed to stay in touch with people they had met at Ethno gatherings, often more at a personal than a professional level. During the pandemic, these networks were in some cases sustained with ad hoc activities within an online environment.

> I would say I have developed a strong musical network, but as I do not perform music professionally more than perhaps 1–2 times per year I wouldn't say for me it's a 'professional' network as much as socially musical.
> With Ethno I have been able to meet people from places I never imagined, forming friendships and connecting through the internet.

Similarly, some reported that participation in Ethno stemmed from a professional need to learn different styles of music and to be connected with the international folk scene. Furthermore, Ethno gatherings had opened up doors for professional careers in music performance and music leadership.

> Every Ethno experience for me has been a significant point of growth. Rekindling my relationship to music when I was losing sight of it, learning to be more accepting,

developing leadership skills (to name a few). The main take away is that I feel like I level up as a person after every Ethno experience, whether it comes to music or as a person.

Leadership development, as a professional skill, was reportedly nurtured through teamwork. Teamwork was founded upon deep listening, building consensus and joint decision-making.

> We listen to each other, we go forward together, sometimes it's a little bit slow, you know, decisions are just taking, we need consensus, we need to build that consensus and that that takes time. But when we do build that consensus, those decisions are very solid we implemented the Ethno values and commitments to empower organizers to be able to say what Ethno is.

There was a sense that over time the Ethno network had become more unified and effective in the way that it worked for people. At the same time, there were some critical questions raised about whether expansion might be at the expense of the intimate and closely bound qualities of the smaller Ethno network.

> Now, there is a lot more communication there's a lot more transfer of knowledge and information possible, so it is also possible for the network to collectively work in a unified way […] I would like to see it in every country, there are so many cultures that are not here.
>
> Friends that I have at Ethno, they are lifelong friends, I would say now, having been friends since 2003 with many of them, you like you have a connection if you even if you're not in touch.

To summarize this first section on the contribution of Ethno experiences to the participants' personal and professional development, key areas included enhanced self-confidence, self-knowledge, and self-belief in the participants' own potential. Ethno was also perceived to have fostered transferable skills, such as openness and curiosity, the capacity to respond to unexpected situations, and to be more accepting. Furthermore, participants often reconceptualized who they were as musicians: they noted the positive implications of Ethno gatherings for their musical skills, including demonstrating musical leadership (more details on musical skills in the following section). Ethno gatherings also functioned, for some (but not all) participants as a context where professional networks could emerge. These networks of relationships framed planning for future collaborative artistic work. Overall, it emerged that Ethno experiences offered young musicians the scope to reimagine themselves in music, in an environment where they learnt or relearnt to love music and where they developed deep understandings of the role of music and musical networks in their lives.

The following section turns to the implications of Ethno for shaping and re-shaping musical possible selves and perceptions of Ethno participation as transformational.

Shaping and reshaping present and future musical possible selves through Ethno experiences

Ethno was perceived by the participants in our research as a transformational space where musical possible selves, or 'internal personal projects', as one participant called them, could be realized. As we suggested earlier, professional and personal development were closely linked: Ethno participants discovered, rediscovered, and reimagined musical roots, identities, and trajectories in a process that aligned with the six phases of development of musical possible selves identified by Freer (2009). The process of developing musical possible selves furthermore involved the development of transferable personal qualities, such as self-knowledge, self-confidence, and self-belief, as well as the expansion of musical skills in improvisation, arranging, and songwriting. It also involved the development of leadership skills that focused around teamwork, collaboration, and consensus-building, all of which were practised within a variety of social networks that the participants built. What is more participants perceived that Ethno's links and partnerships within the wider context of music education further supported the development of Ethno participants' musical identities as performers, music leaders, or lifelong learners' in music. For example, one Ethno leader spoke about strong links with a local Sistema-inspired programme while another described workshops in a conservatoire setting that had been proposed, with the objective of motivating beginners to continue with music.

> We propose since few years, some Ethno workshops in the Conservatoire in France, I mean music schools […] they want to use this Ethno method for the beginners to keep them to keep the spirit of wanting to play music.

In Germany, Ethno had implemented a voluntary training programme for teachers across a large network of public music schools (separate from the compulsory school system), the aim being 'to influence the existing music education at large', while also maintaining a 'strong presence of music lessons in the compulsory schools as well'. The overarching goal was 'to integrate Ethno, to be able to teach Ethno or to facilitate Ethno with our tools'. While this initiative had faced challenges such as resource, timetabling, and budget limitations, a positive legacy was in the form of multicultural Ethno ensembles that had been implemented in two music schools, rehearsing weekly and performing regularly. The aspiration was to extend such practices.

I hope that Ethno can establish itself or we can establish Ethno in a number, a significant number of music schools in Germany. If you consider that we have nearly 1000, every smaller town has one, so it's quite a big number but of course they [...] if you have the flagships of them. They have a kind of role model function. So, the Association of music schools, has a big congress every other year, so I think it is next year. We try to have a showcase then [...] we have the chance to reach about 1000 or 2000 music schoolteachers and directors in this conference. So, if you have to showcase the workshop there will be a big success, so that we can establish it as want to have parts of the, of the music schools' program that, that would be great thing within five years. That would mean that about 20 big music schools, on which of the others look.

Discovering musical possible selves

Discovering possible selves usually emerges from affective learning involving personal and collaborative processes of making sense of experience in the 'here and now'. Ethno was experienced as a safe zone where participants could explore and discover their musical strengths and interests, and where language, age, introversion, special needs or high expectations, and self-criticism, did not function as barriers. During the 'discovering' musical possible selves stage participants reported discovering or rediscovering their musical roots through engaging with diverse people, musics, and learning methods. These experiences were deeply meaningful and shaped personal and professional musical and social identities.

> I never had such a great interest in traditional music before, even from my own country/region. Mostly because I didn't know much about it. Now I got really inspired by Ethnos to discover other places' traditions, and then it 'bounced back' to me and prompted me about my own 'traditions'. Now I'm also curious about that. It might have never happened without Ethno.

What is more, participants argued that through the immediacy and immersive experience of the power of the community, teaching the tune when asked to be workshop leaders, learning from different cultures through making connections with international friends, playing without being afraid of making mistakes, experimenting with new musical instruments and new musical genres, they had grown in self-confidence discovering or (re)discovering a 'musician' in themselves, and expressing themselves musically.

> Musically, it's a whole new world because you are confronted with very different ways of playing, very different instruments, very different ways of singing, so you're all the time stretching. [...] It's scary sometimes, because you don't know if you can

do it, singing this language, or playing this rhythm, or this groove [...] but you feel like you grow musically and it's beautiful. [...] it forced me to understand my musical identity, to go back to understand what was this, like these songs I grew up with, this culture that I have.

I would like to participate in other Ethnos and it will just push me a little bit to just discover a bit more and maybe my own identity, my own country.

I discovered that I'm quite a social person, I wasn't really aware of that beforehand.

Thinking about familiar and unfamiliar ways of making music

Ethno was perceived to have supported participants in making a transition in thinking about ways of making music. Through immersion in jamming, songwriting, improvisation, and intercultural learning, participants experienced a deeper understanding of specific forms of musical engagement involving affective, imaginal, conceptual, and practical experiences of learning. These musical experiences occurred through structured workshops and informal moments and provided the material for participants to develop conceptual frameworks around their new musical possible selves, built upon prior (musical) knowledge and experiences.

When you have to share something, you also have to [...] before you share that, you really need to understand it yourself, so then you can share it with others, so musically that is also very, very important part of Ethno for me.

Apart from that it has changed my life, my location and my path. And I became very critical also. [...] and I wanted to get deeper and deeper to understand [...], and because it felt like the thing I'm good at doing and, but then I also, I started to question things that I experienced in Ethno.

Imagining musical possibilities

Imagining musical possible selves appeared to have been fostered by Ethno through interactions with a variety of people, musics, and pedagogical tools. These experiences had prompted participants to reimagine their musical identities as autonomous and expressive, achieved through effecting change in their everyday lives (e.g. starting world music studies, considering a music teacher's career, or writing a book).

It gave us a feeling of 'wow, I really can do this!' And that was an amazing experience as well because there again I felt that I want to do it [...] That gave me maybe confidence that I want to do it.

I feel more artistic, and I feel I can write something and do something I love to do – I want to write a book. I feel going to Ethno is slowly but surely helping me

get to a point where I could write something. Possibly I will want to create, maybe play, something like that. I also feel that I'm slowly getting to a point where I can do that. Because I'm getting more artistic, and I understand music and creating and art more after going to Ethno every time.

Imagining future musical possible selves enabled participants to learn or re-learn to love music and to appreciate the role of music and musical networks in their lives.

It has boosted my image of myself as a musician. It has improved my listening, collaboration and arrangement skills, and band leading (I was already good at improvising and jamming). It has exposed me to so many amazing musicians who now play music with me, outside of Ethno, for which I am super grateful. Now I feel like I am successful, despite not being on the radio and not being big in mainstream pop. My Ethno friends love my songs, and respect me as a musician. They think I'm a really good guitarist and pianist. I am fine, but quite average really, not as good as the real pro session musicians and jazz musicians. But it doesn't matter. I can confidently collaborate, jam, support, lead and contribute to the Ethno band, and can make my own compositions and arrangements sound amazing, and facilitate/accompany other people confidently, and I can teach others, so what more could you want?

My first Ethno came at a time where my relationship with music was on the rocks. Ethno actually helped me learn to love music again because of the way in which it is structured, as well as the freedom. It's a paradox but that is actually how I came to my epiphany about my relationship with music. I wasn't enjoying music because I saw it as something with levels, a competition even. Ethno brought the concept of community back, allowing me to unlock a non-judgemental view of myself as a musician, therefore making me a much more open (and subjectively, a better) musician.

In summary, the phase of conceptualizing musical possible selves within Ethno was characterized by discovering, thinking, and imagining new possibilities in developing identities as performers, teachers, or leaders and as lifelong learners in music. Gayraud (2016) identified Ethno as a multifaceted space where young musicians can share their traditional musics and through processes that enable them to establish musical meaning, such as through teaching a tune to others, sharing songs, jamming together, and playing and sharing music with various audiences in schools and in the community, to enter a new identity. Similar to Gayruad (2016), our research highlighted that the immersive and intense 'residential context' of Ethnos that combined music learning with more casual activities, such as having meals and drinks together, a speed-dating dinner or busking competitions, offered a fertile ground for discovering a new musical identity or reframing an existing one rooted in interest and experiences that are personally meaningful.

Reflecting musical possible selves

Reflective practice emerged as being closely related to the capacity to imagine possible selves. Fay (1987 cited in Johns, 2013, p. 6) defined reflective practice as a process of (1) enlightenment or understanding (why things are as they are; self in context); (2) empowerment to take an action as necessary based on understanding; and (3) emancipation (action that transforms situations for a vision to be realized). In this vein, reflective practice at Ethno referred to reflecting on one's musical identity, for example addressing questions concerned with *Who am I? Who am I being seen as?* Reflecting on musical possible selves within the context of Ethno was focused on identifying challenges and evaluating possible future solutions. Some of the examples of prevailing obstacles were insecurity about teaching the tune and leading groups in free jamming; being conflicted in occupying different roles in Ethnos (e.g. artistic leader, participant-musician, organizer); and catering for the skills and the interests of the participants, especially those with limited musical skills.

> I've noticed learning tunes by ear is absolutely more inclusive than learning from notes.
>
> I tried to give some help to people, sacrifice some things or take time to play something through with them so that they understand this, so that they can play as well. For the evening jams, always give them a possibility to be part of it and ask them if they have a tune to play and play this tune, give them a possibility to be in the jam.
>
> Teaching was not generally understood as what the artistic leaders do. They wanted to be seen as guides on the side, acting as facilitators, supporting and developing musical sharing.
>
> As a participant I think for me it was feeling that I'm not good enough and, and I see that every single year. [There are] the participants who feel that they are really struggling musically and that they, you know that they don't fit and they're not good enough and […] those musicians who are there, who are studying music […], you know, finding it easy and really enjoying and really able to do everything […] and that has both its pros and it's cons so it lifts them [i.e. the latter] up but it also really makes those who, who, it isn't their life [i.e. the former], you know, or their passion necessarily struggle. And I think that was the thing that I found the hardest.

Some participants elaborated on how Ethno gatherings had helped them develop a musical possible self that honoured tradition yet was also expansive and open to change.

> I see myself as a musician playing traditional music from different parts of the world. I love the traditional tunes, but I don't see the tunes or the music as something from the past or that stands still. I respect the tradition, older musicians and traditional ways of playing, but in my opinion 'tradition' also means 'evolution'. I know for some people it's probably a horror scenario to mix up traditional tunes from Ireland, India and Chile in one set, backed with instruments from Congo, Tunisia and France. But I love it!
>
> I always see music in traditional ways, but Ethno show me that is possible to put together totally different instruments and in the final sounds really good. After Ethno certainly I am more open to mix and create new arrangements in many different musical styles.

Growing musical possible selves

Growing future musical possible selves was found to be related to practical learning and progress towards musical goals. For example, musical possible selves grew and developed through practices that included playing new instruments and singing techniques; improvisation; and reviving an interest in music, especially applied to musicians who were stressed with the requirements of classical training. Ethno participants grew their musical possible musical selves by moving out of their comfort zones: by becoming confident to stand, play, and sing in front of an audience; by travelling away from their homeland, and by meeting and living with new people; by developing self-knowledge around ways of breaking boundaries and personal blocks; and by forging emotional connections (also see Figure 4.1).

> I found myself growing quite a bit as just myself as well. Taking myself out of that situation I feel like it's all like a lot of life skills that I could apply to my life as well.

Participants also spoke of a strong move towards forging professional links between Ethno and the wider world of folk music, community music, and formal music education, as was mentioned earlier with regard to the voluntary training programmes for teachers in Germany.

Led by the question *How do I get to my (musical) goals?*, some participants grew their musical possible selves by identifying a number of areas for further professional development beyond what Ethnofonik could provide, including formal training and more situated, informal developmental opportunities. These training needs were in musical as well as social domains, and to some extent were being met through the existing Ethno networks.

One of our team members worked with refugees, [...] we all kind of all leaned quite heavily on her. And [...] we've got it on our radar to do some more kind of professional development as a team actually as well in that space.

We have the Ethnofonik experience where you go and you have this meta layer where you discuss, you prepare to be an artistic mentor, but it doesn't make you per se an artistic mentor [...] it gives you experiences in that regard, but you're not done or finished, or you don't get a certificate – you're not an example suddenly. Because, yeah, it comes by experience, and we always encourage people to stay open and not think they know everything just because they went to Ethnofonik course.

In summary, 'growing' musical possible selves within Ethno was a significant phenomenon, often scaffolded by participation in professional networks, and leading to social and musical personal growth.

Every Ethno experience for me has been a significant point of growth. Rekindling my relationship to music when I was losing sight of it, learning to be more accepting, developing leadership skills (to name a few). The main take away is that I feel like I level up as a person after every Ethno experience, whether it comes to music or as a person.

Definitely Ethno helped me to believe more in my musicality because it allowed me to see diversity in a healthy environment, something you usually don't see in a more Classic learning system.

For me, Ethno was a big change in my life. I developed leadership skills that I thought I didn't have, and now I enjoy a lot by helping other people to develop theirs too. It has been the best learning experience.

Ethno changed me from being really closed to being really open after that. Socially and musically. For me, Ethno changed my life.

Performing musical possible selves

Ethno was a natural context for 'performing musical possible selves'. The idea of 'performing' possible selves corresponds closely to the notion of transformative learning, as the enactment of a possible self necessitates having explored in great detail and developed the change mechanisms that underpin the achievement of a previously imagined possible self (Creech et al., 2020). Within the participants' personal narratives, the theme of transformation was prominent, supporting the idea that Ethno could function as a vehicle for exploring and formulating new musical identities. Transformation at a professional level was reported by participants who highlighted that through exposure to different musical traditions, and through working collaboratively in a group comprising different levels of musical

skill, Ethno experiences had encouraged them to pursue professional careers in music and to consider new ways to sharing music with others.

> After I went to Ethnos I started to work in a Chilean record label of world music. So even my work was related to world music so it was great. Now, I no longer work there but world music still really present in my daily life.
> I started using more elements of folk in my music. Ornamentations from Sweden, for example, and other things. I started listening to other culture and music.
> I had to unlearn a lot of those inhibitions in the business that came with being a classically trained musician, for example, but also, you know, what does it mean to share music and what is the right way to do or how can I expand my understanding of normal.

Transformation at a personal level was reported with a particular focus on life-long music learning.

> The impact is very personal, but the input is very rich […] I think it can have a big musical impact […] in terms of the arrangements, in terms of direction, in terms of collective creative work, tools, to get tools from the different traditional music, […] it's really rich in musical terms. In social terms, I think it can have a huge impact […] to change dramatically, to open a door for a wider way of looking at music […] it's a project that opens internal spaces for internal personal projects. […], I think it becomes a very intense and transformational personal experience.

Personal transformation was also reported within a wider frame: through participation in Ethno some individuals had changed the course of their lives, including developing expansive versions of possible future selves and moving to regions of the world where they had Ethno networks.

> It really changed my life in a way. I'm living now in the place where I first went to Ethno.
> And it changed my life in the way of daily routine and how do I live, because I met another way of living, I mean: keep it simple […]. I really learned a different way of living – more healthy, not so stressful, it's what I really learned […] and this changed immediately in my life. I came from Ethno and my life was completely different. I wanted other things.
> Today I think it [Ethno experiences] influence[s] a lot everything I do and my way of seeing music and my way of seeing the approach to the people through music; or my way of traveling, or my way of making friends, it's very important.

Ethno was also considered to have changed perceptions around group dynamics and facilitating social connection.

> You kind of have to think about the way you're communicating with people all the time.
> It changed how I think about bringing people together. And, like I've just learned so much from the organizer's perspective of what it's like to try to bring a group of people together who virtually don't know each other and help them try to connect and try to support each other.

The following case study demonstrates the sense of transformative experience that flowed from an Ethno encounter, encompassing all six stages of developing a musical possible self. The participant described discovering (an initial experience of Ethno), thinking and reflecting (taking stock of challenges and thinking about how to resolve them), imagining (researching and evaluating options), growing (continuing to train, engaging in further education), and finally, performing (being a professional musician).

> I was studying I think I was very unhappy and was very tough. And then for two or three year, I was really remembering Ethno as something very positive [...] So I started to look up courses to change my subject of study. And I was also very encouraged to train vocally more, play guitar, keep on doing it. And, and then I changed my college degree and I moved to a different city to study world music, to understand the music from an anthropological, like from a deeper view, because here we see the people, we see the music, we see a story [...] So, for me [Ethno] completely changed my whole life. The reason I live in [country] is because of Ethno and the reason I work so musician, is because of Ethno.

To summarize this section on realizing musical possible selves, Ethno experiences emerged as salient in facilitating professional and personal transformations through processes of reflecting upon possible responses to musical and social challenges and growing in confidence, self-knowledge, and transferable skills. Musical possible selves could be performed when participants became integrated into a network of relationships centred upon the intercultural exchange of folk music traditions and when they put into practice facets of personal and professional development that they had discovered, imagined, and thought about in and through Ethno.

Conclusion

Returning to the first research question concerned with the structures developed and reinforced by Ethno that supported the personal and professional development

of participants, our research suggested that Ethno gatherings functioned as spaces for personal and musical learning, and for the creation of professional networks. These two areas of development emerged as interlinked, leading to shaping or re-shaping the participants' musical identities. For example, Ethno had reportedly supported lifelong engagement in music-making and musical development. The motivation to continue as a lifelong learner in music was attributed in part to the feeling of recognition and personal value derived from Ethno. This motivation was also perceived to have fostered deeper self-knowledge as well as life skills that could be transferable to other contexts. In addition, Ethno offered structures, such as a strong professional musical network, which had led to online musical collaborations or to travelling to other countries for musical collaborations with other participants. During the pandemic, these networks were in some cases sustained with ad hoc activities within an online environment. At the same time, Ethno offered structures for the development of personal networks, whereby through social media, participants stayed in touch with one another after a gathering had finished, or they joined the Ethno community in their own country. What is more, leadership skills that focused on teamwork, collaboration, and consensus-building were particularly important facets of professional development within Ethno. In some countries, links and partnerships had been forged within the wider context of music education, offering training and workshops with the aim of embedding an 'Ethno approach' within wider contexts.

The practices that emerged as transformational within the context of Ethno (second research question), underpinned by a change in the way that Ethno participants thought about music and communication, included developing a rich musical repertoire with tunes from different countries; getting ideas about ways of arranging this music for diverse groups; jamming; and improvising. These creative activities inspired some participants to explore learning new instruments, different styles of music, and some others to even forge connections with the international folk scene. Finally, organizers identified training needs for Ethno leaders, which included developing specific musical or social skills beyond those provided 'in house' through Ethnofonik.

In addressing both questions, we framed our analysis and discussion with the theory of musical possible selves (Creech et al., 2020), referring to discovering or rediscovering musical self-stories or musical 'personal projects' through a transformational process that included thinking and using imagination, exploration, reflection, growing and developing one's musical skills and networks, and finally 'performing' a previously imagined musical possible self. Salience and elaboration, two core features of possible selves (King & Hicks, 2007; Leondari, 2007; Rossiter, 2007) underpinned participants' motivations for joining Ethno gatherings and events. For many participants, pedagogical practices, such as learning by

ear, peer learning, and self-directed, situated learning, were personally meaningful (salience). In addition, intercultural learning experienced through 'authentic' musical repertoire and approaches for learning it, facilitated by workshop leaders as culture bearers of their traditions, provided unique opportunities for making personal sense of experiential learning, and for personalized in-depth knowledge of the skills and attitudes required to develop musical identities as performers, educators, and/ or lifelong learners in music (elaboration). Participants reported that personal and professional development were expansive processes, requiring moving beyond one's comfort zone. This process of reimagining musical possible selves involved the development of transferable personal qualities (e.g. self-knowledge; self-confidence; self-belief) as well as expansive musical skills that included improvisation, arranging, and songwriting. Ethno participants often reconceptualized who they were as musicians through the varied musical and social practices they had experienced. For example, they noted the positive implications of Ethno gatherings for their musical skills, including arranging music and demonstrating musical leadership. Ethno gatherings also functioned, for some (but not all) participants as a context where professional networks could emerge. Overall, Ethno offered young musicians the scope to reimagine themselves in music, in an environment where they learnt or relearnt to love music and where they developed deep understandings of the role of music and musical networks in their lives.

An interesting and potentially useful observation that emerged from our research, which could support Ethno in envisioning future training and recruitment structures that are more accessible and inclusive, was the findings that some participants talked about 'finding Ethno' via serendipitous events. For instance, when questioned about how they had come to be involved with Ethno, participants described stumbling across Ethno by being 'in the right place at the right time'. Three of our interviewees reported the following:

> It was totally by accident.
> I was traveling in Europe; I heard some musicians busking [...] I ended up chatting to them and they were like oh we've just finished this thing called Ethno and I was like 'so, what is this?' [...] And then got roped into going [...] and then it kind of spiralled from there.
> I was, you know, very intrigued I would say, and I said yes and of course I was always open up for some new musical adventure so I went to Ethno [location ...] in [year] little knowing that nearly 20 years later I would be working at [position] of the same project.

Therefore, the question arises as to whether Ethno tends to attract individuals with the qualities deemed to be important at Ethno, such as openness to new experience,

readiness to learn, a sense of community and preparedness to trust, or whether these salient professional qualities (Creech, 2014) were fostered by Ethno. This observation raises further questions related to inclusion and approaches to publicising and promoting Ethno, so that it can become an accessible and inclusive site for transformative life experiences in and through music for more young people.

REFERENCES

Čorić, A. (2024). Ethno camps: Possibilities for meaningful collaborations across the formal and non-formal continuum. In M. Hahn, C. Björk, & H. Westerlund (Eds.), *Mastering collaboration – New professionalism in 21st century music schools*. Routledge.

Creech, A. (2014). Understanding professionalism: Transitions and the contemporary professional musician. In I. Papageorgi & G. Welch (Eds.). *Advanced musical performance: Investigations in higher education learning* (pp. 349–364). Ashgate.

Creech, A., Hallam, S., Varvarigou, M., & McQueen, H. (2014). *Active ageing with music*. IoE Press.

Creech, A., Varvarigou, M., & Hallam, S. (2020). *Contexts for music learning and participation: Developing and sustaining musical possible selves*. Palgrave Macmillan.

Creech, A., Varvarigou, M. Lorenzino, L., & Čorić, A. (2021). *Ethno: Pedagogy and professional development – Final report*. McGill University, Montreal.

Cross, S., & Markus, H. (1991). Possible selves across the life span. *Human Development*, 34, 230-255.

De Bonte, M., & Dokuzović, L. (2015). *Being an artistic leader: Ethnofonik 2015 report* [Unpublished]. Paris: Alors On Le Fait (AOLF).

Ellström, L. (2016). *Ethno: Using borders as bridges* [Unpublished master's thesis]. Malmö Academy of Music.

Erikson, M. G. (2007). The meaning of the future: Toward a more specific definition of possible selves. *Review of General Psychology*, 11(4), 348.

Freer, P. K. (2009). 'I'll sing with my buddies': Fostering the possible selves of male choral singers. *International Journal of Music Education*, 27(4), 341–355. https://doi.org/10.1177/0255761409345918

Freer, P. K. (2010). Two decades of research on possible selves and the 'missing males' problem in choral music. *International Journal of Music Education*, 28(1), 17–30.

Gayraud, E. G. M. (2016). *Towards an ethnography of a culturally eclectic music scene: Preserving and transforming folk music in twenty-first century England* [Unpublished Ph.D. thesis]. Durham University. http://etheses.dur.ac.uk/11598/

Hargreaves, D., & Lamont, A. (2017). *The psychology of music development*. Cambridge University Press.

Heron, J. (1999). *The complete facilitator's handbook*. Kogan Page Ltd.

Johns, C. (2013). *Becoming a reflective practitioner* (4th ed.). John Wiley & Sons Ltd.

King, L., & Hicks, J. (2007). Lost and found possible selves: Goals, development and well-being. *New Directions for Adult and Continuing Education, 114*(Summer), 27–37.

Leondari, A. (2007). Future time perspective, possible selves and academic achievement. *New Directions for Adult and Continuing Education, 114*(Summer), 17–26.

Mantie, R., & Risk, L. (2020). *Framing Ethno World: Intercultural music exchange, tradition and globalization.* York St John University. https://www.ethnoresearch.org/wp-content/uploads/2020/06/Ethno-Research-condensed-Framing-report-.pdf

Markus, H., & Nurius, P. (1986). Possible selves. *American Psychologist, 41*(9), 954–969.

Roosioja, L. (2018). *An ethnographic exploration of the phenomenon behind the international success of Ethno* [Unpublished master's thesis]. Estonian Academy of Music and Theatre.

Rossiter, M. (2007). Possible selves: An adult education perspective. *New Directions for Adult & Continuing Education, 2007*(114), 5–15.

Smilde, R. (2018). Community engagement and lifelong learning. In B.-L. Bartleet & L. Higgings (Eds.), *The Oxford handbook of community music* (pp. 673–692). Oxford University Press.

Smith, J., & Freund, A. M. (2002). The dynamics of possible selves in old age. *The Journals of Gerontology Series B: Psychological Sciences and Social Sciences, 57*(6), 492–500.

Spring, J. (2016). The power of metaphor in rural music education research. *Action for Change in Music Education, 15*(4), 76–103.

Varvarigou, M., & Creech, A. (2021). Transformational models of music learning. In A. Creech, D. Hodges, & S. Hallam (Eds.), *Routledge handbook of music psychology in education and the community across the lifecourse* (pp. 169–184). Routledge.

5

Marvelling at the Ethnoverse: Intercultural Learning through Traditional Music[1]

Roger Mantie and Pedro Tironi

> *It's like through music I know you better [...] [W]e come from different parts of the world and we share something with each other.*
>
> (Interview #19070)

In this chapter, we examine intercultural learning as it occurs at a series of music camps operating under JM International (formerly Jeunesses Musicales International), one of the largest youth music non-governmental organizations in the world. Known as 'Ethnos', these 'gatherings' now operate, at the time of writing, in 42 countries across the globe. Typically seven to fourteen days in length and limited to young musicians (usually ages 16–30, with anywhere from 20 to 100 at each gathering), these independently operated gatherings follow a format where each attendee brings a piece of 'folk' or 'traditional' music they teach to the other attendees in the first days of the meeting. In subsequent days, the source tunes from the attendees are then arranged either by the participants or by the facilitators, known as 'artistic mentors', in preparation for a culminating performance.

Six values of the programme are espoused on the Ethno World website (early 2022): preserve/conserve cultural heritage; embrace diversity; promote non-formal music education; facilitate the mobility of young musicians; create a democratic space; and build confidence in young people. These values speak to a desire for the Ethno programme to function as a site for intercultural youth development that celebrates and promotes cultural diversity through travel, music, and shared learning experiences. The current pedagogical process requires that participants

share music from a country, preferably their place of origin. This suggests an assumption that (a) culture is isomorphic with national boundaries, (b) nations are culturally homogenous, and (c) the 'culture' of attendees is representative of their national place of origin.

The JMI website describes the Ethno programme thusly:

> At the core of Ethno is its democratic peer-to-peer learning approach whereby young people teach each other the music from their countries and cultures. It is a non-formal pedagogy that has been developed over the past 32 years and embraces the principles of intercultural dialogue and understanding.
>
> (JM International, n.d., para. 3)

The values and aims of Ethno World are aspirational, leaning towards utopian ideals. A former iteration of the Ethno World website, for example, offered the following assertion about Ethno gatherings: 'This unique process of learning and teaching common goals creates lasting connections based on respect for each other's music, culture and values. It is a microcosm of an ideal society, where everyone feels supported and heard' (Ethno, n.d., n.pag.).

The first Ethno gathering occurred in Sweden in 1990, in conjunction with the Falun Folk Festival. The focus of the music camps for the first dozen years, which included only Sweden, Macedonia, Estonia, and Flanders, was primarily on promoting the value and professionalism of traditional folk music for young people. Today, however, the Ethno World website states, the Ethno programme 'has evolved into an entire ecosystem of Ethno-related activities' (Ethno, n.d., n.pag.). Importantly, the evolution has included a focus on intercultural music exchange.

The Ethno programme's emphasis on intercultural dialogue and understanding is consistent with the operating ethos of its parent organization, JMI. Founded in 1945 on the heels of the Second World War, JMI reflected widespread hope for a world with less ethnic nationalism of the kind that fuelled the war in Europe. Headquartered in Brussels, the original name of Jeunesses Musicales International was meant to reflect an equivalency between the colonial languages of French, Spanish, and English. The early JMI vocabulary of national 'delegates', 'General Assemblies', and a leader known as the 'Secretary-General' could also be viewed as emulating a post-war, UN-style organization aiming for international peace and cooperation. The inclusion of the Ethno programme as part of its activities in 2000 can be viewed as a logical expansion of JMI's mission. Although the emphasis on 'traditional' music in the Ethno programme represents a departure from JMI's original focus on classical music, it is consistent with its evolving relationship with

UNESCO and its efforts with respect to cultural democracy and cultural preservation (see The World Heritage Convention Section; WHC, 2012). It is also consistent with an ongoing desire to foster peace and harmony in a world that became increasingly interconnected throughout the 1970s and 1980s.

The chapter sets out to compare the espoused and enacted goals of the Ethno World programme with respect to intercultural dialogue and understanding. Specifically, this chapter examines the extent to which Ethno organizers and *artistic mentors* – the term Ethno World now uses to describe those hired as music facilitators for Ethno gatherings – introduce and/or facilitate discussions of intercultural issues and the extent to which they feel obligated or responsible to do so. The chapter draws on (a) a post-hoc analysis of interviews ($N = 114$) of Ethno participants conducted by members of Ethno Research, 2019–21; notably, each interview is associated with thorough socio-demographic and background data; (b) additional interviews ($N = 14$) of Ethno organizers and artistic mentors conducted in spring 2021 by members of the Arts and Culture research team of Ethno Research; and (c) the first author's attendance as a participant-observer at Ethno France in February 2020.

Theoretical considerations

Arjun Appadurai's influential essay, 'Disjuncture and difference in the global cultural economy', was published in 1990, the same year as the first Ethno gathering. Beyond this timely coincidence, 'Disjuncture and difference' provides ideas highly salient to understanding the emergence and development of Ethno World. Invoking the phenomenon of deterritorialization, whereby the breakdown of place-based stability of culture and ethnicity accelerated in the 1980s, Appadurai writes,

> because of the disjunctive and unstable interplay of commerce, media, national policies and consumer fantasies, ethnicity, once a genie contained in the bottle of some sort of locality (however large) has now become a global force, forever slipping in and through the cracks between states and borders.
>
> (1990, p. 306)

In his essay, Appadurai sketches out what he calls 'five dimensions of global cultural flow': *ethnoscapes, mediascapes, technoscapes, financescapes*, and *ideoscapes* (1990, p. 296). Most salient of Appadurai's five 'scapes' for present purposes is the ethnoscape, which he defines as 'the landscape of persons who

constitute the shifting world in which we live' (1990, p. 297). As Chun (2012) summarizes:

> From Appadurai's description of ethnoscapes, it is clear that mobile groups and populations are now an essential or staple feature of societies everywhere, and that these ever-evolving communities and transient, hybrid, and transnational imaginations that epitomize such lifestyles and identities were engendered by underlying disjunctures that have given birth to all other scapes and linked them functionally in a [...] borderless world.
>
> (p. 1).

The idea of a 'borderless world' (Ōmae, 1990; Bauder, 2018) is fascinating when juxtaposed against the format of the Ethno programme, which appears to lean towards a borderless, universal humanity (akin to the 'global village') while simultaneously celebrating difference predicated upon the logic of the nation state. By virtue of their travels and intercultural interactions with people from dozens of countries at each gathering, Ethno attendees can be viewed as an embodiment of Appadurai's ethnoscape.

The borderless world of the ethnoscape also conjures up notions of *cosmopolitanism*. Although Ethno attendees are not necessarily cosmopolitans of the clichéd jet-setting variety, many of them attend multiple Ethno gatherings, often on different continents, volitionally pursuing intercultural experiences. Ethno World's simultaneous celebration of cultural diversity rooted in nationality *and* universal humanity that transcends national borders is arguably the epitome of what cosmopolitanism is claimed by its proponents to be about. Cosmopolitanism theorist Kwame Appiah writes, '[c]osmopolitanism imagines a world in which people and novels and music and films and philosophies travel between places where they are understood differently, because people are different and welcome to their difference' (2010, p. 231). Appiah points out, however, that 'cosmopolitanism poses a congeries of paradoxes' (2010, p. 196). Indeed, in the eyes of some, cosmopolitanism is simply another version of western imperialism – 'liberalism on safari', as Appiah puts it (2010, p. 196).

For Appiah, conflating difference and disagreement is a mistake based on the presumption of 'the cognitive option of agreement' (2010, p. 229).[2] The discourse of European interculturalism, however, assumes that misunderstandings produce conflict, and that *knowledge* (intercultural dialogue, cultural competence) represents the solution. Ignorance produces disagreement; awareness (i.e. knowledge, enlightenment) produces agreement. In the context of Ethno gatherings, intercultural music exchange is presented as one possible solution to the problem of cultural conflict.

Beyond stating that their gatherings promote a 'peer-to-peer learning approach', Ethno World does not explicitly offer a theorized statement on how intercultural music exchange achieves intercultural peace and understanding. One way

of theorizing Ethno's intercultural claims and activities is with Allport's (1954) 'contact hypothesis', also known as intergroup contact theory. According to intergroup contact theory, 'interpersonal contact is an effective method to reduce prejudice: if majority group members have the opportunity to communicate with minority group members, they are able to understand and appreciate them, and prejudice will diminish' (Bertrand & Duflo, 2017, p. 365). This is particularly the case – as it is with Ethno gatherings – when the groups 'share similar status, interests, and tasks and when the situation fosters personal, intimate intergroup contact' (Pettigrew & Tropp, 2006, p. 752).

Importantly, the effects of intergroup contact 'typically generalize beyond participants in the immediate contact situation', favourably impacting the attitudes of participants not only towards other participants, but also towards 'the entire outgroup, outgroup members in other situations, and even outgroups not involved in the contact' (Pettigrew & Tropp, 2006, p. 766). Some research on contact theory, for example, investigates outcomes of imagined contact, i.e. an imagined interaction with someone from an outside group, and describes 'significant reductions in bias […even] in studies which gave participants little or no detail [about the imagined interaction]' (Miles & Crisp, 2014, p. 18). In the case of Ethno gatherings, musical repertoires may function as potential catalysts of imagined contact. In addition, the value of the global network of friendships generated by Ethno should not be overlooked, as 'long-term close relationships' optimize the positive benefits of intergroup contact more than do 'initial acquaintanceship' (Pettigrew, 1998, p. 76).

Analysis

The post-hoc interviews ($N = 114$) from 2019 to 2021 were analysed by five members of the Arts and Culture Team of Ethno Research using the collaborative research programme, Dedoose – an online platform that allowed the qualitative interview data to be analysed alongside the quantitative data produced by the Ethno Research socio-demographic questionnaire. The multi-stage coding process began with a team discussion on the implicit and explicit theoretical bases of the original Ethno Research interview protocols. The team then analysed the case studies produced by Ethno Research as part of its first-year research efforts. These discussions produced a codebook with nine categories consisting of 29 analytic codes. The team then conducted a first round of coding, with team members coding five interviews each. These original coded interviews were independently re-analysed by another member of the team. A subsequent team meeting discussed issues of inter-rater reliability, clarifying interpretations of codes and the

use of double codes where warranted. Finally, the team engaged in a process that analysed codes according to multiple categories of quantitative data (e.g. nationality, educational background, number of Ethno camps attended, etc.).

The post-hoc interview analysis generated a set of questions intended to generate clarifications and deepening of understanding on several key issues specific to Ethno organizers and artistic mentors. A stratified convenience sampling method generated fourteen names (six organizers, four artistic mentors, four who had acted in both roles). Four members of the Arts and Culture Team interviewed two to four people each based on a common interview protocol. Four of the interviews were conducted in Spanish. Interviews were subsequently transcribed, translated, shared, coded, and discussed. Aspects of the analysis related to themes beyond the focus of this chapter are reported elsewhere in this volume (Risk & Manson-Curry, this volume).

The co-authors of this chapter focused on issues specific to interculturalism and intercultural music exchange in light of the espoused and enacted values of Ethno World. Three themes are reported here: intergroup contact, artistic mentors, and culture as political. Interviews are reported using ID numbers rather than pseudonyms to circumvent the possibility of identification or connotations due to culturally specific names. The master codebook of interview ID numbers was managed by Ethno Research.

Intergroup contact at Ethno

Intergroup contact was mentioned in many interviews (e.g. 'the more Estonians I get to know the more I want to go there because it's such an intense, interesting culture' [Interview #20057]). As one interviewee explained, '[t]hrough Ethno, you can learn so much. Not just the music – also the culture and all the traditions that are there' (Interview #20153). Another attendee was emphatic about the life-changing nature of the Ethno experience:

> Ethnos really opened my view – my brain – and I now have another vision of the world [...] more tolerant, respectful, knowledge of new cultures [...] I think it has changed my life in that way – in having curiosity of knowing why people do the things the way they do, in the different languages or ways to express things. It was really wonderful.
>
> (Interview #20076)

Several interviewees drew attention to how the Ethno structure shapes cultural perceptions and opinions by having people 'become so curious about each other. It is not the case that Ethno is a course in other cultures; it is more the case that it

evokes a feeling of sympathy and a desire to find out more' (Interview #20139). The immediacy of intergroup contact at Ethno gatherings was celebrated by some organizers and artistic mentors because of the embodied and interactive nature of knowledge:

> If you're interested in the culture, you have the people to ask, because usually you go to the Internet to look up something. But the Internet is not like a real person from that country. And I think Ethno is the best Google, in a way.
>
> (Interview #19083)

Conceptualizations of intergroup encounter ranged from curiosity to confrontation. One interviewee, for example, suggested that 'the power of Ethno' derives from being placed in a forced situation: 'It can make people learn other cultures, which is for some people also extremely important because they're so drowned in their own stuff [...] It's necessary that some people open their mind' (Interview #20148). Another interviewee offered that Ethno gatherings often represent a challenge for many first-time Ethno attendees unaccustomed to intercultural contact.

> I think it's probably the first time that many of these young people get to know new music, and music from all over the world – which is quite strange sometimes. Because we all come from a background in one way. Either we come from jazz, or pop, or rock, or maybe even folk – Swedish folk, or Americana, or whatever. But to face another style, to face another culture [...] It's really, really hard.
>
> (Interview #20153)

The interviewee above describes the encounter as face-to-face, where a person must react or respond to the other. Several others, however, invoked metaphors of Ethno as a doorway or window, where intergroup contact is more self-reflective. One artistic mentor explained that Ethno is

> really about broadening the perspective [...] The music tells something about the environment or the language tells how people think, and when you can open the door for that then it feels like it's easier to understand different kinds of thinking.
>
> (Interview #20041)

Another artistic mentor was a bit more circumspect, stating: 'You won't learn a lot about Indian tradition, about Mongolian tradition, about Swedish tradition. But you will get an insight, like a window is opened' (Interview #20021).

Artistic mentors

Gateway metaphors of doors and windows raise questions about expertise, authority, and authenticity with respect to socio-cultural musical practices. To what extent is the window really transparent or to what extent does the window really look onto the practice in question, for example? To what extent are any of the actors involved in a position to make authoritative (i.e. knowledge) judgements on such matters? An important starting place for many artistic mentors is the shared understanding that Ethno gatherings do not function as sites for learning or perpetuating folk/traditional/world musics in the way many other folk/traditional music camps do. As an organizer explained, attendees do not arrive under false pretenses of musical authenticity: 'People don't come here to learn to play folk music. They know that' (Interview #19009). Similarly, an artistic mentor stated that, 'Ethno is not about learning traditional music. It's about traditional musicians that meet each other' (Interview #20022). The analysis of the Ethno Research interview corpus reveals a general consensus that participants arrive with an understanding that traditional musics function as the premise of Ethno gatherings, but that the repertoire shared by individual attendees is authentic by virtue of their nationality and is not mistakenly viewed as musical offerings by traditional culture bearers.

Many of the artistic mentors expressed similar views on how they approached the musical challenge of mediating gatherings with people from disparate cultures. These similarities may be due in part to their attendance at Ethnofonik, an annual training event for artistic mentors, and to the developmental system whereby artistic mentors are typically 'apprenticed' into their roles. Artistic mentors often described themselves as functioning as a kind of mediator or arbitrator (though typically as translating non-western musics for a western audience):

> I play the role of translator [...] The most important task of the leader is to translate – not always like spoken language, but the music traditions. Because we are talking about musicians that don't belong to the West European traditions. So you have to translate their traditions to the way of learning that the rest of you are used to.
> (Interview #19085)

Despite the prevailing view among participants that music serves as a universal medium for intercultural dialogue and exchange, experienced artistic mentors recognized that their intervention was sometimes required to avoid conflict.

> [There are times when] you need some guidance, especially when the music is totally different from the one that you have learned. But still, you can guide it without any

> translation or words needed. You just need somebody who knows the tips of teaching or, you know, a policeman.
>
> (Interview #21015)

The artistic mentor approach to intervention can be viewed as central to the success of the Ethno concept. Rather than anticipating musical or cultural fidelity or authenticity, Ethno attendees almost always arrive with the expectation that the repertoire they share will serve as the raw material for creative arrangements intended to celebrate the intercultural spirit of Ethno. This necessitates a kind of detached playfulness that invites alternative perspectives. The key to successful intercultural music exchange, explained one artistic mentor, is respect.

> As long as I approach a tradition with respect, I have the right to do with it whatever I want. As long as I try to learn about how it should be played [...] I play a lot of West African instruments in Balkan music and it can fit very well [...] As long as it is respected, I can play with it.
>
> (Interview #20021)

Curiously, however, the playful approach to treating disparate repertoire as raw material inevitably ends up in musical arrangements that exhibit homogeneity. As one artistic mentor described it, '[i]t's making all these tunes and traditions blend into this one thing [...] Anything that goes through Ethno and comes out of Ethno – there's this Ethno sound' (Interview #20044).

Although the ostensible goal of Ethno gatherings is to work towards a culminating concert, some artistic mentors and organizers pointed out that an important criterion of a successful Ethno gathering was not the quality of the musical performance, but whether or not participants were having a good time: 'It's a camp for young adults [...] It has to be fun', observed one artistic mentor (Interview #20044). The artistic mentor role thus often blurs the line between musical facilitator and social convener/camp counsellor. Artistic mentors, for example, often lead evening social activities and other warm-ups and ice-breakers. Artistic mentors are thus responsible for ensuring both musical and social enjoyment. As one artistic mentor explained, 'artistic leaders are paid to have a good group dynamic [...] The role of the leader is fifty percent group dynamic and fifty percent musical skills' (Interview #20044).

Based on the ongoing expansion of the Ethno World programme, it would appear that creating and sustaining a good group dynamic occurs more often than not – something directly attributable to the effectiveness of artistic mentors in mediating socio-cultural matters. The challenge of negotiating differences, however, varies according to the intercultural makeup of each gathering. Socio-cultural

differences mentioned in interviews were sometimes quotidian, such as a report of Chinese participants who were unaccustomed to communal showers in dormitories in Sweden (Interview #20153), but were sometimes deep-seated and potentially volatile: 'If there are people both from Israel and from Arab countries, for example, it needs to be considered in some way' (Interview #20139). The potential for socio-cultural conflict is arguably embedded in Ethno's *raison d'être*; intercultural gatherings invariably entail a risk-reward condition, something evident in the words of one experienced organizer and artistic mentor: 'We have been really lucky about this, so no big issues between different countries or participants [...] This is something that I'm afraid of every year' (Interview #21015). In the opinion of another artistic mentor, however, conflict often represents an opportunity, not a problem. Any time you 'encounter a rub [i.e., when there's conflict], that's when you learn things' (Interview #20044).

Avoiding/embracing the political

We actually had, spontaneously, really big, big group conversations about gender issues and sexism in traditional music.
(Interview #20041)

Facilitated discussions of intercultural issues within planned activity time have not been part of Ethno gatherings to date. The example above represents one of the only reports of explicit discussions related to intercultural dialogue and understanding. In this case, artistic mentors shared two prevailing feelings about, what they understood as, a lack of explicit attention to non-music cultural issues. The first was that the time pressure to prepare a high-quality culminating performance militates against spending time on anything other than the music (e.g. 'Ethno is just a scramble to learn the tunes' [Interview #20044]; 'We had planned [to have conversations], but it didn't actually eventuate because we didn't have enough time' [Interview #21013]). The second was the belief that such discussions are largely unnecessary because intercultural harmony occurs in and through the music. As one artistic mentor stated, '[w]e do not have Ethno just for people to learn about other cultures and create peace on earth [...] Of course we want that to be the case, [but] we have really focused on the music' (Interview #20139). Another echoed this sentiment, explaining, '[T]his is a good environment for [intercultural conversations] to happen, but it's not about them, actually. It should be about the music, you know' (Interview #20025).

Arguably, there is merit in letting music-making organically guide the intercultural process. Attendees arrive with the understanding that an Ethno gathering is primarily a music event that will be intercultural by virtue of the participants; it is

not an intercultural learning gathering with some add-on music activities. At the same time, many participants (including artistic mentors and organizers) seemed to believe that music-making could be divorced from issues of power. They went out of their way to dissociate Ethno from what they perceived as 'politics'. As one artistic mentor stated, 'Ethno is totally non-political, non-religious, non-nothing, except music. And it's totally open' (Interview #20153). Another was even more emphatic in attempting to distinguish what was perceived as Ethno's principle of all-inclusive interculturalism from the perceived divisiveness of politics.

> Is there a political aspect? No! Politics always ruin things. I don't want to have a sticker on Ethno. It doesn't need to be people from right or left, poor or rich; diversity is important. Everyone should be here. In other countries where political freedom is not as easy to acquire, it might create difficulties with the inclusion if there is a political stamp on the Ethno concept.
>
> (Interview #19082)

Invoking the word *politics* (as synonymous with political parties) rather than *political* can be viewed as a rhetorical strategy used by some interviewees in order to maintain the perceived 'purity' or innocence of the Ethno environment. Other participants (including artistic mentors and organizers), however, recognized that issues of culture are necessarily political insofar as they involve perpetuating values, mores, and practices (e.g. 'For me, I think Ethno is political' [Interview #20141]; 'I've always been very vocal about how I think Ethno is an incredibly political project. And a very important one at that' [Interview #20089]). One artistic mentor shared an example from Ethnofonik where someone from Sweden objected to a tune being taught that had a dance with traditional gendered male/female roles, suggesting that Ethno should not support gendered hierarchies. The person teaching the tune countered, 'This is my culture; this is the tradition' (Interview #20044). Another interviewee provided a realistic assessment: 'Is Ethno political? Yes! Ethno is a ritual. The component of diversity also implies a component of hierarchy. It becomes political when you mix people with different cultural histories and different economic backgrounds' (Interview #19091).

Discussion

> *You have people from very different countries. I remember my first year there were some girls from Cyprus and from Turkey. And somehow they came with [their] countries' conflicts. Yes. So on the first days, they were in conflict [...] And of course, throughout the camp*

> *that disappeared. That faded away [...] The girls who came from Cyprus, when they go home, they don't have the same idea about the Turkish people [... After Ethno] I'm getting along with people from countries I know nothing about [...] I get more curious about their culture and the other way around.*
>
> (Interview #19032)

Like many intercultural exchange programmes, Ethnos are carefully designed temporal events. As one organizer/artistic mentor observed: 'Does it make you bond? Yes, very deeply. Yes, very fast, also. But it's also a little bit artificial, I think' (Interview #20148). The regular references to 'the Ethno bubble' in the interviews make clear that at least some participants are conscious of the artificial nature of Ethno gatherings. Despite the utopian imaginary of peace and harmony expressed by most Ethno attendees and the underlying belief that traditional musical repertoire can be adapted as long as it is done respectfully, the reciprocal give-and-take during an Ethno camp occasionally gives rise to moments where the inevitability of limits becomes apparent.

> For example, someone wanted to go out on stage dressed in a Palestinian flag. And we're like, 'Well, that's not really okay'. But at the same time, we talk about countries and like, where do you draw the line? You just have to keep on discussing it, I think.
>
> (Interview #20141)

As evident in this organizer's comment, culture is always already political. This is exposed, to varying degrees, at Ethno gatherings where attendees must grapple with the many antinomies inherent within notions of interculturalism, such as the presumption that cultures are stable and unchanging, that one's culture is defined by state citizenship, that nationalities are culturally homogenous, that one should be expected to identify with the culture associated with one's passport, that all cultures operate on an equal plane, and that all cultural conflicts can be resolved through knowledge (i.e. understanding).

By their nature, Ethno gatherings involve individuals predisposed to the espoused values of Ethno World. As one interviewee explained about the kind of people who attend Ethno: 'I think it's more that folk musicians in general are a specific kind of person and those people who go to Ethno are folk musicians' (Interview #19095). It may be questionable to suggest that all folk-traditional musicians are a specific kind of person, however. A more likely explanation is that Ethno attendees are people with pre-requisite musical skills (i.e. applicants are vetted to ensure sufficient musical competency) who share (a) a general affinity for or openness toward folk musics, *and* (b) a desire for intercultural experiences.[3] By creating the conditions for like-minded individuals to come together in an environment suspended from

everyday life (i.e. 'the Ethno bubble'), Ethno organizers and artistic mentors catalyse opportunities that allow attendees to confront the ambiguity and complexity of intercultural learning experiences, even if those who attend are already so inclined.

Dialogue, understanding, and loyalty

The European tradition of 'intercultural competence', understood as a problem of knowledge in relation to the norm of European experience (i.e. 'Global Westerners, local others'), appears to provide the basis for Ethno World's conception of intercultural dialogue and understanding. The interviews revealed differences between those seeking 'intercultural experiences' (most of whom hailed from Global North countries), and those seeking networking opportunities that might open doors to professional advancement (most of whom hailed from Global South countries). Although this suggests a slightly more transactional approach on the part of Global South participants – this is not to suggest a lower commitment to the universalist ideals of Ethno World.

One of the intriguing issues raised by the analysis – and the Ethno World programme in general – is the extent to which sameness and difference affect loyalty commitments. As Appiah (2010) points out, there are many collective identities that connect us to strangers. In the case of Ethno, affinities are immediately present by a shared interest not just in 'music' – which is hardly distinctive to Ethno gatherings – but by a shared interest in the importance of folk-traditional music understood as a marker of cultural identity. Unlike forms of codified nationalistic traditional/folk music practices as found in conservatories or revivalist movements (see 'Framing Ethno World'), however, Ethno's fluid approach to folk music traditions, whereby nation-based source material is the starting point for musical explorations and dialogue, serves to problematize loyalty commitments. *Am I loyal to unaltered fidelity of my national identity expressed through music or loyal to how the folk music of my country can be played with as part of a global dialogue and commitment?*

The Ethno format lands squarely on the side of loyalty to universalism, where national cultures are recognized but not reified. This resonates strongly with Appiah's idealized version of cosmopolitanism:

> The cosmopolitanism I want to defend is not the name for a dialogue among static closed cultures, each of which is internally homogenous and different from all the others; not a celebration of the beauty of a collection of closed boxes.
>
> (2010, p. 229)

While the 'Ethno sound' provides evidence of the willingness to treat culture as open and dynamic (rather than a collection of closed boxes), many interviews

also reveal that participants see this openness as de facto evidence of a universal human nature. On this point, Appiah urges caution:

> I want to suggest that there was something wrong with the original picture of how [intercultural] dialogue should be grounded. It was based on the idea that we must find points of agreement at the level of principle: here is human nature; here is what human nature dictates. What we learn from efforts at actual intercultural dialogue – what we learn from travel, but also from poems or novels or films from other places – is that we can identify points of agreement that are much more local and contingent than this.
>
> (2010, p. 227)

This is not to suggest that all Ethno participants share the same conception of human nature or that Ethno participants fail to grasp the points of agreement that are local or contingent. Rather, it is to acknowledge the ambiguities in Ethno World's approach to intercultural exchange – ones that can be viewed as both a strength and a weakness.

Hands on or hands off?

Ethno gatherings seek to promote intercultural dialogue and understanding through its facilitated music-making and social activities. It is therefore unsurprising that analyses of the research interviews reveal that very few artistic mentors or organizers stated that they facilitated organized discussions of cultural issues. Artistic mentors regard their primary responsibility as preparing a high-quality culminating performance while maintaining social harmony amongst attendees (i.e. a good 'group dynamic'). The pressure to create arrangements considered both culturally respectful and creative (the ubiquitous 'Ethno sound') within the limited timeframe of the gathering means that artistic mentors generally feel that explicit discussions of cultural difference are unnecessary if not counterproductive to the aims of the gathering. In the eyes of the artistic mentors, the goal is to make good music, not to explicitly discuss intercultural issues – even though cultural differences are omnipresent due to attendees hailing from diverse countries.

That Ethno gatherings do not typically include planned discussions of intercultural issues does not mean that intercultural dialogue and understanding are not achieved. Many interviews support the view that Ethno is successful in achieving feelings of global peace and harmony amongst attendees. The presumption amongst participants is that such discussions take place informally as attendees learn each other's music, share living quarters and meals, socialize, and so on.

Intercultural experiences for everyone?

Unsurprisingly, participants are unequivocal in expressing the value of the Ethno experience. As one interviewee remarked, '[a]ny peaceful interaction between cultures and improving communication between cultures […] is crucial to improving humanity's understanding' (Interview #19033). She added, however, that interactions need to be more encompassing to truly fulfil intercultural aims: 'I would want to see more people from marginalized communities so it doesn't turn into something that only people who have studied folk music or music at university go to'. Herein lies but one example of the many tensions inherent in the intercultural aims and aspirations of the Ethno programme.

Ethno attendees are determined not just by their proclivity for intercultural experiences, but by their level of socio-economic privilege and cultural capital. Ethno fees vary from camp to camp, but are, by most standards, affordable. International travel is not, however, thus limiting the potential pool of applicants. Moreover, while being self-taught may be more common in the folk world than the classical music world, where years of intensive training in one's youth often requires substantial financial means to afford lessons (and often, expensive high-quality instruments), almost all instrumental music-making involves a financial investment of some kind and typically includes at least some formal study. The development of executive skills in music requires a kind of dedication often dependent on things such as stable home support, adequate time and space to practice, opportunities to learn from and interact with other musicians, and so on. Given the screening application process, where attendance is generally limited to those with proficient, if not advanced musical abilities, Ethno attendees, by definition, do not represent an average cross-section of society. While many Ethno attendees would not necessarily be classified as wealthy, an analysis of the socio-demographic data compiled by the Ethno Research team reveals that (a) the majority have university degrees, (b) many have studied music formally, and (c) members from the Global North far exceed those from the Global South. It is also worth noting that English is the lingua franca for Ethno gatherings, thus limiting attendance to those with functional fluency in English.

Assessing intercultural exchange in the Ethnoverse

The JMI Ethno programme has operated for over thirty years, a period that has witnessed massive changes in almost all facets of human life on the planet. The globalized ethnoscape has morphed and evolved in ways Appadurai could never have anticipated. The internet, in particular, has created previously impossible virtual

relationships and, quite literally, brought the cultures of the world to our fingertips. As Appiah (2010) argues, however, interconnectedness has not automatically resulted in the portended and much romanticized global village. The actors and contexts may be different, but cultural conflict is as present today as it was in 1990.

It is not entirely surprising, then, that the Ethno programme has experienced substantial growth in the number of Ethno camps operating worldwide over the past five to ten years. If anything, politically right-wing nationalist movements developing in the 2010's have tamped the optimism surrounding the promises of late-twentieth-, early-twenty-first-century liberal cosmopolitanism. Even if the mid-twentieth-century European model of intercultural peace and harmony seems quaint or anachronistic, the need for direct intergroup contact is arguably as strong today as it was in 1990.

One question this study raises is whether the proclaimed achievement of intercultural peace and harmony at Ethno gatherings is simply a reification of the European tradition of interculturalism, where cultural difference is reduced to an apolitical 'knowledge' problem. That songs are sung in Portuguese or Arabic, for example, often appears to be taken as sufficient for claiming intercultural experiences. While it might be unrealistic to expect Ethno gatherings to tackle the challenge of epistemological difference, it is potentially problematic to proclaim deep intercultural understanding on the basis of music-making alone. Difficult culture-bound topics, such as race, gender, class, sexuality, or disability inequalities, issues of consent, or even the comparative realities of living in countries outside the Global North, are rarely, if ever addressed at Ethno gatherings. As one organizer put it,

> What does it mean for someone Indigenous growing up on a reservation in New Mexico to 'give away this song for free' to 30 people? What does that mean for someone [whose culture] has been pillaged culturally for hundreds of years? Maybe they don't want to give their song to me. Maybe that's not fun [for them].
> (Interview #20045)

The interviews suggest a general lack of criticality or self-reflexivity regarding cultural difference or disagreement. Ethno World repeatedly strives for what is sometimes referred to as *ambiguity aversion* (or *uncertainty avoidance*), whereby the organizations values are presented and celebrated as unproblematically good at all times.

As discussed in this chapter, many participants believe strongly in the goals of intercultural exchange at Ethno camps, and believe the gatherings are successful in meeting these goals. Expressed feelings of intercultural peace and understanding are hardly surprising. Ethno involves intergroup contact among self-selected attendees of similar ages and interests that are drawn from multiple countries with diverse cultural backgrounds. The perceived success of Ethno gatherings is

thus attributable more to the catalysing conditions than any theorized method or approach. Arguably, what Ethno World offers intergroup contact theory is an example of how 'intercultural' success in breaking down stereotypes and negative assumptions may be dependent upon the mode or mechanism of interaction. Music's ubiquity as a cultural practice makes it exceptionally powerful as a form of interaction with the potential for mediating intercultural differences.

Thanks to a large grant from Margaret Cargill Philanthropies in 2019, JMI has been able to undertake several initiatives to support the ever-expanding 'Ethnoverse'. In addition to sponsoring independent research (such as the studies reported in this volume), Ethno World was also able to create the Ethno Mobility programme (which increases access to Ethno gatherings by supporting need-based applicants), support the creation of Ethno USA, create an annual training for organizers, and invest in organizational support for the Ethno programme. Although the COVID-19 pandemic slowed the rapid expansion of the Ethnoverse that occurred *c.*2010–20, the findings reported in this volume suggest that Ethno World will, more likely than not, resume its upward trajectory post-pandemic. Based on the research conducted to date, it is difficult to determine the future long-term impact of the intercultural goals of the Ethno programme – something that would require more in-depth longitudinal research. The picture that emerges of the short-term impact, however, seems clear: despite their innumerable conceptual difficulties and contradictions, Ethno gatherings leave most participants with positive feelings about intercultural peace and harmony. That this may be due to the predisposition of participants and the capacity of music to facilitate dialogue rather than to any explicit or concerted efforts on the part of organizers or artistic mentors does not discount the immense value and potential of the Ethno programme.

ACKNOWLEDGEMENTS

The authors express their thanks to all those who participated in Ethno Research interviews. They also express their thanks to Laura Risk, Keegan Manson-Curry, Jason Li, and Alison DeGroot for their participation on the Arts and Culture Team. This chapter would not be possible without their contributions.

NOTES

1. Parts of this chapter appear, in different form and function, in 'The complexities of intercultural music exchange' (de Groot et al., 2022), a research report produced for Ethno Research. This chapter is also informed by a white paper produced for Ethno Research: 'Framing Ethno-World: Intercultural music exchange, tradition, and globalization' (Mantie & Risk, 2020).

2. To make his point, Appiah jokingly writes, 'You will have few disagreements with your cat' (2010, p. 228).
3. As evident from ethnographic studies and a participant survey conducted by Ethno Research, attendees vary in their musical backgrounds and interests. Some are quite invested as folk/traditional musicians whereas others have eclectic backgrounds and only a passing familiarity with folk or traditional musics.

REFERENCES

Allport, G. W. (1954). *The nature of prejudice*. Addison-Wesley Pub. Co.

Appadurai, A. (1990). Disjuncture and difference in the global cultural economy. *Theory, Culture & Society, 7*(2–3), 295–310. https://doi.org/10.1177/026327690007002017

Appiah, K. A. (2010). *The ethics of identity*. Princeton University Press.

Bauder, H. (2018). Imagining a borderless world. In A. Paasi, E. K. Prokkola, J. Saarinen, & K. Zimmerbauer (Eds.), *Borderless worlds for whom? Ethics, moralities and mobilities* (pp. 37–48). Routledge. https://doi.org/10.4324/9780429427817-3

Bertrand, M., & Duflo, E. (2017). Chapter 8: Field experiments on discrimination. In A. V. Banerjee & E. Duflo (Eds.), *Handbook of field experiments* (Vol. 1, pp. 309–393). North-Holland. https://doi.org/10.1016/bs.hefe.2016.08.004

Chun, A. (2012). Ethnoscapes. In G. Ritzer (Ed.), *The Wiley-Blackwell encyclopedia of globalization*. Blackwell Publishing Ltd. https://doi.org/10.1002/9780470670590

de Groot, A., Li, J., Manson-Curry, K., Risk, L., Tironi, P., & Mantie, R. (2022). The complexities of intercultural music exchange. Ethno Research. 21 June. https://www.ethnoresearch.org/publication/the-complexities-of-intercultural-music-exchange/

Ethno. (n.d.). About. Accessed 1 May 2020, from https://ethno.world/about/

JM International. (n.d.). Ethno. Accessed 5 February 2024, from https://jmi.net/programs/ethno

Mantie, R., & Risk. L. (2020). *Framing ethno world: Intercultural music exchange, tradition, and globalization*. York St John University.

Miles, E., & Crisp, R. J. (2014). A meta-analytic test of the imagined contact hypothesis. *Group Processes & Intergroup Relations, 17*(1), 3–26. https://doi.org/10.1177/1368430213510573

Pettigrew, T. (1998). Intergroup contact theory. *Annual Review of Psychology, 49*, 65–85. https://doi.org/10.1146/annurev.psych.49.1.65

Pettigrew, T., & Tropp, L. R. (2006). A meta-analytic test of intergroup contact theory. *Journal of Personality and Social Psychology, 90*(5), 751–783. https://doi.org/10.1037/0022-3514.90.5.751

Ōmae, K. (1990). *The borderless world: Power and strategy in the interlinked economy*. Harper Business.

World Heritage Centre (WHC). (2012). *Operational guidelines for the implementation of the World Heritage Convention*. July. https://whc.unesco.org/archive/opguide12-en.pdf

6

Carbon Footprints and Intercultural Exchange: Ethno as Sustainable Practice

Sarah-Jane Gibson

The COVID-19 pandemic resulted in restrictions on international travel and the gathering of large groups of people. These restrictions highlighted the fragility of the globalized world and provided a possible vision of the future should there be further global catastrophes (Manzanedo and Manning, 2020). As a result, no international organization should be ignorant of the impact of global catastrophe, particularly if their sustainability is reliant on international connections.

Ethno aims to 'revive, invigorate and disseminate global traditional musical heritage and to promote ideals such as peace, tolerance and understanding' (Ethno World, n.d., n.pag.). The organization encourages participation by both local and international musicians with initiatives such as the Ethno Mobility programme, which is a scholarship that covers the expenses of travel, visas, and participation fees at an Ethno gathering (Mubazar, 2022). This reliance on international travel may impact the sustainability of the programme, particularly considering the COVID-19 pandemic restrictions. Central to the arguments in this chapter are Ethno's values of preserving and conserving cultural heritage and facilitating the mobility of young musicians. I consider how Ethno can sustain these values and goals during a climate emergency.[1]

Writing about the connections between Ethno and the climate emergency means facing contradictions and exploring their impact on one another. Restricting international travel prevents the opportunity for global connections at a time when the world needs to unite over a global environmental crisis.[2] As well as considering the sustainability of Ethno during a climate emergency, I also argue that international gatherings for young people could be seen as vital to ecological justice by providing a connection between the local and the global. Ethno demonstrates the

connection between local and global as a music programme that meets in various localities around the world. Each locality shapes the music-making of the programme, connecting international musicians with the situated issues and music of the locality and global ideas and concerns. As a Youth music programme, Ethno can hold the space for exploration and reflection of the relationship between local and global, building vital connections that may be essential to peaceful interactions in future environmental catastrophes.

This research relates to academic discourse on the connection between the sustainability of the environment and music cultures. I focus on the tension between maintaining international collaborations and the impact this has on climate change. In line with Tsing (2005), I argue that such 'frictions' can provide a valuable impetus for social change. My literature review explores the connections between sustainable music cultures and the environment; the environment and the COVID-19 pandemic; and ecological justice, local musicking, and international travel. I shall then use three ethnographic examples as a demonstration of how Ethno could remain sustainable in a climate emergency: through the incorporation of immigrant communities into their programme; the inclusion of local Indigenous musical cultures, and through online programmes and events. These examples reveal how the Ethno organization fulfils their values and goals when one aspect of their 'ecosystem' – international travel – is unable to function. I then reflect on 'the other side of the coin' by considering the connections between ecological justice, local musicking, and international travel.

Methodology

This is a hybrid ethnography as the research has been influenced by both a digital and physical environment (Przybyslki, 2021). Online ethnographic fieldwork occurred between April 2020 and May 2021. This fieldwork was influenced by my understandings and experience of offline fieldwork at Ethno England (2019), Ethno Sweden (2019), and Ethno New Zealand (2020). I had also met all my online participants (except for one) in offline contexts, either at the aforementioned Ethno gatherings or at the December 2019 Ethno Committee meeting in Paris.

The online ethnographic fieldwork comprised participant observation of nine Hope Sessions (Session 1; 2; 10; 12; 20; 21; 25; 26); fourteen online interviews; and data gathered from Ethno World's Facebook and YouTube page. The online programmes that were analysed were the Hope Sessions (April–June 2020); the Ethno USA Exchange Sessions (August–October 2020); and Ethno Chile (February–May 2021).

Offline ethnographic fieldwork occurred at three Ethno gatherings: England (May 2019); Sweden (July 2019); and New Zealand (January 2020). Fieldwork in Sweden and New Zealand comprised participant observation at the entire gathering with follow-up interviews conducted online. Participation at Ethno England was observation only of two workshop sessions and attendance at one meal. I conducted one follow-up interview with an organizer of Ethno England.

Interview transcripts, field notes, and online data were analysed using NVIVO quantitative analysis software. Data were analysed using thematic coding techniques and findings were discussed with the Ethno Committee and their Environment working group for further feedback. Participants names have been anonymized and nationalities have been changed where it may be possible to identify the participant due to their national identity.

My experiences during fieldwork at Ethno New Zealand had a profound effect on my personal and professional attitudes towards ecological justice. I recognize the irony of this as it was a field trip that was high in carbon emissions, underpinning my privileged position as a white academic living and working in the United Kingdom. My fieldwork in Ethno New Zealand was also sharply contrasted with the ensuing lockdown due to the COVID-19 pandemic, which may have impacted my positionality surrounding ecological justice and international travel.

Literature

Sustainable music cultures

Schippers and Grant (2016) developed a framework demonstrating how elements within a music culture are interconnected, noting that a change in an element of practice can impact the sustainability of a musical culture. The term 'sustainability' refers to 'the condition under which music genres can thrive, evolve and survive' (Schippers, 2016, p. 7). The sustainability of music cultures relates to concerns over preserving forms of musical expression 'which are at risk due to a range of circumstances beyond their control' (Schippers, 2015, p. 138). Schippers and Grant's research also suggests that music cultures adapt to changing environments and can benefit from them by offering opportunities for the recontexualization of a practice (Schippers, 2015, p. 137; Schippers & Grant, 2016). This has been evident in Ethno's own adaptation to online activities because of COVID-19 restrictions and a resultant deeper understanding of the programme's aims and values (Gibson & Higgins, 2021).

Critiques of the ecological framework of music cultures focus on the lack of inclusion of the 'relationships to environmental crises and the non-human and

abiotic contexts that are fundamental to ecological science' (Allen, 2018, p. 5). Interestingly, Titon's (2015) historical outline of the development of understandings of the conservation of music cultures in ethnomusicology follow a similar line to that of the generation of folk music revivalists of which the founder of Ethno, Magnus Bäckström, belong. In recent years, a new generation of folk musician, such as the current Ethno Sweden organizer, Erik Rask, considers writing about climate change an essential part of their music output (Campfire stories, 2022). There is a call for a similar shift in ethnomusicology. Allen argues 'we may study music and sound in human context, but notable exceptions notwithstanding, we still have not expanded well enough to the planetary, non-human, and abiotic contexts that make human context possible' (2018, p. 5). He continues by distinguishing between weak and strong sustainability discourse, arguing that the former does not consider the planet, whilst the latter includes relationships between 'human societies and non-human life, inanimate environment and natural resources' (Allen, 2017, p. 403). Ethnomusicologists need to draw the natural environment into the elements that comprise the model for sustainable cultural practices. As Grant argues 'the protection and rehabilitation of diverse natural ecosystems can bolster efforts to preserve and revitalise cultural diversity. Conversely, strategies that foster cultural diversity can encourage and stimulate biodiversity' (2012b, p. 158).

Considering music ecologies and the environment

It is within research into Indigenous music-making that ethnomusicology moves beyond using ecological terms as a framework to specific examples of the dependency of music cultures upon their natural environment[3] (Dirksen, 2018; Grant, 2012, 2019; Harrison, 2020, Ramnarine, 2013). This is often due to Indigenous music cultures' direct engagement with the environment through musical expression. In some instances, research highlights a loss of music culture due to changes in the environment. Impey (2018), for example, notes the loss of certain songs in the borderlands of Southern Africa because women are no longer able access the land where the songs were sung. In contrast, Grant (2019) explains how *Etëtung* music is created using water and is now being used to advocate on the impact the climate emergency is having on the Vanuatu community. In earlier research, Grant provides specific examples of UNESCO driven projects to maintain Indigenous language in order safeguard a communities 'intimate knowledge of their natural environment' (2012b, p. 156). These examples demonstrate both how Indigenous communities are losing musical heritage due to the climate emergency and how Indigenous music can be used to respond to it. Harrison cautions, however, that we need to be aware of 'manipulating Indigenous knowledge for non-Indigenous

benefit, a trend of the colonial period' (2020, p. 31). This awareness is evident within Ethno New Zealand and their process of designing an Ethno gathering that is respectful of the Maori cultural framework.

The climate emergency and COVID-19

The climate emergency refers to major concerns over global warming and a rising temperature of the earth's core. One of the leading factors in this rise in temperature is carbon emissions. Air travel accounts for 2 per cent of carbon emissions; however as emissions are emitted at altitude they have around 2.7 times the warming impact of other emissions (Grant, 2018). Aviation also emits other gases aside from CO_2 that contribute towards global warming and not all aviation is covered by climate policies, such as military flights (Gössling & Humpe, 2020). Furthermore, only a small percentage of the world population travel by air (Grant, 2018; Gössling & Humpe, 2020; O'Garra & Fouquet, 2022).

Air transport studies suggest that there are 'highly skewed distributions' of air travel with households in higher income brackets producing more transport emissions than those in lower income brackets. These 'high emitters' are 'geographically located in a few countries' (Gössling & Humpe, 2020, p. 9). Gössling and Humpe's (2020) analysis suggests that in a given year approximately 90 per cent of the world's population does not fly. Of those who do fly, 11–26.5 per cent report one trip a year. Frequent flyers, however, report 300 trips per year. Gössling and Humpe's data suggest that 'halving the flight activity of the percentile of the most frequent fliers would reduce emissions from commercial passenger transport by more than 25%' (2020, p. 10) and argue for a need for better aviation climate governance.

What the expenditure of carbon emissions reveal is an imbalance that relates to power and wealth (Grant, 2018). The literature highlights a gross imbalance regarding which portion of the population is contributing towards carbon emissions. This imbalance towards the wealthiest and most powerful highlights the need for advocacy for whom is being given the privilege of air travel. For example, rather than reducing carbon emissions across Ethno, empowering people with smaller carbon footprints may be an approach that connects the climate crisis with social justice, supporting an ecological justice approach.

The climate emergency highlights the disproportionate effect environmental disasters have on the most vulnerable humans and non-humans in the world, such as the Indigenous communities, who are also the least responsible for climate change. Manzanedo and Manning emphasize that 'ensuring that the most vulnerable and unempowered are properly protected from the climate crisis consequences requires the early establishment of agreements, protections and policies that will

minimise social inequality when the crisis strikes' (2020, p. 1). The need to include environmental impact into decision-making 'alongside inclusivity, accessibility, cost and many others' is also emphasized by Grant (2018, p. 129). Ecological justice recognizes both social and environmental concerns, arguing for systemic change: change at the government and corporate level. Therefore, focusing purely on limiting universal air travel may defeat the broader purpose of ecological justice.

The relationship between sustainable development and the climate emergency is most notable with the COVID-19 pandemic that started in 2020. For example, the restrictions that arose due to COVID-19 severely impacted the sustainability of Ethno drawing attention to the vulnerability of a global music programme in an unstable world and highlighting the importance of considering the natural environment when reflecting on the sustainability of music-cultures. Sixteen out of the 23 gatherings scheduled for 2020 were cancelled or postponed, impacting the livelihood of Ethno organizers and artistic mentors and preventing members of the Ethno network connecting in their regular offline context.

Researchers suggest that the impact COVID-19 has had on society may provide some insight into what may happen in future climate emergencies (Manzanedo & Manning, 2020). Manzanedo and Manning argue for an early response to scientific calls for action to 'avert worst-case scenarios' (2020, pp. 2–3); they note a weakening of international solidarity as nations compete for 'the same limited resources' and argue for agreements to be put in place to 'decrease the chances of nationalistic policy responses, egotistic behaviour or political leaders prioritising powerful or wealthy individuals over the World's general population'. Findings such as these highlight the importance of maintaining empathy across international borders, taking preventative action to lessen the impact of climate changes, and the need for policies and protections to prevent social inequalities. COVID-19 did influence behaviour patterns regarding air travel (O'Garra & Fouquet, 2022). The reduction in air travel also slowed projected increases in carbon output for the sector (Gössling & Humpe, 2020). What remains is to see whether society will return to their previous behaviour patterns once travel restrictions are lifted.

Connecting the local and the global

Due to this discrepancy of access to air travel, advocating for air travel for people from under-represented sectors of society is important. There is an obvious tension between responding to the climate emergency and maintaining human connections, reminiscent of Tsing's use of the term 'friction'. She writes, 'friction reminds us that heterogenous and unequal encounters can lead to new arrangements of culture and power' (2005, p. 5). Or, as Hess reflects, '[c]oming face-to-face with the humanity of others, and imagining different possible futures position musicking as an

important contribution indeed' (2021, n.pag.). Rather than avoid uncomfortable tensions, opening doors to conversations that support intercultural exchange and the environment may lead to unexpected resolutions.

Ethnomusicology already recognizes the impact global decisions can have on local communities. Reily and Brucker reflect how 'the autonomy of the neighbourhood becomes progressively limited as external decisions reduce the space available for its inhabitants to orchestrate the production of their locality' (2018, p. 6). This is brought to greater attention when recognizing the global nature of environmental concerns. Tarrant and Lyons write,

> many environmental issues such as climate change, energy utilisation, ozone depletion, and biodiversity transcend national boundaries with effects distributed across the planet […]. As such, global citizens are not simply international by reason of their world travel but as a result of their environmental footprint – the quantity of nature required and consumed to sustain their lifestyle behaviours.
>
> (2012, p. 405)

Bithell brings local musicking and ecological justice together arguing,

> in a more connected world allegiance to a specific locality has been joined or even replaced by a sense of allegiance to the planet. In the discourse of today's big issues such as climate change it is the earth as a whole that needs saving and not just one small part of it. […] Singing songs from other parts of the world also bring a sense of connection with other lives and histories a sense of what it might be like to live in someone else's skin it may prompt some to reflect on their comparative privilege and rethink their values and priorities this is.
>
> (2018, p. 374)

The local and the global are inextricably connected in contemporary society. Supporting international networks between young musicians brings awareness of issues at a local level that then shifts to global awareness. Enabling connections between young like-minded musicians may allow for the impetus and change needed on a global scale to turn the direction that humanity is moving, relating directly to the United Nations agenda for sustainable development statement that 'there can be no sustainable development without peace and no peace without sustainable development' (United Nations, 2015, n.pag.).

The following ethnographic narratives provide some examples of how Ethno participants have engaged with the values of the programme. In the first narrative, Tammie explains how Ethno sparked curiosity in her cultural heritage. She was born in England but her family immigrated from Jordan. Her narrative responds

to how Ethno might engage with immigrant communities. Max, a Maori participant at Ethno New Zealand provides some insight into Indigenous musical practice and the Ethno programme. Finally, there is a reflection on the Ethno online events, and how they continued to sustain Ethno values and aims during the COVID-19 lockdown. Each of these ethnographic examples provide insight into how Ethno can be recontextualized according to the needs of their participants or in response to changes in global infrastructures such as air travel. I then focus on the option of advocating for international travel and subsequent musicking to maintain global connections.

Sustaining music cultures in immigrant communities

One of the Ethno organizers considered the options Ethno faces in light of the climate emergency. She reflected that the project could be achieved without 'anybody going anywhere if we just got better at reaching out to the migrant communities where we are' (Alice, Interview, 12 March 2020). Another Ethno organizer noted that Ethno is already asking participants to bring a song to share at a gathering, so 'people already people are thinking, what's my culture?' She continues by connecting this approach to Maori spirituality: 'Traditional musicians are playing the music of their ancestors, which is helping them to connect to who they are' (Jane, Interview, 19 January 2020). The following narrative is from an Ethno participant who reflects on how her continued participation at Ethno led her to explore the music of her mother's cultural heritage.

Tammie was attending her third Ethno when I met her. She explained that the first time she attended Ethno she taught a song in Swahili because she 'only really knew songs from Africa'. Through coming to Ethno, she realized she did not know anything about her heritage and became curious to know more. She knew she was Middle Eastern and Greek but did not know any music from those cultures. So, she asked her mom if she knew any songs in Arabic and her mum suggested a lullaby. Tammie learned the lullaby and taught it at the next Ethno she attended. She explained that she was nervous because she did not know much about the context of the song. But, when Ethno performed the song, 'it just felt so good. Everyone was singing in Arabic.'

At the end of that performance, some members of the audience who spoke Arabic came up to her afterwards, to thank her. One person asked who her teacher was. When Tammie explained that she did not have one, this person recommended someone. Tammie arranged some lessons and learned some more Arabic songs. She explained that it is important for her to do this because it is 'filling in lots of holes' and that she has discovered how 'natural it is to sing in that style. Something in

me really recognises it and responds and feels really good.' Tammie went further to explain that 'it's a deep connection to where I fit in in the world' because 'I'm British, but I'm not British. That's really obvious in the way that I feel and the stuff that I do.' She went on to reflect how, although her family did not talk about her heritage, it was because of a desire from them to fit in and not be different, rather being told 'she's not allowed to be different'. She continues,

> I think I'm more interested in singing Arabic music than English folk because it's more important at this time to spread a peaceful message about the Arab world and show that it's beautiful and gentle. It's got such a rich history of art and poetry. I think [Ethno] is such a good platform for people who are new to countries for that reason: to meet people and to play and to feel like they have a platform to share and express, because sometimes I think you can feel a bit not able.
> (Tammie, Interview, 20 January 2020)

I contacted Tammie for a follow-up interview and she shared how positively her uncle responded to a recording of her performance at Ethno. He began teaching her Arabic and they then began a conversation. She says 'it was really lovely because I've never actually connected with individuals in my family that way'. Tammie had planned a trip to Jordan, which was unfortunately cancelled due to COVID-19 restrictions. As part of the trip, she was planning on attending a workshop to learn a traditional flute that is being revived in the region. Tammie reflects 'none of that would have happened if it hadn't been for teaching that song and building my confidence and feeling like I had some claim and ownership of that part of my heritage' (Interview, 1 June 2020).

Tammie's narrative is one of a second generation of immigrant. She is a citizen of one country but has a cultural heritage from another. Her experience with Ethno empowered her delve deeper into her cultural heritage in a way that has strengthened her connections with her family and given her ownership of that aspect of her identity. When I met her, she had received a Mobility grant to attend the Ethno. She was emphatic in her gratitude for the programme, saying, 'I would just like to say from the bottom of my heart. Thank you. Because I'm so grateful it exists.'

Tammie's experience connects with Ethno's aims of 'reviving, invigorating and disseminating global traditional musical heritage' (Ethno World, n.d., n.pag.). Her initial experiences at Ethno triggered a curiosity to learn more about her own musical heritage. Subsequently, she invested in music lessons, thereby supporting the 'invigoration and revival' of her musical heritage. She now disseminates Arabic music at Ethno events. On a social level, Ethno connected Tammie's transnational identity as both British and Arabic. This is an area for further development within Ethno World but suggests an opportunity for the children of immigrants

to gain deeper understandings of their ancestral heritage and, in so doing, sustain those music cultures in transnational contexts. Furthermore, the development of a 'strong primary identity' is suggested as being an important element for the construction of successful multicultural societies (Kymlicka, 1995, p. 191; Folkestad, 2002). This may feed into the social values of Ethno in further buidling peace, tolerance and understanding between people.

Sustaining local cultural heritage

Fieldwork with Ethno revealed that the organization is good at promoting local music cultures. In most instances, the majority of Ethno participants will be from the hosting region.[4] In some instances, such as Ethno Chile, Ethno New Zealand, and Ethno Solomon Islands, Ethno has been able to also focus on drawing attention to local Indigenous cultures. As the earlier literature review revealed, tapping into these cultures can open awareness to the connection between culture and the environment; however, it also highlights the impact of colonization upon these communities. As Max, a Maori participant, shared:

> I think its hard to find top quality musicians and Maori musicians in New Zealand just because of the nature of colonial oppression and destruction. I mean, yesterday, we had a large talk on what a Marae is and it was very interesting, very factual, but the speakers did avoid talking about the past for obvious reasons. They just want to talk about the things that aren't problematic. But it is hard to avoid the fact that there are some obvious reasons that things here are the way they are because of things that happened in the past. I guess it's probably the same with any colonised Indigenous culture. Every tribal group had different things happen and it's all so fragmented and individual that one *Iwi* [tribal group], may have maintained the majority of the land and culture, but my main *Iwi* lost 100% of our land and pretty much all of our *taonga* [treasure], our treasures were either stolen or buried to stop people invading and taking them. Then the people got killed that had them or buried them, so it's hard not to be passionate about these things.
>
> (Interview, 18 January 2020)

Max is referring to a talk about the sculptures on the Marae that all Ethno participants had attended the previous day. For some local non-Maori participants this was the first time they had visited a Marae and been exposed to some of the cultural artefacts and their history. From Max's perspective, however, this talk avoided discussing the colonial legacy that resulted in the loss of much Maori cultural heritage. My conversations with Max over the course of Ethno New Zealand highlighted

the tensions with integrating Indigenous musical cultures with western culture. One of the Ethno organizers reflected on how they aim to allow Ethno New Zealand as a space for reviving Indigenous culture, explaining that 'the Indigenous experience is separate to bringing the multicultural thing together' (Interview, 19 January 2020). This is reflected in the sharing of Max's song. Max put together a piece about the dawn chorus of the birds. Ethno New Zealand performed this piece for the children from the day-care centre on the Marae. Max felt that it was:

> quite nice. It seemed like it was just the right way for it to be. I don't know how to put it better than that, but hopefully some kids nowadays can grow up with knowledge and experience about *Taonga Pūoro* [musical instruments] because I didn't find out about it until recently, maybe like a year and a half ago. But as soon as I picked up *Taonga Pūoro* it just feels different […] They seem to have such a connection to Aotearoa […] It feels like the Marae is their natural habitat.
> (Interview, 22 January 2020)

Max's comments reflect on the connection between the place and the way the musical instrument sounds, saying it feels like the *Taonga Pūoro* is in its natural habitat. The underlying connotations are of the loss of *taonga* from the marae. In this ethnographic account, Ethno provides a space for the revival and invigoration of a musical tradition, but one where the dissemination of the tradition is amongst the local population. In this example, it is the children from the local daycare who Max hopes will be able to engage more with Maori musical culture.

There is value in drawing Indigenous culture and experience into a programme such as Ethno. As demonstrated in this ethnographic account, Indigenous cultures are still suffering the effects of colonialism and to make too many demands for input on the global western-dominated stage risks further detriment and abuse of these communities (Harrison, 2020). Ethno New Zealand is an example of working within an Indigenous cultural framework rather than applying Indigenous cultural practices into western frameworks.

Grant writes,

> local approaches to supporting music vitality must take into account the specific situation at hand and develop (or choose not to develop) appropriate mechanisms according to the degree and causes of endangerment, the socio-economic and political circumstances, and the human, financial and material resources at hand.
> (2012, p. 46)

This is essential when drawing upon Indigenous musical cultures. Max's narrative reveals how much music culture has been lost and his strong desire to revive it

for the younger generations. He also notes how the music feels best situated and performed within its local context of New Zealand. All the values of Ethno, both musical (revive, invigorate, and disseminate global musical traditions) and social (peace, tolerance, and understanding) could occur within the local encounter when considering Indigenous musical practice.

Sustaining Ethno through online programmes

In response to the COVID-19 restrictions, members of the Ethno community created online programmes and events. The online projects comprised three types of activity: collaborations, podcasts, and workshops (Gibson, 2022). Collaborations were projects where members of the Ethno community created online music videos. The videos created the illusion of a group performing together in an online space; however, recordings were edited together rather than performed live. Podcasts comprised interviews with members of the Ethno network, either sharing their current professional music activities or reflecting on their experiences at past Ethno gatherings. Workshops were live sessions where members of the Ethno community taught folk songs to each other.

The online Ethno events provided deeper understandings of Ethno values and pedagogy due to organizers and mentors needing to assess what elements of Ethno were essential to include in an online environment. It also provided an opportunity to include new elements to the programme, such as more opportunity to learn about the cultural background to a piece and to allow bilingual workshops (Gibson, 2021, 2022; Gibson & Higgins, 2021). As one Ethno organizer explained, 'instead of replicating every experience, you replace them, or try to bring in different concepts' (Pablo, 26 April 2021, Interview). The workshops provided efficacy for the network by supporting their membership in learning new skills, such as how to present in an online setting (Gibson & Higgins, 2021).

The online setting also enabled more inclusive opportunities for the programme as the events were available without the need for international travel (Gibson, 2021; Gibson & Higgins, 2021). The accessibility of online gatherings is an important finding. It is already evident that international travel is difficult for musicians from the majority world due to either financial limitations or attaining visas (see Ethno Global report). Another limitation is the choice of using English during the gathering. Ethno Chile used the online platform to their advantage by using translator options. They invited a workshop leader from the Easter Island Rapa Nui who presented her session in Spanish with someone translating the session into English for the English speakers. The organizers of the event reflected that this would not have been possible at an offline gathering because few people from

the Easter Islands are able to speak 'perfect English' (Interview, 26 April 2021). Online events may be a more inclusive option than offline gatherings because they remove the barriers of expense, visa limitations, and language that come with international travel.

What also appears to have been important to the Ethno community, however, was that the online activities kept them connected during the 2020 lockdown. One of the organizers of Ethno Chile 'OnLive' highlighted the importance of connection through their online event: 'People felt accompanied with someone in another part of the world, living the same struggles and stresses of the pandemic. What was really special was that we could actually be connected' (Isabelle, 26 April 2021). This was also experienced during the Hope Sessions, where participants expressed feelings of connection when they saw people they knew from attending Ethno gatherings commenting in the 'chats' during the live workshops (Tara, Interview, 17 May 2020; Eliise, Interview, 29 May 2020).

Ethno online activities highlighted ways in which the community could maintain international connections when air travel was severely restricted. Musicians were able to disseminate their global traditions often with greater attention to the rudiments of their practice (Gibson & Higgins, 2021). However, Ethno participants also commented on it not being 'the same' as an offline gathering, expressing a desire for the contextual nature of being together in one space and collaborating on a musical performance (Rohan, Interview, 12 October 2020; Tara, Interview, 17 May 2020; Annya, Interview, 21 May 2020). Whilst it is possible to recontextualize Ethno, as these three ethnographic accounts reflect, how do offline Ethno's connect with ecological justice?

Maintaining connections

The three ethnographic narratives I have drawn upon for this chapter suggest ways in which Ethno can 'preserve and conserve cultural heritage' by considering how to integrate with local immigrant or Indigenous communities or present workshops where folk tunes from around the world are taught to an international audience. These are necessary considerations considering a climate emergency, however, what of Ethno's value of intercultural understanding? Alice, an organizer for Ethno England, reflects:

> As the climate emergency gets worse, the social problems are only going to get worse as well, especially if we have climate refugees coming from India or Africa to Europe because it is the only land that's inhabitable anymore. Then we're going to need to be welcoming and peaceful and less divided than we are now to cope with it. But

that really is only justifiable under the climate emergency if we're truly achieving intercultural understanding.

(Interview, 12 March 2020)

From her perspective, international travel is only justifiable if Ethno's aims of intercultural understanding are being achieved. Tammie felt this was a definite intention of Ethno, explaining:

The intention of Ethno for me is about intercultural dialogue. It's a dialogue in a sense of sharing music and taking it out into the wider community. But it's also a miniature training ground of how to talk to people, how to interact, how to share and how to watch, how to learn and how to listen. Then, I think that young people like me and others here can take those skills out into the wider world and use them in different contexts. And that's the most powerful tool for peace: communication and dialogue.

(Interview, 20 January 2020)

Tammie's understanding connects with Hess (2021, n.pag.) and her argument that '[s]eeing, recognising and honouring the humanity in all provides an impetus for change and change is what is needed to avert severe climate change'. Another Ethno participant considers how Ethno is not only a point for recognizing the humanity in all, but a place to connect and learn about how different communities are responding to issues such as the climate emergency, saying 'if you go to Ethnos, through the participants you can see the wider picture what is happening in other countries as well and how [...] the problems they face there, how they try to solve or do so generally' (Olivia, Interview, 27 April 2020).

Tied in with intercultural understanding is how this relates to music-making. Pedelty (2012, p. 183) suggests that music can be an important tool for environmental sustainability in that it integrates material and cultural environments, keeping ecological systems vital in the cultural imagination. Reily and Brucher (2018, p. 7) suggest that activities involving music have the potential to 'confer cohesion a group' relating clearly to Ethno participants' reflections on the feeling of 'togetherness' they experience during their final performances on stage (see the Ethno History report). They also argue that '[m]usicking has repeatedly been shown to be a rich setting for the investigation of connections and encounters between internal and external agents in localized settings' (Reily & Butcher, 2018, p. 9). Bithell extends the feeling of connection that is felt through performance to a sense of fulfilment for singers who are advocating for global concerns through their singing. She argues 'individuals and communities have already been empowered and transformed by the act of participation and by registering their dissent' (Reily & Butcher, 2018, p. 382). Furthermore she reinforces 'the fact that music makers across the world are

embracing these causes reinforces a sense transnational kinship' thus connecting the local and the global (Reily & Butcher, 2018, p. 380). Olivia notes this kinship with Ethno: 'It's also like a "breathing way" of escaping the reality but also it gives you strength to come back to this reality': 'The political and social climate of this crisis we are going through. So it also gives you strength' (Interview, 27 April 2020).

In terms of ecological justice, there is social value in advocating for the right for young musicians to connect through global music programmes. International travel that is inclusive and accessible could enable encounters that mobilize a collective effort to create the systemic change necessary to avert a more serious climate emergency.

Conclusion

In this chapter, I have discussed Ethno World in relation to environmental and cultural sustainability. Acknowledging both the sustainability of the environment and music cultures is now extremely relevant (Allen, 2017). Music cultures cannot be sustainable when a local environment is under threat. There are examples where music cultures bring awareness to the climate crisis therefore becoming actors in the fight for environmental justice, such as the Vanuatu women's water music (Grant, 2019). Indeed, Grant (2019, p. 43) argues that cultural practices may play an important role in adapting and mitigating climate change. Music cultures from Indigenous communities offer a particular lens for safeguarding the environment, but there is a caveat to how western culture approaches the usage of such musics because of the colonial legacy.

The sustainability of the Ethno gatherings has been impacted by environmental and socio-political circumstances around the world. Ethno's response to COVID-19 restrictions showed innovation and potential to remain sustainable through online programmes should there be more global lockdowns. Such stringent closures of borders limit how many international participants can attend an Ethno gathering. This situation can be mitigated by drawing on the immigrant population within each country. Such an endeavour enables the opportunity for reconnection with cultural heritage for the children of migrants, as the first narrative in this chapter explored.

The COVID-19 pandemic may be highlighting an issue of discrepancy between wealthier and poorer countries that was already apparent within the Ethno community when it came to the issue of visas for participants from regions within Africa and the Solomon Islands. There is, therefore, a strong argument to continue to support the international travel of participants from the majority world as an act of ecological justice. Air travel does emit high carbon emissions per individual. Based on the statistics what matters is not the collective amount of carbon emissions,

but the carbon footprint per individual (Gössling & Humpe, 2020). Thus, what matters is *who* is travelling and the extent of their annual carbon footprint.

The United Nations recognizes the need for intercultural understanding and dialogue, especially as climate change continues to impact the living patterns of humanity (United Nations, 2015). Programmes that encourage intercultural connection are therefore vital to support future generations. The Ethno gatherings I participated in moved beyond social connections towards an awareness of the environment due to the spaces they inhabit and some of the music cultures that joined the gatherings, such as the Sapmi (Ethno Sweden) and the Maori (Ethno New Zealand). Such malleability within the structure of the programme suggests great potential to support future intercultural understandings through music-making.

Grant (2019) postulates the role of ethnomusicologists at this time, particularly regarding the extent of international travel required both for fieldwork and dissemination of research. I believe ethnomusicologists can play a fundamental role in the advocacy for supporting international travel to enable mobility for younger generations. It is within those connections that unexpected resolutions to a global crisis could be devised (Tsing, 2005). A chapter such as this forces pause for thought. Whilst there is value in advocating for international travel for young musicians there must also be a recognition that humanity needs to act as stewards and caretakers of the world, both the natural environment and members of the global community who are already suffering from the effects of climate change. If an organization can see a way to fulfil their values and aims whilst also fighting for environmental justice, they need to do so.

ACKNOWLEDGEMENTS

I would like to thank the participants who agreed to be interviewed for this research project, for their insightful reflections and generosity with their time. I would also like to thank the gathering organizers and artistic mentors who were so welcoming during my participant observations.

NOTES

1. The full list of Ethno Values is available at http://www.ethno.world/about (accessed 17 January 2022).
2. Terminology, such as environmental justice, climate emergency, climate change, climate crisis, etc., has associations with differing environmental movements and are related to the motivations behind each campaign. 'Climate emergency' is a recent term relating to a consensus at the International Panel on Climate change that there are not many years left to prevent catastrophic climate change. It aims to motivate governmental policy towards

systemic change alternatives and is associated with activist campaigns such as Extinction Rebellion. The shift towards a 'stronger' use of language in recent years is to emphasize the environmental crisis (Carrington, 2019). For this chapter, I will be using the term climate emergency to highlight the need for political action to enforce systemic policy changes. I will also refer to ecological justice to emphasise how 'environmental degradation affects the most vulnerable first and worst' (Catherine Heinemeyer, personal communication).

3. For example, the Uluru-Kata Tjuta region in central Australia holds both environmental and cultural importance for the Aboriginal population (Grant, 2012b, p. 155); the *joiking* of the Sapmi is directly connecting to environmental spaces (Ramnarine, 2013); the songs of the women in the Limpopo borderlands are only sung on certain footpaths in the area (Impey, 2018) and the water-music of the Vanautu uses water as a form of musical expression (Grant, 2019).

4. About half the participants at Ethno Sweden and Ethno New Zealand were from those countries, for example.

REFERENCES

Allen, A. (2017). Sustainable futures for music cultures: An ecological perspective. *Ethnomusicology Forum, 26*(3), 400–405.

Allen, A. (2018). One ecology and many ecologies: The problem and opportunity of ecology for music and sound studies. *MUSICultures, 45*(1–2), 1–13.

Bithell, C. (2018). Local musicking for a global cause. In S. Reily & C. Brucher (Eds.) *The Routledge companion to study local musicking* (pp. 373–383). Routledge.

Campfire Stories. (2022). Kolonien: A documentary series. Episode 2. YouTube. Accessed 26 January 2022, from https://www.youtube.com/watch?v=9CFHnP_9T-w&list=LL&index=4&t=6s

Carrington, D. (2019). Why the Guardian is changing the language it uses about the environment. *The Guardian*. Accessed 24 January 2022, from https://www.theguardian.com/environment/2019/may/17/why-the-guardian-is-changing-the-language-it-uses-about-the-environment

Dirksen, R. (2018). Haiti, Singing for the land, sea and sky: Cultivating ecological metaphysics and environmental awareness through music. *MUSICultures, 45*(1–2), 112–135.

Ethno. (2021). Monitoring and evaluation matrix. Accessed 29 June 2021, from Google Document.

Ethno World. (n.d.). Info. Accessed 2 November 2019, from https://www.ethno-world.org/info

Folkestad, G. (2002). National identity and music. In R. Macdonald, D. Hargreaves, & D. Miell (Eds.), *Musical identities* (pp. 151–162). Oxford University Press.

Gibson, S.-J. (2021). Shifting from offline to online collaborative musicmaking, teaching and learning: Perceptions of Ethno artistic mentors. *Music Education Research, 23*(2), 151–166. https://doi.org/10.1080/14613808.2021.1904865

Gibson, S.-J. (2022). *Sustainability report*. York St John University.

Gibson, S.-J., & Higgins, L. (2021). The ethno hope sessions: Sustaining musical exchange during the COVID-19 pandemic. *Journal of Music, Health, and Wellbeing* (Autumn). https://storage.googleapis.com/wzukusers/user-20563976/documents/53a7fcbb353441a9b-67d09a4cfcf5bd4/Gibson%2C%20Higgins%20October2021.pdf

Gössling, S., & Humpe, A. (2020). The global scale, distribution and growth of aviation: Implications for climate change. *Global Environmental Change, 65*, 102194, ISSN 0959-3780. https://doi.org/10.1016/j.gloenvcha.2020.102194

Grant, C. (2012a). Rethinking safeguarding: Objections and responses to protecting and promoting endangered musical heritage. *Ethnomusicology Forum, 21*(1), 31–51.

Grant, C. (2012b). Analogies and links between cultural and biological diversity. *Journal of Cultural Heritage Management and Sustainable Development, 2*(2), 153–163.

Grant, C. (2018). Academic flying, climate change and ethnomusicology: Personal reflections on a professional problem. *Ethnomusicology Forum, 27*(2), 123–135.

Grant, C. (2019). Climate justice and cultural sustainability: The case of *Etëtung* (Vanautu women's water music). *The Asia Pacific Journal of Anthropology, 20*(1), 42–66. https://doi.org/10.1080/14442213.2018.1529194

Grant, C. (2022). Music sustainability, human rights, and future justice. In P. G. Kirchschlaeger, M. Nowak, J. Fifer, A. Allegrini, A. Impey, & G. Ulrich (Eds.), *Music and human rights*. Routledge.

Harrison, K. (2020). Indigenous music sustainability during climate change. *Current Opinion on Environmental Sustainability, 43*, 28–34. https://doi.org/10.1016/j.cosust.2020.01.003

Hess, J. (2021). Musicking a different possible future: The role of music in imagination. *Music Education Research, 23*(2), 270–285. https://doi.org/10.1080/14613808.2021.1893679

Impey, A. (2018). *Song walking: Women, music, and environmental justice in an African borderland*. University of Chicago Press.

JM International. (2020). Ethno: About. Accessed 17 January 2022, from www.ethno.world/about

Kymlicka, W. (1995). *Multicultural citizenship: A liberal theory of minority rights*. Clarendon Press.

Manzanedo, R., & Manning, P. (2020). COVID-19: Lessons for the climate change emergency. *Science of the Total Environment, 742*(140563), 1–4.

Mubazaar (2022) Ethno mobility grant. Accessed 31 January 2022, from http://www.mubazar.com/en/opportunity/ethno-mobility-2022

O'Garra, T., & Fouquet, R. (2022). Willingness to reduce travel consumption to support a low-carbon transition beyond COVID-19. *Ecological Economics, 193*(107927), 1–17.

Pedelty, M. (2012). *Ecomusicology: Rock, folk, and the environment*. Temple University Press.

Przybylski, L. (2021). *Hyrbid ethnography: On-line, off-line and in between*. SAGE Publications.

Ramnarine, T. (2013). 'In our Foremother's Arms': Goddesses, feminisms, and the politics of emotion in Sámi songs. In F. Magowan & W. Lousie (Eds.), *Performing gender, place and emotion in music: Global perspectives* (pp. 162–184). Boydell and Brewer.

Reily, S. A., & Brucher, K. (2018). Introduction. In S. A Reily & K. Brucher (Eds.), *The Routledge Companion to Study Local Musicking* (pp. 1–12). Routledge.

Schippers, H. (2015). Applied ethnomusicology and intangible cultural heritage: Understanding 'ecosystems of music' as a tool for sustainability. In S. Pettan & J. T. Titon (Eds.), *The Oxford handbook of applied ethnomusicology* (pp. 134–155). Oxford University Press.

Schippers, H. (2016). Sound futures. In Schippers & Grant (Eds.), *Sustainable futures for music cultures: An ecological perspective* (pp. 1–18). Oxford University Press.

Schippers, H. & Grant, C. (2016). Approaching music cultures as ecosystems. In Schippers & Grant (Eds.), *Sustainable futures for music cultures: An ecological perspective* (pp. 333–352). Oxford University Press.

Tarrant, M., & Lyons, K. (2012). The Effect of short-term educational travel programs on environmental citizenship. *Environmental Education Research*, 18(3), 403–416.

Titon, J. (2009). Music and sustainability: An ecological standpoint. *The World of Music*, 51(1), 119–137. https://www.jstor.org/stable/41699866

Titon, J. (2015). Sustainability, resilience and adaptive management for applied ethnomusicology. In S. Pettan & J. T. Titon (Eds.), *The Oxford handbook of applied ethnomusicology* (pp. 157–195). Oxford University Press.

Titon, J. (2018). Ecomusicology and the problems in ecology. *MUSICultures*, 45(1–2), 255–264.

Tsing, A. (2005). *Friction: An ethnography of global connection*. Princeton University Press.

United Nations. (2015). 2030 agenda for sustainable development. Accessed 29 July 2021, from https://www.un.org/sustainabledevelopment/development-agenda

7

Ethno Online: An Analysis of Social Media Engagement on Facebook

Roger Mantie

Facebook – yeah, that's happening and there are problems with that. But it's beautiful because it unites us and we get a common ground. We have Ethno Facebook pages and everybody has access to them. And then people gathered from all over the world and these things spread more. And that is like counter-colonialism as a result of colonialism.

(Interview #20061)

In this chapter, I explore Facebook engagement by those affiliated with the intercultural music exchange programme known as Ethno. Additional details on the Ethno programme, which operates globally under the auspices of JM International as Ethno World (JM International, n.d.), can be found in the Introduction to this volume, as can detail about the larger-scale programme of research conducted by the Ethno Research team. This study of Ethno-related Facebook pages and sites resulted from a conceptual framework paper produced for Ethno Research, 'Framing Ethno World: Intercultural music exchange, tradition, and globalization' (Mantie & Risk, 2020), which called for research into social media usage in the Ethno World community.

Discipline-specific examinations of social media (e.g. social network analysis) or language (e.g. speech acts, semantics, pragmatics, or sociolinguistics) were considered beyond the scope of this study. In short, the various Ethno-related Facebook pages and sites reported on here were examined in order to draw broad-based, general conclusions rather than apply *a priori* discipline-specific

theoretical frameworks. It should be noted that, with the exception of posts on the longer-standing Ethno World Facebook page, most of the analysed Ethno-related social media activity reported on here coincided with the onset of the COVID-19 pandemic. It is difficult to determine the extent to which social media behaviours were affected, and how behaviours might be different in the post-pandemic world. It should also be noted that the results presented here should be interpreted judiciously. As McCay-Peet and Quan-Haase caution, '[d]espite the plurality of voices on [platforms such as Facebook], scholarly work has consistently shown that social media only provides a narrow view of our social world, as not all social groups are equally represented' (2017, p. 14). It is, in other words, tempting to assume that everyone everywhere participates on Facebook in the same way, when in fact there remain many socio-economic and geopolitical disparities that must be considered, such as Global North-South internet access, language barriers, and so on. This is especially true with a population such as the Ethno community, which comprises individuals from numerous, culturally diverse countries.

The study

Given the wide range of meanings associated with the word 'ethno' – which includes such things as *ethnography* and *ethnomusicology* – it is not surprising that the #ethno hashtag (appearing over 4000 times on Facebook at time of writing) exceeds its usage within the Ethno community. For the purposes of this chapter, I restricted my approach to an introspective examination of Ethno-related social media. The analysis here focuses on three Facebook groups and one Facebook page. In total, 855 Facebook posts and their replies/reactions, from inception through 30 June 2021, were examined. Posts were drawn from Ethnopia ($n = 258$), Ethno Forever ($n = 90$), EthnoFest ($n = 30$), and Ethno World ($n = 477$).

Among the questions guiding the inquiry in this chapter are: *What is the nature and purpose of Ethno-related posting on Facebook?* and *What is the level of Ethno-related engagement on Facebook?* At times, the introspective analysis of postings involved exploring contextual issues, such as the explicit and implicit purposes of social networking and how Ethno participants perceive online interactions and virtual community building. As a caveat, I was conscious of Vitak's caution to researchers about how Facebook's algorithm shapes user experience, 'with small changes to the algorithm yielding large shifts in behavior' (2017, p. 633), and how the opaqueness of the algorithm results in a condition where 'researchers can only make educated guesses about individual users' experiences'. The analysis here should be interpreted in this light.

Ethical considerations

Unlike other academic research involving 'human subjects' that falls under institutional ethics board approvals based on such things as minimizing potential risk or harm, anonymity, confidentiality, and so on, online research raises complicated questions around ownership, privacy expectations, and what does or does not constitute 'human subjects' research. These questions are further complicated by platform-specific 'terms of service' requirements. Do the posters on social media own their content or does the hosting platform own it? Do Facebook users or other social networking users have an expectation of privacy when it is common knowledge (e.g. the Netflix docudrama, The Social Dilemma) that commercial entities regularly monitor and exploit their activity?

Scholarship in media studies (e.g. Beninger, 2017; Mancosu & Vegetti, 2020; Vitak, 2017) paints a picture of an evolving ethical field, with a complex interplay of legal and regulatory considerations. On the one hand, Vitak (2017) cautions that researchers should not automatically assume that social media content is fair game for collection and analysis because it is essentially 'public'. When it comes to Facebook specifically, Mancosu and Vegetti (2020) point out that, while unlikely in most cases, 'scraped' data can expose researchers to potential violations of the European Union's General Data Protection Regulation or the risk of being charged for violating Facebook's terms of service agreement. On the other hand, Beninger points out that '[consent] remains contentious amongst social media researchers and views change depending on the topic, website, and sample population one is working with' (2017, p. 58), and that '[m]ultiple judgements are possible, and ambiguity and uncertainty are part of the process. Research needs to be supported by an inductive and flexible approach to ethical thinking' (Beninger, 2017, p. 59).

For the purposes of this study, a conservative, measured stance was adopted. Following Beninger (2017), I paid particular attention to the nature of content (text, photos), sensitivity of content, user expectations, the nature of the research, and research purpose. The following items factored into the study's ethical considerations:

- The overarching purpose of Ethno Research was to explore its 30-year history; there were no commercial, marketing, or third-party motivations at play in this study.
- Ethno-related social networking sites are not 'friends and family' pages. Members are fully aware of their contexts and what Quinn and Papacharissi (2017) describe as 'Boundary Work and the Rules of Social Media Connection'. As Beninger observes, '[n]ow more than ever, users of social media are becoming aware of inherent risks of sharing their information online' (2017, p. 62).

- Representatives from JMI/Ethno World, including the administrator of the Facebook site, Ethno Forever, were aware that research on social networking sites was being conducted. The administrator of Ethnopia, a Facebook private group site, was interviewed by members of Ethno Research in 2020 and was aware of Ethno Research activities.
- The Ethno Research team was led by established university researchers intimately familiar with research ethics, including 'Internet Research: Ethical Guidelines 3.0' published by the Association of Internet Researchers.
- The Ethno community at large was aware of Ethno Research due to regular communications through multiple channels, multiple research survey invitations, the presence of researchers at multiple Ethno gatherings, and the conducting of over three hundred interviews (all of which required signing participant consent forms).

The foremost ethical consideration in this study was the minimizing of the potential for inadvertent risk or harm. While risk can never be eliminated in research, every step has been taken to try to ensure that, when identifications are necessary or unavoidable, the individuals in question have been informed and/or provided permission. In other cases, direct quotations have been paraphrased to minimize back-tracing identification.

Social media posting behaviours

Participants on social networking sites are typically thought to comprise creators, sharers, and observers. It is understandably easier to monitor and analyse the social networking behaviours of creators, and to a lesser extent sharers, than that of observers. It is thus difficult to ascertain the overall impact of Ethno-related social networking. Without additional research in the form of directed surveys or interviews, it is difficult to determine (without access to proprietary server/algorithm information) the extent to which the Ethno community pays attention to Ethno social media, for example. Analyses were thus restricted to observable posting and sharing behaviours.

One distinction made in the analysis was between informational and phatic communication. As evident, *informational* expressions (i.e. postings) include content intended to inform or to seek information (e.g. Does anyone have experience with Ethno mobility funding?). *Phatic* expressions, by contrast, are generally understood as 'small talk' aimed at fostering connections between speakers (e.g. I'm looking forward to the next time I meet you!). Some phatic expressions on social media, which Danica Radovanovic has labelled 'phatic posts' (see Radovanovic & Ragnedda, 2012), include such things as Facebook shares, 'likes', and emojis.

Analysis

Of the 114 research participants who completed an Ethno Research questionnaire soliciting extensive participant background information, 23 listed performing musician/artist as their primary source of income, and 19 others listed performing musician/artist as work that they had done in the past. As the 114 participants represent a convenience sample, it is unclear how representative this figure is for Ethno World attendance as a whole. If anything, self-selection motivations might suggest that those with a greater investment in professional careers in music and music-related fields may have been more likely than casual participants to complete the Ethno Research questionnaire. It seems probable, then, that professionally oriented musicians do not make up more than a third of Ethno attendees (though in absolute terms this may number in the hundreds, given the size of the Ethno World programme). This context is important for understanding the possible motivations for social networking engagement. There are clear differences between those who engage social networking platforms for the purposes of information-seeking, professional network development (i.e. 'Professional Facebooking'), and relational maintenance.

Information seeking (or sharing) took many forms on Facebook. Posts of this type often blurred the boundaries between information seeking/sharing and what is sometimes described as a 'professional learning community'. Some members posted resources or engaged in self-promotion, but others attempted to leverage 'collective intelligence' (known in some social networking circles as the 'hive mind'): 'Dear fellow Ethnopians, who can give me advice on universities that offer ethnomusicology courses for international (research) master students? Which ones are necessary to check out?' One notable example of an information-seeking post focused on an intercultural-related topic is discussed further below (Issue-Oriented Discussions on Facebook).

Directly or indirectly, Ethno gatherings have catalysed professional music activity. For the population of aspiring 'indie artists', Ethno social networking represents an invaluable resource for exposure and promotion. Likely due to their more advanced musical level and their commitment to the pursuit of careers in music, many of the participants making music-promotion posts were made by Ethno mentors (i.e. camp music facilitators). Posts seeking the support of professional artistic activities received relatively little reaction. One post advertising a recently completed album by a member of the Ethno community generated only nine 'likes', for example. Another participant who attempted to solicit crowd-funding support for a video project received only ten 'likes', one comment, and two shares.

There were also those who attempted to leverage the power of the affinity group for other professional or paraprofessional music-related purposes, such as this example:

> I am looking for someone who would like to start an Ethno tune learning program and take it to schools! The idea is to be an ambassador of traditional music and oral transmission.
>
> > deadline is March 30/ 2020
> >
> > anyone out there who would like to join and fits the criteria?
> >
> > let's spread the Ethno Virus
>
> [reply post:]
> Author
> > Dear all, I made a new group to collect songs and collaborate more!

In this example the poster created a separate group to continue the conversation. While this can be viewed as a respectful and pragmatic choice in not wanting to bloat the group page with a personal interest project, it can also be viewed as an important mechanism for exercising control over the interactions.

The third major genre of posts can be considered relational maintenance. One member, for example, posted, 'I haven't met you all […] but I love you all' – to which one person replied, '[t]his is a very Ethno post'. A more extensive example – one that solicited ten comments and 52 'likes' – was posted approximately a year into the pandemic:

> How is everyone doing?
>
> > I just felt like telling you that I am so grateful to have found you and this community 5 years ago.
> >
> > The way Ethno participants gift each other total acceptance and make each other feel welcome and included means more to me than you could know.
> >
> > Sometimes even more so than some of my real family …
> >
> > I can't wait for another chance to meet some of you again, or for the first time!
> >
> > I was having a bad day and thought I'd use this post for some digital soul healing!
> >
> > If anyone else has something that's heavy on their heart, feel free to share it here!
> >
> > I know it's not the same as a bunch of people crying together in a dark room during a sound bath but it will have to do for now 😊
> >
> > ♡ u guys an' gals.

Grassroots participation or administrative regulation?

The Facebook posts examined in this study exhibited behaviours that both supported and undermined the grassroots, decentralized ethic that appears, from the research interviews, to be at the heart of Ethno's appeal. In other words, social networking has the appearance of democratized participation where all voices are equal. The pursuit of a hierarchy-free, borderless world aspired to in the offline

(in-person) 'Ethno bubble' would appear consistent with the egalitarian spirit of 'user-generated content' and interaction online. At the same time, there is a 'panopticon' quality to Facebook participation that functions as a disciplinary mechanism.

The problem is twofold. First, Facebook's algorithms (and other social media algorithms) serve to dictate content and information flows. While the presence of these algorithms is by now well-known to many users, the exact operations of these algorithms remain hidden. Users thus post, share, and surf knowing they are being watched and manipulated, but without clear knowledge of exactly how they are being watched and manipulated. Second, Facebook community pages/sites, both public and private, are monitored and facilitated by an administrator. This functions as a form of surveillance and regulation that imposes an authoritarian structure on social networking that is out of keeping with a core Ethno value.

There were notable differences in content and posting behaviour between the private Facebook group, Ethnopia, a grassroots group formed and administered by Ethno attendee Max Christensen, and the public Facebook group, Ethno Forever, formed and administered by the Ethno World organization. Discussions on Ethnopia typically involved greater interaction and sharing than those on Ethno Forever. This was especially evident in posts soliciting help (i.e. information-seeking). Overall, less than a quarter of the 90 posts examined from Ethno Forever received a reply compared to about half of the 258 posts examined from Ethnopia. In part, this is attributable to differences in the nature of postings. Ethno Forever contained more advertising and sharing of musicians and events by the site administrator, whereas most Ethnopia posts were made by users and tended towards engagement-seeking and relational maintenance.

Given the existence of Ethnopia and its over seven hundred members (at time of writing), the subsequent creation of Ethno Forever on 6 May 2020, raises questions about perceived needs and purposes for social media participation. The 'about' description of Ethno Forever, modified 5 January 2021, reads:

> Hello everyone! And a warm welcome to this group created by Ethno World.
> This group is to connect Ethno musicians past and present from around the world.
> Ethno's announce Ethno-related opportunities for musicians to apply to, and as an Ethiopian [sic], you can also share links to your music here.
> Ethno love!!

The only comment on this discussion post questions the spelling of 'Ethiopian' (which is surely an auto-correct typographical error for 'Ethnopian', though the error remained uncorrected as of this writing). Given that Ethnopia was

presumably created specifically for the same purpose of connecting Ethno musicians past and present, it is unclear why a group duplicating an existing one was formed. Some posts by the Ethno Forever group administrator made on the Ethnopia page direct people to the Ethno Forever group:

> We have an ongoing poll to ask Ethnopians what would they want out of a 'Digital Ethno'.
> Please join us on the Ethno Forever group to tell us what you are looking for out of this initiative – [link to Ethno Forever].

Overall, the level of engagement on Ethno-related social networking appears low. This may represent apathy or disinterest possibly attributable to the pandemic – although this explanation does not account for low levels of engagement prior to the pandemic, nor does it square with early research examining social media use during the pandemic.[1] An alternative speculation is that efforts perceived as not in keeping with the rhizomatic, hierarchy-free ideal of Ethno are regarded negatively. A case in point posted on Ethno Forever from 13 July 2020:

> Been to an Ethno and had an amazing experience?!
> Then share a quote with us in the comments below! Something that expresses what being at Ethno made you feel and how it impacted you.
> We're looking for quotes for an upcoming booklet about Ethno!! We can quote with name or anonymously, as the author prefers!
> Go!

The post received only two replies and five 'likes'. It could be that interested participants chose to direct-message their stories rather than sharing them publicly, but, given the consistent and overwhelming sentiment of passion about Ethno experiences expressed in the research interviews, the general reticence towards this post is surprising. Another example of indifferent reaction is a 23 February 2021, post by the Arts and Culture Team of Ethno Research that solicited input on the creation of an Ethno 'sound map', along with a link to a Google form for uploading examples. The post received only one like and no comments, and the form itself received only five responses.

Without direct surveying of members, it is impossible to ascertain perceptions and opinions about posting and sharing behaviours. While only speculative, it does appear that efforts on the part of Ethno World (or Ethno Research) intended to facilitate engagement and support may be perceived negatively when they appear like acts of top-down control and ownership. For example, a post on Ethnopia (also posted to Ethno Forever) from 14 May 2020 reads:

In these digital times, it is great to stay connected, and also let our community know of the good work you are doing! To support this, Ethno World has created a unified place for free-to-share documents, meaning these can be edited, added to, and shared freely!

One of the documents is for 'Ethno Recording Artists – Musicians in the Ethno community who have recording facilities, equipment and skills'. The post goes on to say, '[t]his is the same doc as [the Ethnopia administer] had created earlier, but now available in one place together with all other docs.' It is curious why it was felt necessary to duplicate an existing grassroots effort.

Issue-oriented discussions on Facebook

Is there anyone studying ethnology/Ethno-musicology here? In one of my film music composer forums there's a debate about the term 'ethnic' and 'exotic' being bad because it's supposedly being used to differentiate anything that's different from white, western musical culture.

I argue that that's not the case. I don't know anyone that is offended by the word 'ethnic' and I've never seen it used in a derogatory way. It just describes a group of people with a unique heritage and traditions. In the world of classical music this doesn't really exist because the instruments and the way of playing are the same around the world. I think most people arguing in that debate don't actually have a lot of contact to foreign cultures and they just assume that others would be offended by that word, so they make it out to be a no-no word to be avoided. What do you think about this?

On 26 February 2021, a post on Ethnopia solicited input on perceptions and uses of the words 'ethnic' and 'exotic'. The post galvanized engagement, with many members of the Ethno community weighing in. Unlike most of the 855 posts examined, this one had considerable participation (66 comments); many posts received phatic reactions of support and affirmation.

The post above is significant for at least three reasons. The first is that, unlike most of the relational maintenance and promotion-related information posts examined, this post clearly struck a nerve. The second significant aspect is what the subsequent discussion reveals about how various members of the Ethno community understand concepts like *ethnicity* and *exoticism* – concepts central to the core values of the Ethno World programme. The third, and arguably most significant, is that it introduced explicit discussion on intercultural issues – something atypical during planned meeting times at Ethno gatherings (see Mantie & Tironi,

this volume). In this sense, the Facebook discussion fulfils an important function in realizing the espoused values of the Ethno World programme.

Intercultural dialogue and understanding are core principles of Ethno World (see Mantie & Tironi, this volume). In general, the Ethno Research interviews suggest a shared commitment among Ethno participants to the Ethno ideals of a universal humanity. As some of the discussion posts demonstrate, however, not all members of the Ethno community hold identical views. Some illustrative examples include:

- I think it depends on context. Both *could* be used in a kind of racist way (e.g. portraying western culture as 'normal' and non-western culture as something 'other'), but they can also be used in totally non-racist contexts like the way you've defined ethnic. But I'm totally not studying either of those subjects, so maybe there is a whole lot of background info I'm missing.
- Please don't make a semantic discussion à la 'everything is exotic so someone'. Everything is new to someone. The history of the word 'exotic' includes a romantizing and fetishizing of people, of a constructed 'other'.
- It's really delicate to just assume that 'ethnic' is not used with a negative or racist connotation. This might be an indication that perhaps you are in a position of privilege. I learnt that my privilege is usually invisible to myself. And that's a big thing!
- Every country is exotic for a other country. I don't see nothing racist about this. In Japan, European music is exotic, in Europa, Japon music is exotic same for food. It's not a bad word, so I don't see the problem. For me the problem is more to create this kind of problem. It's like I'm white, when I lived in Senegal, all the child called me 'toubab' who mean 'the white guy', I didn't feel offense, because it's one of the things that I am.
- I'm fine of people calling me exotic, but it's easy for me to say – I am White, hetero, European, privileged person. I know many people who feel offended, when these terms are used, and I think we should always give space and listen to the marginalized groups and people with lower power position and their opinion first.

By voicing their own experiences and self-reflexivity, the discussion eventually moved towards musical issues. Members reflected on how the music they play is conceptualized/defined within the music industry and how this relates to the terms 'ethnic' and 'exotic'. One member, for example, posted: 'I'm often wondering which word to use to describe my duo, which plays folk and traditional music from different countries/continents'. Two members pointed out the western framing of the words 'ethnic' and 'exotic'.

- When I started producing music from my home sounds in genres like blues, Jazz, hip hop, funk, etc. I was told my music is 'WORLD MUSIC' … With due respect YES the terms Ethno, Exotic and World, are used to differentiate anything different from the western musical culture.
- For Latin Americans, lots of folk music from Europe sounds 'exotic' to us, and we even use that term sometimes.

Predictably, perhaps, the discussion eventually connected broader discourses of 'ethnic' and 'exotic' to the Ethno community:

> Every year I find myself wondering whether the concept of Ethno is in fact working so well because it does capitalise on the whole exoticisation to an extent (as well as essentialisation […] 'This is the Moroccan tune'). Originally started with a very Western folk tradition in mind, many Ethnos now are a vessel for all kinds of folk, court, classical, even pop music, original compositions and spiritual music. Nothing wrong with that inherently, but the framing is often one still heavily dominated by the European discourse. Is it just me who feels that uneasiness sometimes?

The desire for broader discussions on intercultural issues was especially evident in a post where a member took the initiative to host a focus group discussion (presumably on a web-based platform like Zoom) in order to go beyond the text-based discussions on Facebook. The post is worth quoting at length for what it suggests about the nature of the Ethno community:

> Dear members,
> A while ago (26 Feb) [an Ethno participant] posted a thought provoking question on terminology of ethnicity and exoticism, triggering an interesting debate on cultural boundaries, colonialism, hybridity […] the list goes on. It appeared to me that many members of this FB group deal with these questions either professionally, in relation to our academic education and/or because of personal interests. It struck me that, even though we have so much knowledge to share (and to discuss), I have rarely encountered a group discussion on these topics at the Ethno camps I attended. A missed opportunity, I would say
>
> The overwhelming response to the post included vast topics such as folk music revival, cultural heritage/tradition, ethnicity, nationalism/patriotism, essentialization of culture, exoticism, cultural politics, accessibility, racism, (post)colonialism, self/other dichotomies, white privilege, gender, class, (world/folk) music industries […] (this is obviously not a summary).
>
> Because talking and listening is way easier than scrolling through a facebook thread of nearly a hundred comments, I therefore suggested to host a focus group: a

self-reflexive space to scrutinize, on a semi-academic level, concepts surrounding the Ethno program, but more importantly, to come up with ideas to introduce such topics as part of Ethno gatherings.

Expressions of the desire for wider discussions on important issues were arguably the most revealing aspect of the discussions of 'ethnic' and 'exotic'. Several members agreed on the need to encourage more discussion of intercultural issues within Ethno gatherings, for example. Some members celebrated the nature of the social networking interactions – e.g. 'It's great that we can have these discussions as a community in a friendly but still challenging / thought-provoking way.' Notably, one member emphasized the need for having more representation of intercultural issues integrated within Ethno activities, 'because here is where the intercultural dialogue actually starts'. Another member concurred, 'Yes! I think these topics and kind of reflective discussion and collective work towards decolonization need to be more present in the camps and organizing communities.'

Discussion

There are three overarching conclusions from this analysis of Ethno-related social media/social networking. The first is that social networking platforms function as participatory ecosystems. Online and offline interactions differ in form and function; each platform's architecture dictates the nature of engagement. Facebook's tagging algorithm controls who sees what and when, for example. Furthermore, online interactions take place between people who may or may not know each other, adding a level of uncertainty about audience and reception. A connected point is that participants know they are being surveilled, either by algorithms or by others, and typically post with the knowledge that they have little control over what happens after they post.

The second conclusion is that the purposes and motives of social media participants are often ambiguous. Unlike motivations for Ethno attendance, which exhibit similarities amongst participants, the motivations for social media participation vary widely. Ethnopia, for example, appears to have started as a grassroots space for Ethno attendees to sustain relationships and interactions beyond the temporal period of an Ethno gathering. Based on the analysis of various social media sites, however, it appears that, with a few exceptions, Ethno-related social media have become more of a marketing and communications vehicle to advertise opportunities and solicit support for individuals, bands, and Ethno World itself. That the general level of engagement appears low on Ethno-related Facebook

pages suggests that the Ethno community may not be as enthusiastic about online participation as they are about attending Ethno gatherings.

The third conclusion is that there is potential for social networking platforms like Facebook to provide a much-needed space for discussions of complex intercultural issues that do not typically occur as part of the formal schedule during Ethno gatherings. Based on a meta-analysis of Ethno Research interviews (see Mantie & Tironi, this volume), it is clear that the intercultural aspects of Ethno occur mostly on an implicit level or in informal settings. The asynchronous, global aspect of a widely used platform like Facebook introduces the possibility for text-based (and occasionally media-based) discussions that are not time-delimited. Given the lack of control that participants have over their posts, such discussions are not without risks, but, to the extent such discussions occur, they help to further the mission and values of the Ethno World programme.

English as the lingua franca

Despite technological advances that facilitate real-time translation, communicative interaction in intercultural settings continues to necessitate a lingua franca. It is currently impractical to incorporate real-time translations for all participant languages during the day-to-day function of Ethno camps. English is the lingua franca for Ethno World, as it is in many other international settings. Unsurprisingly, English has thus far been the default language for Ethno-related social media postings. When the point is to communicate with as many people as possible, posting in English rather than one's native language represents a pragmatic decision. Critiques of English as the lingua franca for international activities are beyond the scope of this chapter. What is of interest here is a consideration of the possible effects of language on Ethno World's intercultural goals and aspirations. For example, while this examination did not empirically determine the percentage of posters from the Global North vs. the Global South (which would have required ascertaining each poster's national origin), it does appear that language comfort plays a part in social media interactions.

Concluding observations

It should be noted that social media platforms in 2021 far exceed the dominant players of Facebook, Instagram, and Twitter. It is possible that Ethno subcommunities may be using alternative platforms (WeChat, WhatsApp, Snapchat, Discord, etc.). The analysis of post creation and sharing in this chapter suggests that engagement on the Ethno-related Facebook sites does not appear to be frequent or widespread. The one exception to the low level of social media engagement was

the enthusiasm of the Ethno community for the Facebook discussion of ethnicity and exoticism. Not only did comments and reactions appear passionate about this topic, but there were overt expressions of the need for greater discussions of intercultural issues in the Ethno community, regardless of whether these are a formal part of Ethno gatherings (as a few posters suggested) or ad hoc initiatives made possible through social media.

It is difficult to ascertain causal reasons for the lack of social media/networking engagement (e.g. apathy, negative reactions, access, and so on). Importantly, creation and sharing behaviours do not account for those classified as observers (or 'lurkers'). It could be that social media participation far exceeds what can be assessed on the basis of creator/sharer behaviours alone. It could also be that, while a small percentage of the Ethno community view social networking as 'Professional Facebooking', the majority of Ethno attendees do not share such motivations. Although the majority of those interviewed as part of Ethno Research no doubt wish to support the professional musical and artistic aspirations of their peers, the appearance of commercial or monetary interests in promotional postings may be perceived as going against the grain of the anti-commercial spirit expressed by many Ethno interviewees. This seems especially true when postings appear self-serving rather than embodying the 'selfless' ideals considered consistent with the ethos of Ethno gatherings. Finally, it could be that the value of Ethno for most participants resides primarily in the offline, face-to-face encounter rather than the online, disembodied encounter.

NOTE

1. A Google Scholar search (early 2022) reveals multiple studies pointing to increased (not decreased) social media activity in 2020 and 2021.

REFERENCES

Beninger, K. (2017). Social media users' views on the ethics of social media research. In L. Sloan & A. Quan-Haase (Eds.), *The SAGE handbook of social media research methods* (pp. 57–73). SAGE Publications. https://www.doi.org/10.4135/9781473983847

JM International. (n.d.). Ethno. Accessed 5 February 2024, from https://jmi.net/programs/ethno

Mancosu, M., & Vegetti, F. (2020). 'Is It the Message or the Messenger?': Conspiracy endorsement and media sources. *Social Science Computer Review*, 39(6), 1203–1217. https://doi.org/10.1177/0894439320965107

Mantie, R., & Risk. L. (2020). *Framing ethno-world: Intercultural music exchange, tradition, and globalization*. York St John University.

Mantie, R., Risk, L., Manson-Curry, K., Tironi, P., Li, J., & de Groot, A. (2022). *The complexities of intercultural music exchange: Ethno world as cultural change agent*. York St John University.

Mantie, R., & Tironi, P. (2022). *Marveling at the ethnoverse: Intercultural learning through traditional music.* York St John University.

McCay-Peet, L., & Quan-Haase, A. (2016). A model of social media engagement: User profiles, gratifications, and experiences. In H. O'Brien & M. Lalmas (Eds.), *Why engagement matters: Cross-disciplinary perspectives and innovations on user engagement with digital media.* Springer Verlag. https://ir.lib.uwo.ca/cgi/viewcontent.cgi?article=1043&context=fimspub

Radovanovic, D., & Massimo, R. (2021). Small talk in the digital age: Making sense of phatic posts. In M. Rowe, M. Stankovic, & A.-S. Dadzie, *2nd Workshop on Making Sense of Microposts, Lyon*, 16–20 April 2012.

Vitak, J. (2017). Facebook as a research tool in the social and computer sciences. In *The SAGE Handbook of social media research methods* (pp. 627–642). SAGE Publications Ltd. https://dx.doi.org/10.4135/9781473983847

8

Sharing Songs, Shaping Community: Revitalizing Time-Honoured Pedagogies at Ethno USA

Huib Schippers

Introduction

Aural and holistic learning within communities has been a characteristic of much of the musical history of humankind. So has being inspired by meetings between cultures. However, these have largely been forgotten with the rise and dominance of institutionalized western formal music education in the nineteenth and twentieth century, with its emphasis on notation and analysis. Born of the European folk music revival during the second half of the twentieth century, Ethno – a programme of Jeunesses Musicales International – recreates intense experiences based on intercultural encounters and aural peer-to-peer learning in order to broaden the development of openminded musicians in their 20s from across the world.

Boasting a history of over thirty years involving participants from 80 different countries, the 'Ethno approach' was already quite refined when it came to the United States for the first time in October 2021. Drawing a highly diverse group of 30 participants guided by three artistic mentors in an idyllic mountain setting in North Carolina, participants shared and learned songs from twelve different cultural backgrounds over a period of twelve days. This culminated in two festival performances and an album recording in a professional local studio. This chapter examines the pedagogy – arguably the defining characteristic of Ethno – as witnessed at the first Ethno USA.

To contextualize the findings, I will first discuss the history of approaches to culturally diverse music learning in the United States and beyond in brief, before focusing on the pedagogy as witnessed during the gathering in North Carolina, as the pedagogy is probably the most distinctive element of the 'Ethno method' (cf. Mantie & Risk, 2020, pp. 21–44). Next, to structure my observations, I will

use the Twelve Continuum Transmission Framework (Schippers, 2010), which provides a tool to create a nuanced perspective on aspects that are often glossed over in descriptions of music learning across cultures: issues of context; modes of transmission; dimensions of interaction; and approaches to cultural diversity, all of which are highly relevant to this project. The richest sources for this analysis are twelve sessions (plus two songs by mentors Ahote and Olivia), during which musicians from highly diverse cultural backgrounds first shared their songs with the entire group through peer-to-peer learning:

TABLE 8.1: Song sharing participant list.

Song sharer[1]	Main instrument(s)	Song	Culture/composer
Ahote	Vocals (hand percussion)	Morning Song	Traditional Hopi
Will	Accordeon (fiddle)	The Loopy Paddlers	Irish/Will
Sophia	Vocals, guitar	Arbol Azul	Latin/Gisun
Rosemary/Julio	Vocals, accordeon	Aire, Tierra, Fuego, Agua	Lyrics: Rosemary. Music/ lyrics: Julio
Robbie	Cello (percussion)	Hijaz Mandera	Turkish traditional
Mika	Vocals, guitar	Circadia	Funk/Mika
Serena	Vocals, ukulele	I Love to Praise His Name	Gospel/traditional
Amarjit	Vocals	Sobhillu Saptaswara	Carnatic/Thyagajara
Jane/Stephen	Banjo, fiddle, vocals	Red Rocking Chair	Old time US
Karim	Vocals, guitar	St. Joan	Americana/R.O. Shapiro
Nadia/Maryam	Vocals, ud	Reedaha/Wein A Ramallah	Jordan / traditional
Ines/Arya/Lauren	Fiddle, vocals	Slängpolska efter Ola Olsson Fewer from Lövestad, Skåne	Swedish traditional (Ola Olsson Fewer)
Mateo	Guitar, vocals	I Hate When She Calls	Piedmont/Mateo
Olivia	Latin percussion	Mi Bomba	Latin/Olivia

Many of my observations on these sessions align with the insights from the Ethno Research reports by Mantie and Risk (2020) and other chapters in this volume (e.g. Creech, Varvarigou, Lorenzino, and Čorić). In the final section, I will test my findings against the ten objectives that Ethno has set for itself, which include creating a democratic space for the creation and performance of music; providing equal opportunities to musicians of all genders; fostering intercultural dialogue and understanding; promoting non-formal music education through peer-to-peer learning; facilitating the mobility of young musicians; building confidence and mutual respect in young people; promoting learning and teaching methodologies by ear, making music learning accessible to all; and preserving and promoting cultural heritage amongst youth (Ethno, n.d.; cf. Mantie & Risk, 2020).

Framing the experience: Approaches to cultural diversity in music education

With its genesis in the Swedish folk music revival and an open attitude to cultural diversity in the 1990s, Ethno in 2021 is a well-defined organization, formula, and approach, which has been replicated in 40 countries worldwide (cf. Reis et al., 2021). In its brochure and on the website, the essence of the 'Ethno method' is described thus: 'Ethno is based on peer-to-peer workshops wherein participants from around the world teach each other music from their respective cultures' (Ethno USA, 2021). As key success factors, JMI/Ethno USA identifies: no hierarchy; respect; youthful can-do spirit; breakdown of barriers; common identity on stage; and real-world integration (2021; cf. Mantie & Risk, 2020). In this sense, it resonates with three major shifts in music education that evolved over the past six decades: learning music from other cultures from culture bearers in the countries of origin (e.g. Neuman, 1980, Rice, 1994; Saether, 2003 – see also below); the teaching of music outside of context by culture-bearers (e.g. Campbell, 1998); and the learning of more than one musical idiom (e.g. Hood, 1960, 1995; Solis, 2004).

From the middle of the last century, there have been frequent recorded instances of people learning music from other cultures. This is likely to correlate with the steady decline of colonial empires and associated constructs, greater opportunity and ease of travel, and new recording/dissemination technologies. According to leading ethnomusicologist Ki Mantle Hood, his teacher Jaap Kunst – who was a widely recognized expert on Javanese and Balinese gamelan (e.g. Kunst, [1934] 1949) – probably never even touched a gamelan instrument, let alone that he would have sat down with the 'natives' to experience what it is like to be part of this intensely communal way of music-making (personal communication, 1993). Hood himself was one of the first to engage his ethnomusicology students in

playing gamelan in the 1950s. This was not universally admired: he reports that his colleagues characterized him as 'the mad professor who sits students on the floor and has them beating on pots and pans in the name of music' (Hood, 1995, p. 56).

Meanwhile, travellers developed a fascination with the music practices they encountered in other cultures and engaged with them in various ways. This was also the time that music from Europe and the United States seriously started crossing ethnic boundaries: Latino and white musicians had been playing jazz since the 1930s, and instrumentalists of Asian descent became a common presence in symphony orchestras. One of the first US individuals who dedicated his life to learning a tradition away from his own was Jon Higgins (1939–84), who became a recognized master of Carnatic (South Indian) music. Many others followed, mostly focusing on music from Asia, Africa, or Latin America.

From the 1980s (arguably building on Blacking's 1973 seminal work *How musical is man*), some of the experiences of learning music outside one's own culture have been documented in detail. Probably the most well-known of these is Tim Rice's *May it fill your soul* (1994), but Daniel Neuman's *The life of music in North India* (1980) and Eva Saether's *The oral university* (2003) are also worth mentioning here. In addition, there are numerous accounts of students learning music from other cultures as part of ethnomusicology courses in university, the legacy of scholars/pedagogues like Hood (1995) and Brown (1995). These start from the astute observations by Ricardo Trimillos (1989) and extend to the present via the more in-depth accounts of world music ensembles at universities in *Performing Ethnomusicology* (Solis, 2004). Finally, a number of dedicated world music degree courses emerged in Europe and the United States, which gave students the opportunity to fully immerse themselves in musical forms like gamelan, flamenco, ragas, and tango.

These practices inspired ongoing thinking about the concept of bi-musicality (or multi-musicality), introduced by Hood in 1960, and expanded by Rice (2018): the idea that humans are capable of working within more than a single musical frame of reference. Awareness of this started with musicians switching from classical to folk, or pop to jazz, but extended into music practices based on entirely different sonic and conceptual precepts. Meanwhile, there had been a groundswell of thinking and practice focusing on teaching children music from other cultures in school. While there have been some thoughts and efforts in this direction as early as the interbellum (Volk, 1998, pp. 48–49), a convenient starting point for this openness is the influential 1967 Tanglewood Declaration, which explicitly stated:

> Music of all periods, styles, forms, and cultures belongs in the curriculum. The musical repertory should be expanded to involve music of our time in its rich variety,

including currently popular teenage music and avant-garde music, American folk music, and the music of other cultures.

(Choate, 1968, n.pag.)

This work took flight in the 1990s, with the work of scholars/practitioners like Teresa Volk (1998), Estelle Jorgensen (2003), Patricia Shehan Campbell (e.g. 1998, 2005), and many others. One of the phenomena that Campbell documented and advocated was 'Culture bearers in the classroom' (1998). This broke with the idea that music from other cultures could be adequately – or even sensibly – introduced through staff notation or recordings by teachers who were not themselves well-versed in the music practice they taught. This in turn was related to the awareness that music was more than sound alone, and represented an entire culture of thinking about sound, beauty, community, and the universe.

In addition to its practical challenges, this approach had one major practical drawback: while the culture bearers were mostly competent or even excellent in the tradition they represented, they were often not sufficiently skilled in transferring their knowledge in the specific European nineteenth-century construct that is K–12 education (for 5/6 to 17/18-year-olds). As a result, some of these experiments backfired, creating more prejudice about the cultures that were supposed to be promoted than enlightenment among young learners. This was an even greater risk with teenage learners, who tend to have less open ears and minds than K–6 learners (5–12-year-olds), as prejudice tends to settle in the early teens.

Meanwhile, inspired by progressing insight into the merits of other cultures and communities, many people re-evaluated their approach to other cultures – whether far-flung or in their own backyard – and started engaging with them. World music acts at major pop festivals and dedicated folk and world music festivals abounded, as well as independent world music record labels, finding an audience ready for aural adventures. This is the context in which Ethno was conceived by the iconic Falun Folk Music Festival.

Coming from a folk music environment, Ethno did not have to shake off the yoke of many 'world music initiatives' that came from the shadows of western festivals and institutions. In folk, there is already an appreciation of aural transmission, improvisation, and musical flexibility and change, all of which are key characteristics of the Ethno approach. Ethno founder Magnus Bäckström cited 'uniting young musicians around the world' to include folk music, and supporting 'individuals and cultures [...] thriving and finding their own identity' as motivation, but also bringing 'folk musicians together in order for them to get to know each other', and to 'create international connections and networks for [a] professional future' (Roosioja, 2018, pp. 56–57 cited in Mantie and Risk, 2020).

Four aspects of intercultural learning

Pedagogy and professional development of Ethno globally and historically have already been described in considerable detail by Creech et al. (see Chapter 1, this volume). From an extensive literature study and feedback from participants, they found many of the same key factors I will discuss here. In this chapter focusing on Ethno USA, I will use a theoretical framework particularly suitable to investigate the myriad aspects of pedagogy as a lived experience by participants at that gathering. The Twelve-Continuum Transmission Framework (TCTF) was developed to analyse complex music transmission processes within and between cultures (Schippers, 2010). In one of the other Ethno Research reports, this was kindly characterized as a framework that 'may be one of the most useful frameworks for understanding [...] music transmission in culturally diverse environments' (Mantie & Risk, 2020, p. 23). I hope it will prove to be here.

The Twelve-Continuum Transmission Framework (Figure 8.1) is based on centuries of practice, fifty years of literature and thirty years of observing, participating in and organizing projects focusing on cultural diversity in music education. The framework focuses on four domains that have proven important in shaping successful learning experiences across cultures. They are modes of transmission; dimensions of interaction; issues of context; and approaches to cultural diversity. Within each of these domains, there are one or more continuums focusing on specific aspects relevant to that realm.

For instance, in *modes of transmission*, the framework considers not only whether learning occurs more aurally or notation-based, but also to which degree the music transmission is holistic or atomistic in nature, and whether it emphasizes tangible or intangible elements of music-making. In these and all other dimensions the framework examines, these are not either–or choices, but rather places on a continuum. An example of this is that all notation-based music practices use at least some aurality in their pedagogies, and many oral traditions use some form of notation or graphic representation.

In *dimension of interaction*, the framework considers the power distance between learner and teacher/facilitator, the centrality of the individual or the group, the degree to which learning and playing the music is gendered, long- or short-term orientation, and the degree of tolerance towards uncertainty in the learning interaction. These continuums are derived from the influential work of Hofstede (1985). Although he based his study on corporate environments, his findings reveal highly relevant aspects of music learning and teaching that are often ignored in assessing the nature and success of transmission processes.

Issues of context considers the degree of fluidity in traditions, constructs regarding authenticity, and the degree of emphasis on – real or imagined – contexts of

TWELVE CONTINUUM TRANSMISSION FRAMEWORK (TCTF)

Issues of context

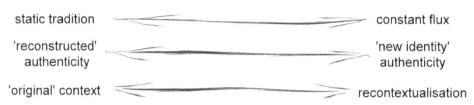

static tradition — constant flux
'reconstructed' authenticity — 'new identity' authenticity
'original' context — recontextualisation

Modes of transmission

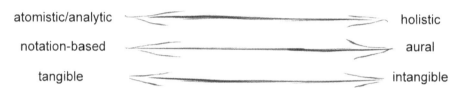

atomistic/analytic — holistic
notation-based — aural
tangible — intangible

Dimensions of interaction

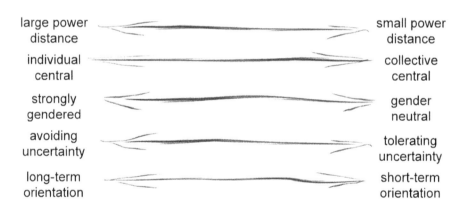

large power distance — small power distance
individual central — collective central
strongly gendered — gender neutral
avoiding uncertainty — tolerating uncertainty
long-term orientation — short-term orientation

Approach to cultural diversity

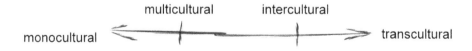

monocultural — multicultural — intercultural — transcultural

FIGURE 8.1: The twelve-continuum transmission framework (Schippers, 2010, p. 124).

the music practice. Thinking about these aspects has been strongly influenced by ethnomusicology, which has raised awareness among music teachers to think beyond the sound, but at times has also stifled practice by instilling fear that a non-expert can never do justice to context.

Approaches to cultural diversity range from monocultural to transcultural via multicultural and intercultural. In a monocultural environment, a single dominant culture is the only frame of reference. In a multicultural environment, different cultures are acknowledged, but they have minimal interaction. In an intercultural environment, conscious efforts are made to enable cultural meetings and mixing. In a transcultural environment, different cultures mix to the degree that their individual features are all but indistinguishable.

As I have argued before, the underlying constructs and visions of learning environments are often decisive for how music is taught (Schippers, 2010). That translates into the graphic representation on page 154.

Importantly, as mentioned before, each of these fields of tensions is regarded as continuum rather than a set of opposites: where teachers/facilitators and (groups of) learners position themselves may shift from month to month, day to day, session to session, and even within a single session. In general, formal music education tends to gravitate towards the left of the continuum: rather static approaches to tradition, authenticity and context, atomistic, notation-based, emphasis on tangible aspects of music, clear hierarchies and gender roles, individually focused, avoiding uncertainty, with long-term orientation.

Community-based learning tends to gravitate to the right of the continuums, with a more fluid idea of musical material, readiness to prioritize a sense of authenticity among the participants over striving for historical authenticity, and being comfortable with creating new contexts for making music. Learning tends to be more aural and holistic, often with more intangible goals (e.g. a sense of community over technical flawlessness). In terms of interaction, community music tends to favour small power distances, focus on the collective over the individual, embrace genderfluidity, tolerate uncertainty, and work more towards short-term goals (like a performance). While there are many monocultural community music activities, there is often an openness to or active embracing of cultural diversity.

However, a priori there are no right or wrong positions on any of these continuums. Research shows that successful transmission processes depend on intelligent – or intuitive – alignment between tradition, institution, facilitator, and learner in each specific situation and at any moment in time (cf. Schippers, 2010, pp. 125–136). In the following pages, I will closely consider the learning experiences at Ethno USA 2021 from the perspective of each of these continuums, noticing alignments, discrepancies, synergies, and challenges, taking the observed and

related experiences of the participants as the basis, with additional input from mentors, the coordinator, and the responsible organizations.

Modes of transmission

Holistic learning

Music teaching in western institutions is largely organized in what I have referred to before as an 'atomistic' way (2010): breaking down the music into its constituent elements or small parts, introducing learners to these 'bite-size chunks', and then later reconstructing them into a whole. However, it is important to realize that most music learning in the world is rather holistic: learners are exposed to a musical whole – maybe a pop song through Spotify, or an ewe-rhythm in a Ghanaian village – and use the striking capacity that almost every human brain possesses to process music (cf. Blacking, 1973; Sacks, 2007) to make the music their own.

Many of the song sharers at Ethno USA actively considered the advantages and drawbacks of holistic and aural transmission in their choice of repertoire. Striking examples of this are songs conducive to quick memorization, like the old-time classic Red Rocking Chair, the gospel Hallelujah, and the refrains of songs like Circadia and Ridaha. Greater challenges for holistic learning were the songs where melody and structure were furthest removed from the musical experience of most participants, like the Turkish Hijaz and the South Indian composition. Such confrontations with musical structures out of most participants' comfort zone tend to cause cognitive dissonance, which can be an obstacle to learning, but also as a stimulus. Most participants embraced the challenges of holistic learning wholeheartedly:

> The fact that we have this more open way of teaching from peer to peer through just doing and through sharing and showing for me is an incredible way to make music a bit more openly accessibly without the language of theory of westernized theory. I think going through this world tour of music is actually a beautiful experience to travel sonically and have this open-mindedness about, you know, taking down any barriers, any preconceptions or notions, and just getting into the music, in whatever language or style.
>
> (Sophia)

In addition, there was the sheer quantity of musical material that had to be retained in the mind over a very short period. This inevitably led to confusion at times: 'It's definitely a challenge. When I try to think about the tunes in my head, they kind

ATOMISTIC ←--X--------→ HOLISTIC

FIGURE 8.2: Balance between atomistic and holistic transmission within Ethno USA.

of blur together' (Jane). This led to very practical coping strategies: 'I think something that's so beautiful about being a part of a large ensemble is the way that you can lean on people' (Jane).

In terms of the framework, most songs are presented as a whole, and then broken down somewhat. Thus, the workshops at Ethno USA oscillate between atomistic and holistic, with the balance firmly towards the latter (Figure 8.2).

Aural learning

The way of learning music at Ethno USA is not only predominantly holistic but also almost exclusively aural (I prefer using aural – by ear – rather than oral – by mouth – as much of the music was instrumental). Most of the song-sharers took this into account when choosing the songs they brought in: many of them were based on simple rhythms and short melodies that are easy to remember, or repetitive, or both. As discussed in the previous paragraph, the ones that were not as easily digestible posed much greater challenges for the group learning, notably the complex melody from South India and the Turkish melody with quarter notes, set in a seven-beat cycle.

For some of the participants, aural learning was the way they learned music in the first place:

> For me, it's working very well because it was how I learned music, you know, mostly by ear. We didn't really get chance to be in schools of music […], back then. I mean, we learned from France and we can read some sheet music and stuff like that, but most of the time our music was transmitted by ear from generation to generation.
>
> (Khaled)

Others were trained in the West but had been exposed to aural traditions for a long time:

> Middle Eastern music can be notated, but a lot of it is passed aurally, the songs and the folk songs and the rhythms, it's an aural art. You're not handed a piece of paper and then telling you which notes to play. You know, it's more about interpretation through learning aurally this way. Indian music is very much the same way: this aural method. I studied tabla [a percussion instrument for which each stroke is represented by a syllable which students learn to speak] for eight years, so I'm very

familiar with 'if you can't say it, you can't play it', and I think it's fantastic learning each piece measure by measure by call and response.

(Robbie)

Many of those trained in formal settings relished the opportunity to see 'what happens when you put down the sheet music and you step away from the studio and you simply interact' (Marie). Yet lyrics – particularly those in languages other than English, such as Hopi and Arabic – were notated, and in most cases taught by reciting them line by line. While the group engaged with this very seriously, the effectiveness of presenting the lyrics with the melody from the beginning proved much more effective than separating out the two.

In the Carnatic melody, sargam (Indian solfege) notation was used, but it did not offer much of support as none of the participants were familiar with it. More significantly, many of the songs were presented with chord progressions. This sped up the process for those familiar with the system, but it also took away from the aural immersion, and caused a dichotomy in the group of those who were and those who weren't familiar with working with western chords.

Many seemed to echo the comment by one of the participants: 'I love learning stuff by ear. I think it feels really correct in my body and the way that I do music' (Danielle). Like in many traditional communities, informal aural learning continues after hours: 'outside of the formal workshops, we're just gathering on the porch in the evening and jamming and running through things. And that's just as much part of the learning experience' (Marie). On the whole, learning at Ethno USA very strongly tended towards the aural transmission, which felt comfortable to most (Figure 8.3).

Tangible/intangible

The emphasis in the learning experience of Ethno USA is on tangible aspects of the music: the melody, the rhythm, and the words. This is closely related to the product-oriented nature of Ethno. As Ethno Global Coordinator Suchet Malhotra points out, Ethno may be primarily process-oriented for the participants, but it is quite product-oriented for the artistic mentors and coordinators, as well as for external sponsors, who wish to see concrete and demonstrable impact of the project. Consequently, relatively little significance is attached to the roots of specific songs or the music, or to aesthetics, or to improvisatory structures.

NOTATION-BASED ←--X--------→ AURAL

FIGURE 8.3: Balance between notation-based and aural transmission within Ethno USA.

A less evident aspect of cultural diversity at Ethno USA is religious/spiritual diversity. There are songs that are emphatically from particular spiritual traditions, such as the Hopi morning song, the South Indian song by Saint poet Thyagaraja, and the gospel song Hallelujah, I Want To Praise His Name. About the latter, song sharer Serena learned that gospel and its spirituality were not known to all:

> I was speaking to the sisters from Jordan and they were like 'Gospel? No, I don't know.' I find that so crazy because of course it's commonplace here. Even if they heard the word gospel before they may not necessarily know what that means, so then I explained that not only is it something that sung in a church, but something that's sung in a black church specifically. And like what that means for me and my heritage and my culture. It's really interesting to try to explain. And then make sure that I'm doing it in a way that feels authentic.
>
> (Serena)

In some instances, there was an explanation of the background of the song, from the obvious emotional basis of love songs like I Hope That She Calls and Arbol Azul to the Indigenous significance of the Hopi Morning Song and Ayre, Tierra, Fuego, Agua. A number of participants obliquely referred to more intangible aspects of the songs they were learning, but it was rarely the focus over the melodic and rhythmic material.

Perhaps the spiritual nature of music and performance was most clearly embodied by artistic mentor Ahote, who brought his native American background to Ethno, which permeated the music-making, as well as the interaction with all participants through learning, rehearsing, and performing. Every day, the first session was devoted to his Morning Song, which to him represented a valuing of Indigenous culture beyond tokenism:

> I was very humbled when I was first asked to do this [...] I just wasn't expecting to be at the forefront first thing in the morning. And as you said, the whole, the whole token Indian kind of exposure kind of thing, like it doesn't feel very real, [here] I actually feel. I think that's the very big difference. Bluntly, I feel valued. And I feel that my culture has a place here and that people are taking it seriously, to learn it.
>
> (Ahote)

Ahote also performed smoking ceremonies before the festival performances, which imbued the participants with a sense of the sacred in music and performance. But with two performances and three days of professional recording on the programme, tangible aims inevitably prevailed (Figure 8.4).

TANGIBLE ←------------X--→ INTANGIBLE

FIGURE 8.4: Balance between tangible and intangible aspects of transmission within Ethno USA.

Dimensions of interaction

Power distance

Peer-to-peer learning suggests a very small power distance between learner and teacher. Inevitably, in each of the twelve sessions where the young musicians shared their songs, the song-sharers are in a position of power as they are the only ones who know the songs and lead the session, but as it rotates, this does not really cause a disruptive power dynamic. In fact, throughout the workshops, there was a strikingly equal balance of power. This was one of the aspects of Ethno most commented on by the participants, who spoke of the 'level playing field' (Robbie) as 'my favorite thing' (Jane), and 'peer-to-peer learning is what makes it really different here: everyone just wants to share it as much as they can of what their culture is' (Maryam). Another comments: 'I think it's empowering for most folks to be able to teach. And a lot of people are teaching their own works too, which is really special and really cool' (Carla); and finally:

> You're learning how to teach both while you're learning it, and while you're teaching. You're always thinking in the back of your mind while you're in a workshop, oh, that's a good idea. I should do that when I run workshops as well.
>
> (Will)

A number of participants had learned music without authority figures:

> I was never around people who were master musicians per se. It's people who just maybe have learned their guitar from someone they knew, or a friend like this: 'here's how you play this song.' And I can really relate to that because I never learned how to read music or anything, but just learning basic theory and just understanding enough chords to learn how to put them all together and tie them all together.
>
> (Mika)

Others, however, contrasted it with their earlier learning experiences in formal environments: 'I have a background in arts, but like acting, performing arts. At some point it was not fun anymore to learn like school' (Rosemary). This sentiment is shared by other participants: 'When you have a professor or a doctor,

you will always fear to play something in front of him because he will catch your faults maybe' (Nadia). Another expresses it more graphically: 'there's no master that teaches everything; everybody teaches each other' (Julio). And finally, with a little more detail:

> There's something about other music learning environments. You're given a song by someone who you assume is the professional in that type of music, or who at least holds some sort of a degree or a badge to show 'I can teach this music.' Stepping away from that and personally feeling the agency to step into that teaching position is really difficult, but also cool. [...]: Seeing everybody find their own agency and teaching, feeling and acting and teaching as they are and with all of the experience that they have, without this power dynamic that comes from maybe the more traditional ways of teaching.
> (Lauren)

As the days went by, people got more familiar with each other, and production (of the festival performance and the album) became the focus rather than the learning experience. There was a noticeable shift in power dynamics, with those feeling most experienced in arranging and producing becoming more pronounced than many others. This caused some friction, to the point where one of the mentors intervened by starting a recording session with emphatic advice to the entire group to continue ensuring all voices are heard.

On the whole, the three artistic mentors – justifiably renamed from the previous 'artistic leaders' in all Ethnos as the Ethno programme director pointed out – played a key role in creating an atmosphere of low power distance by deliberately remaining in the background during virtually all artistic and pedagogical interactions; only intervening subtly or when there were concerns only they can deal with: 'within the peer to peer process, I personally like to take a step back in some instances, just to allow natural leaders to show themselves' (Ahote). The mentor overseeing the percussion – who also effortlessly fits clave patterns over Scottish reels – identifies more as a participant than as a mentor: 'I love the fact that I can be learning from other cultures so I can basically adapt, you know, and actually show what I can bring from my country too and blend it in a great way' (Olivia). This hands-off approach was quite organic:

> The mentors didn't have a lot of planning time, but seemed to work with one another on intuition, trusting each other to bring forth and use liberally their own gifts. With Megan, it was organization, with Ahote it was nurturing, unification, and deep authentic expression. With Olivia it was the rhythmic flavor created in the percussion session which led heavily to the unique sound of the Ethno USA 'folkestra'.
> (Julie)

LARGE POWER DISTANCE ←---x--→ SMALL POWER DISTANCE

FIGURE 8.5: Degree of power distance within Ethno USA.

The mentor with the most experience in leading musical groups feels Ethno resonates with what she prefers to do in the first place:

> One thing I've been trying to do as a teacher is to step back and not do something, either not speak or not play or not teach or something like that. And that's always a balance. I think that in teaching I have done in the past, I have always looked for elements of peer-to-peer learning and ways to ignite a little fire to make things go. [But] it's really fun being able to sometimes not have to light the fire, just step away and, and watch the cool thing that's going on and try to be one of the people who's learning from whoever's sharing in the moment.
>
> (Megan)

With this remarkable restraint, and in line with how Ethno approaches this globally, the power distance stayed strikingly small throughout Ethno USA (Figure 8.5).

Individual vs. collective

While much music-making – particularly in the West – has a strong individual focus, valuing individual excellence and striving to be better than others, the ethos of Ethno USA is very much towards the collective. In that sense, it echoes many traditions from across the world where the collective spirit supersedes individual brilliance. This can be found in the concept of Ubuntu in music from Africa below the Sahara, in the practice of gamelan in Bali and Java, and in the music of many Indigenous peoples from Australia to Canada.

Most participants revelled in the group spirit:

> [T]he amount of focus that everyone has, and creativity and willingness to share music and experiences is amazing. Having people gathered together and being so willing to put in just in so much energy to sharing music and to creating music together when we didn't know each other three days ago is, is pretty incredible.
>
> (Lauren)

'[T]here's no pressure to do it one way or another. You know, we worked together as a group' (Amarjit); and

We're both teachers and students, so it feels really [like a] collaborative learning process. It's not like 'You do that.' It's like 'Well, what do you think of that? [...] I'm gonna teach you this melody, and then we're going to figure out how to put it together'.

(Stephen)

Several participants identified this as their favourite aspect of Ethno USA:

I can say my favorite part of this whole thing is just the chemistry of the people that are around. It's great chemistry, because everybody has come to the table with such an open mind. And everybody's so humble. So it's just so warm. It's loving, it's inviting, it's welcoming. There's not a moment I've felt like an outcast or anything just because I came from a different place and no one knows me. Like, it's just all like family, the moment you set foot on these grounds together with that band, you're a family. [...] My friend Jesse said something so beautiful the other night: 'You don't take from Ethno. You give to Ethno.' And you know, I would tell someone, yeah, go and give your gift to Ethno because you're going to get a lot more than you give [...] that's the beautiful thing of giving because it all comes back. It's just the circle of flowing love and music and culture. And it just makes us all better.

(Sam)

In the end, virtually everybody voiced in one way or another how comfortable the peer-to-peer learning and group arranging felt to them:

It's a group effort, so I see us all kind of working together. If someone is struggling with something, I've been more than happy to help think at any point, if someone's working on it, I'll just go grab my guitar and we'll work on it really quick. And I see that everyone's kind of working together, which is really, really awesome, instead of it being like everyone's an individual and you have to get it right.

(Danielle)

Almost all expressed in some way that 'it's really not about ego or yourself or personal or financial gain. It's about coming together' (Stephen). During the staged performances, this spirit of the group over the individual was palpable. This extended beyond music sessions: 'you have this connection and we're working together for like, who's getting the chairs, who's going to wake people up: we're becoming this team slash family slash working peer group' (James). A delightful feature of Ethno is that every night, three participants are asked to assist the caterer with washing up: two to do the dishes, and one to provide music while they do so. The spirit of collectivity pervades all aspects of Ethno (Figure 8.6).

INDIVIDUAL CENTRAL ←--X-→ COLLECTIVE CENTRAL

FIGURE 8.6: Balance between individual and collective at Ethno USA.

Gender

The gender balance at Ethno USA is quite even in terms of male and female participants. 'My focus in recruitment was cultural diversity, but I also worked on retaining gender balance. That worked out pretty naturally with most participants' (Julie). There were three female overseas participants from regions where there is a perceived or implied or historic gender imbalance, who were enabled to participate with considerable additional effort:

> When I was contacted by Maryam in Jordan and found she wanted to travel with her sister, I did give substantial time making sure they were both able to attend, working with my colleagues and friends at Petra National Trust. I worked very hard together to obtain visas for these women, working closely with embassy officials to ensure that this happened. Likewise for Tendai from Zimbabwe.
>
> (Julie)

A number of instrument groups are slightly gendered: there were more women who play the violin and more men drumming. Some of the lyrical content is also gendered, but none of it is overtly sexist. All participants seem to be aware and respectful of Ethno's insistence of embracing LGBTQI+.

> With the mentors, there was a female-focus in recruitment, but in total the mentor positions were offered to 3 males and 2 females. Megan and Ahote were secured first, then three black males declined the 3rd spot before I finally found Olivia.
>
> (Julie)

With three women and one man (plus Roger as a more informal mentor for the album recording), the leader/mentorship ended up balanced, so that no issues of gender arose perceptibly, with the possible exception of a few of the male participants becoming a little more dominant in the process towards performance and recording, which was addressed by one of the – female – mentors, as mentioned above (Figure 8.7).

STRONGLY GENDERED ←--X--------→ GENDER NEUTRAL

FIGURE 8.7: Balance between strongly gendered and gender neutral at Ethno USA.

Welcoming uncertainty

The very formula of Ethno invites embracing uncertainty. The young musicians come to the gathering with a deliberate desire to be confronted with music, words, and ideas that they are not familiar with. That extends to the learning process – which is removed from the comfort zones of some of the participants – and the process of jointly arranging the songs for performance and recording.

This group tolerance towards uncertainty was perhaps most readily noticeable with the songs that were furthest from the other participants' comfort zone. One participant commented that during 'the Jordanian song [set in maqam Hijaz], everybody was just coming up [against] this scale. We've never heard this language before, and we're just going to nail it, which is so amazing' (Karim). The participants who shared the song felt the same: 'I looked at their faces when I told them about the quarter tone [a characteristic of much Middle Eastern music]. It's something new to them […] they are not familiar with this tuning' (Nadia). However, her sister continues,

> they're very receptive and they just picked it up. They were welcoming to learn my song, my culture, and how the maqams [Arabic tonal structures] are different from what they're used to. So it was easier than what I had in mind or what I anticipated.
>
> (Maryam)

The state of mind required for making that possible pervaded comments from many of the participants: 'push yourself out of your comfort zone' (Karim). One participant emphasized the need to 'be open to all the possibilities and show up with my full self, because if I hold anything back, then I'm not going to get as full of an experience and not going to share as deeply' (Jane).

> This situation itself is like a surprise box, you know: sometimes you open the box and then you have a certain tune and then five minutes later, or 10 minutes later, you are playing another song from another part of the world, with different feelings, connections, […] and that's really impressive, to be able to rehearse so many kinds of music in such a short period of time. It opens your head.
>
> (Julio)

One participant considered his Ethno experience,

> learning music in one of the truest ways: someone plays or sings a piece for you and you learn it by ear and you go back and forth and you try and you make mistakes

AVOIDING UNCERTAINTY ←--X--→ TOLERATING UNCERTAINTY

FIGURE 8.8: Degree of embracing uncertainty at Ethno USA.

> and you go through it and there's no judgment. And there's no preconceived notions about what it might end up sounding like. We're all just there to learn.
>
> (Amarjit)

Embracing uncertainty to that extent requires a great amount of trust in a group and an environment that makes it feel safe to take risk and explore untrodden paths (Figure 8.8).

Short-term orientation

The intensity of the programme and the expectations in terms of short-term sonic outcomes create a 'pressure-cooker' effect on processes and participants: 'the first few days have felt like a few weeks. They've been so full. I mean it's wonderful. The way that the community has, has come together so quickly, and already feels like a family, is so wonderful' (Karim). The intensity increases with the diversity and expected format of the songs: 'people from all these different cultures are coming together and actually putting in. To make one fantastic song or orchestral song, you know, so that, that's what I've taken from it' (Jesse).

While there is considerable emphasis on the long-term results of Ethno in terms of deeply embracing other cultures, as the days go by, the focus of the gathering is more and more on short-term results, in this case the festival performances and the album recording. There is a real sense of urgency regarding learning the different songs and creating arrangements that will work on stage and in the studio. While in the first five days there was ample time for creative ideas that may or may not work, discussions and rehearsals focused more on how each of the songs would sound with the entire orchestra involved at the performances and in the recording during the second part of the gathering. Particularly a professional recording with the need to lay down tracks which will be heard in perpetuity necessitated focus. The fourth mentor Roger – an experienced producer – admirably tried to keep the flow of the recording sessions natural and most of the decision-making processes with the participants, but in the end inevitably organization needed to be tightened in order to get all elements of all tracks down.

Overall, the output-oriented second half of the gathering was beneficial in keeping the level of focus high among the participants, but perhaps something was lost in the potential of freely exploring creativity without an immediate application or purpose beyond the musical experience. This idea also emerged strongly

LONG-TERM ←---X----------→ SHORT TERM

FIGURE 8.9: Long-term vs. short-term orientation at Ethno USA.

from the survey of the participants. So, while there are demonstrable long-term effects of Ethno at large in terms of networks and attitudes, the actual pedagogy at Ethno USA and the way it was experienced by the participants strongly gravitated towards short-term outcomes (Figure 8.9).

Issues of context

Tradition

While many of the songs derive from traditions going back decades or even centuries, the way they are adapted and performed shows a very flexible approach to tradition: songs, performance formats, and even musical structure are changed so that each song aligns with the Ethno sound and format. While the Ethno leadership speaks of sustaining traditions, it is a little difficult to see how this works in practice. The songs as they are adapted for Ethno do not fit 'back' in the tradition, and are unlikely to become part of the fibre of those traditions.

The participants reflect on tradition in various ways. Some truly value their heritage, even if it is not prominent in one's own awareness or musical life:

> [Sharing] your culture and your culture and your heritage is actually really important. And if you don't know it really, it [Ethno] actually makes you want to know it better because it's something that we should all have to share. Singing gospel music is an American art form. Singing blues, that's an American art form. And it comes from the way that this country started and all of that is important. [...] We can always bring that to the forefront and learning about our heritage and just asking questions to our elders is really important [especially] if you don't have elders that are in your life all the time.
>
> (Serena)

Others express awareness of the narrow perspective musicking in a single tradition can bring:

> We often think in genre, and within tradition. I'm realizing that people who play traditional music around the world are linked. And I hadn't, to be honest, thought

STATIC TRADITION ←--X---→ CONSTANT FLUX

FIGURE 8.10: Approach to tradition at Ethno USA.

> about that. I knew that tradition was powerful and it was passed down and, that there was something special about traditional music, but thinking about them as part of the same story and part of a common ground, I think has been a big development for me.
>
> (Stephen)

As the song-sharing sessions are very intense and focused on getting the music across, some use the time between and after sessions to learn more about traditions by

> talking to the musicians after hours, trying to learn the tunes as much as we can during the rehearsals. And then just having that time later to speak with them and talk about, you know, some more of the intricacies of what should we be doing here? How is your music different from their music?
>
> (Danielle)

One participant specifically brings up sustainability: 'Preserving music and having that come up through a next generation, that's such an important piece of Ethno: the young folks, the young people learning their music and passing it on to others' (Marie). Overall, however, the tradition was approached as highly dynamic at Ethno USA: there was little emphasis on sustaining music traditions as they were, but a great deal of effort towards creating new music based on those traditions (Figure 8.10).

Authenticity

Ethno is not an initiative which aims at perpetuating specific traditions in ways they were performed for tens or hundreds of years. In none of the songs, with the possible exception of the Hopi morning song, is there a desire to be authentic in the sense of 'the way it was when the song as created'. It is clear to all that the purpose of Ethno USA is mixing rather than perpetuating traditions in an authentic way (whatever the reference for authentic may be):

> Learning about the culture is not just through the music, but also the rest of the culture. It gives you more insight into the world, which you wouldn't be able to get

RECONSTRUCTED AUTHENTICITY ←--X------→ NEW IDENTITY

FIGURE 8.11: Approach to authenticity in Ethno USA.

> if you played with people from your own culture or stayed in your own country. Coming to an Ethno is like traveling to 20 different countries and experiencing all that culture. I think having this fantastic mix of cultures is a real treat, both in terms of the chance to try out all these music from all around the world and experience their music and learn about their music and their culture, but specifically for the mixing as well.
>
> (Will)

No particular value is attached to authenticity in the sense of how (some expert says) it once was. This static (and often superimposed) approach to authenticity – which has been an obstacle to many initiatives involving music from different cultures – is not at all the focus of Ethno USA. Coordinator Julie celebrates the inauthenticity at Ethno and similar projects:

> This inauthenticity is part of the integration process – first people have to come together to joyfully share – even if the recipients inevitably put an accent on it. Through the joyful sharing comes the love of a new music, and then a new love for the people sharing it, and then a true interest in and compassion for the culture from whence the music came. It can take years to pull back those layers, but over time the effect is tremendous.
>
> (Julie)

Therefore, a strong argument can be made for a deliberate new identity (Schippers, 2010: pp. 50–53), 'strategic inauthenticity', as Taylor (2007: pp. 126–36) calls in the context of West African popular music, or even a new tradition, as the songs become Ethno songs, which can be seen as their own tradition with their own authenticity in many senses (Figure 8.11).

Recontextualization

Certainly, there is interest in the – real or reconstructed – context of each tradition among the participants: 'it's been really cool to learn not only the actual tunes themselves, but learn, you know, about where everyone's coming from and the context of this music as well' (Marie). However, ultimately all of the songs are drastically recontextualized. Ethno is a magical but profoundly decontextualized

ORIGINAL CONTEXT ←--X--→ RECONTEXTUALISATION

FIGURE 8.12: Approach to the context at Ethno USA.

setting for the musics being performed. But the very setting of Ethno becomes a new context, with a well-defined process:

> Sometimes people have really defined vision for what their song and trying to allow us to fulfil their vision. That's really interesting. And then other people, they kind of want us to help them create the vision of the songs and it's also really exciting. So I guess what's been really interesting about that is just seeing how we can fit all the pieces of the puzzle.
>
> (Ines)

Participants naturally incorporate recontextualization in their activities at Ethno USA and the creativity that implies:

> There's a lot of really good work happening, and it's been really cool to come up with arrangements for tunes that I've never heard before. Kind of in real time with the musicians that either wrote them or are showing them to us from their cultures.
>
> (Danielle)

This great flexibility with new identity and recontextualization characterizes Ethno (Figure 8.12).

Approaches to cultural diversity

The realization that there are many different worthwhile music cultures on planet earth was not so much a lesson participants took from Ethno USA, but rather a key reason why they took part:

> All the reason I came here was to experience other cultures and learn something completely different than my own. I'm just stuck in the Americana land, you know, and I just wanted to know what everybody else was doing. It makes your mind hurt a little bit to learn in so many languages at once, but [in the end] they're all vowels and notes and beats.
>
> (Carla)

Others came from diverse cultural backgrounds:

> I come from so many different cultures and backgrounds and actually, I was kind of uncertain coming to Ethno, like, should I share something Canadian or something from some of my other [Latin] culture. I think it's so interesting to explore. So many different parts of our heritage, our identity, our language, our styles of music, our interpretations. And so I think going through this world tour of music is a beautiful experience to travel sonically and have this open-mindedness about taking down any barriers, any preconceptions or notions, and just getting into the music, in whatever language or style.
>
> (Sophia)

An important aspect was the representation of cultural diversity in the United States:

> I have been loving the diversity within the American – like USA – representation: to experience [that] in terms of the feel of the different songs. We have different cultures of the US represented like the Hopi song and gospel. We have Mika's indigenous blues funk type of thing. And then we have Justin's Piedmont blues. And is there another one? Oh, and shoot, we have the old-time song. And then we also have Americana. So we got six. We got the country!
>
> (James)

This was carefully curated and stimulated through travel grants by the coordinator of Ethno USA:

> I've tried the hardest [...] looking into the black American community and specifically I wanted blues represented or gospel, and I ended up getting both, which was really beautiful and super important to all of us for launching the first US Ethno.
>
> (Julie)

In line with the wishes of Jeunesses Musicales, she also ensured that there was sufficient Indigenous representation (one participant and one mentor; the latter a first for Ethno worldwide), Latino presence (one participant and one mentor), as well as participants with African, Asian, and Middle Eastern national and musical backgrounds.

While all celebrated the diversity of sounds that arose from this pro-active drafting of participants, some sought similarities in the music practices they encountered:

> [I]n the workshops, we'll go from a Jordanian tune to an old-time tune to a Scottish tune. And it's this kind of musical whiplash that feels delightful, because I'm

realizing not only how all the traditions are unique, but also how they're connected in this.

(Stephen)

And:

I've loved hearing the echoes between melodies between different cultures. I mean, it's obvious: I'm not the first one to say that obviously, but it's still really cool to hear a similarity between melodic structures and scales between Indian classical music and a Swedish fiddle tune and the Hopi morning song. I mean, we're all more similar than we are different. I knew that coming in, but it's just validating. It's very special.

(Karim)

Others felt a little apprehensive at first:

How do I feel that mixing of so many different cultures works? It seems to be working really well. But I was a little nervous at first, knowing that there were going to be so many different types of music, especially some that people might not have heard before or even heard of. So I think I was a little in my head about it. And then I realized that, you know, there's like a baseline of what ties a lot of music together.

(Amarjit)

This raises the question of music as a universal language. Some participants subscribed to this idea: 'music is an equalizer of sorts, a universal language' (Carla), or

I've been really excited personally to sing in Arabic and learn some Indian songs, and Turkish, something like that I I've never experienced myself [...] you have the opportunity to spend lots of time with people from different cultures and soak it up and you see that we're mostly pretty similar.

(Justin)

Another added: 'it really just goes to show that music transcends all languages, all borders, all barriers, and really connects us to one another' (Sophia).

However, others challenged the notion that music stands as a universal language by itself:

I struggle with this idea that music is everyone's language or that music is the universal language, because I don't really think that's true. I think we've all found ourselves in jam sessions where you're like: 'I know none of these tunes', and then it doesn't

really feel like it's the same thing. But being here and being able to hear all of those things and then have them translated for you (or to be walked through the translation so that you can understand) is really impactful because it gets rid of this assumption that everyone's music is easy for everyone else. And it gets at this idea that even though all of our musics are different and they're not in the same language, musically or lyric wise, that there's still a way to translate and communicate.

(Lauren)

A few participants commented explicitly on an underlying sense of making the world a better place through Ethno: 'I think this is the whole thing of this program: build bridges between countries. We're saying no borders. We need to open the borders and build more bridges between countries and cultures and spread peace in the world' (Khaled). And,

this thing right here, that we are all doing, changes the world because you learn about culture and can then pass that on. And hopefully at some point, it trickles down or trickles up if you will, to the rest of the world, you know, including presidents and things like that. If we could all do it, I think the government can do this too.

(Sam)

Such sentiments are also evident in the leadership of the two organizations that were responsible for Ethno USA: JMI International and Folk Alliance. The latter speaks of:

The dream of Ethno, which ultimately in my view is about peace and international development more than it is about music. Music is the thread of the fabric, but it's people falling in love with the idea of connection, global connection and going back home and not thinking places, but thinking about people from places. I see this as much deeper than a music enterprise. It is about peace and international development. These are people who will go home changed by the experience with the news on, and hearing about a person that they know [first], not the politics of the day.

(Aengus)

These sentiments are echoed by Ethno Global Coordinator Suchet, who is careful to point out that Ethno does not make any grand claims on combatting racism, but does believe that prejudice comes from what one is fed. And with its rich and well-structured musical menu, Ethno at least sparks cultural curiosity.

Interestingly, in the arranging process by the group, there is a tendency to shape every melody into the format of a western-style 'track': a main melody sung or played by one or two participants, then a refrain in which everybody participates,

and space for improvisations against a background of chord progressions. This leads to the quite characteristic and compelling 'Ethno Sound' that is also evident from the online material of previous Ethnos across the world, and from the world music orchestra Världens Band that emanated from it (cf. Gibson, 2020). Still, it is useful to reflect on the implications of this process: negatively, it can be seen as a form of Eurocentric colonization of the project; more positively, as a natural process in which music develops as time and circumstances change.

The 'Ethnofication' of the songs does have implications for the degree to which Ethno contributes to the preservation of specific traditions. Most of the final songs as they appear on stage, the web and the forthcoming CD are quite removed from the original song. This is by design, and there is nothing wrong with it. However, as mentioned before, it is unlikely that these altered songs will contribute substantially to the sustainability of the traditions from which they came, although they may pique interest in the underlying traditions.

In the end, it may not be very useful to consider whether Ethno USA helps sustain individual traditions. Rather, its strength lies in creating an 'instant community', where participants buy in to a particular ethos in terms of approach, working together, and sound, much like long-established 'organic communities' (cf. Schippers, 2018: pp. 25–26) do. Membership of this community is not exclusive – all the participants belong to several other communities, like most of us – but it is also not limited to the ten days and particular place where they gather.

Several participants comment on expecting their experiences to resonate in their future music-making: 'different countries bring different sounds and different vibes and stuff, which I can definitely utilize in my own personal work' (Nepthalie); 'I feel like I'm collecting all these pieces in my brain and that will feed a lot of more creativity in the future as well' (Marie); and

> I think the main shift I've had so far is sitting there and thinking I'd really like to have an ud someday in my string band or to kind of cross boundaries a little more: not in a corny, but in a deep and meaningful way.
>
> (Stephen)

Overall, it is safe to say that cultural meeting and interaction are at the heart of Ethno. It does not take a monocultural approach in the sense that a single culture is the central reference. Nor can it be characterized as multicultural, where cultures exist next to but separate from each other. Probably the strongest case can be made for intercultural, as a voluntary meeting of cultures. To some extent, some of the outcomes could be seen as transcultural, where there is an in-depth adoption of ideas from different cultures to the point that it is hard to tell them apart (Figure 8.13).

```
MONOCULTURAL ←----------------------------------------------X----------→ TRANSCULTURAL
                    MULTICULTURAL     INTERCULTURAL
```

FIGURE 8.13: Approaches to cultural diversity at Ethno USA.

Pedagogy at Ethno USA and the objectives of Ethno worldwide

After careful analysis focusing on the participants' experience, the Twelve Continuum Transmission Framework for Ethno USA looks like this:

Issues of context

```
STATIC TRADITION ←----------------------------------------------------X---→ CONSTANT FLUX

RECONSTRUCTED AUTHENTICITY ←---------------------------------------X------→ NEW IDENTITY

ORIGINAL CONTEXT ←------------------------------------------------X--→ RECONTEXTUALISATION
```

Modes of transmission

```
ATOMISTIC ←---------------------------------------------------------------X--------→ HOLISTIC

NOTATION-BASED ←----------------------------------------------------X--------→ AURAL

TANGIBLE ←------------X---------------------------------------------------------→ INTANGIBLE
```

Dimensions of interaction

```
LARGE POWER DISTANCE ←-------------------------------------------x--→ SMALL POWER DISTANCE

INDIVIDUAL CENTRAL ←----------------------------------------------X-→ COLLECTIVE CENTRAL

STRONGLY GENDERED ←----------------------------------------------X--------→ GENDER NEUTRAL

AVOIDING UNCERTAINTY ←-----------------------------------X--→ TOLERATING UNCERTAINTY

LONG-TERM ←----------------------------------------------------------X-----→ SHORT TERM
```

Approaches to cultural diversity

```
MONOCULTURAL ←---------------------------------------------------X-------→ TRANSCULTURAL
```

FIGURE 8.14: Twelve continuum transmission framework for Ethno USA.

That is a striking picture: virtually all places on the continuum are much towards the right: an indication that the carefully crafted and honed Ethno approach succeeds in creating an intense and safe and creative community experience for young musicians. Very few music transmission settings show this combination of qualities across the twelve continuums. Such observations invite reflections on whether and to what extent the experiences at Ethno USA and the pedagogical practices encountered there align with the ethos of the international social enterprise it has become. On its website www.ethno.world, Ethno makes explicit ten objectives of the organization:

1. Preserve and promote cultural heritage amongst youth;
2. Foster intercultural dialogue and understanding;
3. Promote non-formal music education through peer-to-peer and experiential learning;
4. Facilitate the mobility of young musicians and emerging talent, locally and abroad;
5. Build confidence in young people's talents and inspire them to further their musical and creative development;
6. Grow self-respect, self-awareness, and respect for others;
7. Create a democratic space for the creation and performance of music;
8. Provide equal opportunities to musicians of all genders;
9. Celebrate young talent in an inclusive environment;
10. Utilize, develop, and promote learning and teaching methodologies by ear, making music learning accessible to all.

As discussed above, preserving and promoting cultural heritage amongst youth seems to be one of the more marginal outcomes of Ethno USA, with effects that are largely indirect or oblique. A claim can certainly be made for empowering young musicians who almost invariably have a background in diverse cultural heritages. However, the sonic material gets transformed so drastically, that it would be hard to claim that the underlying music practice directly benefits from Ethno USA.

Fostering intercultural dialogue and understanding is a more pronounced outcome of Ethno USA. Young people from a wide range of backgrounds spend ten days in close quarters with each other. While the very nature of Ethno implies that most participants had an open attitude towards cultural and musical diversity from the start, the 'Ethno method' provides the opportunity to deepen that considerably.

As stated in the introductory remarks of this report, to '[p]romote non formal music education through peer-to-peer and experiential learning' may seem like a revolutionary idea to those anchored in primary/secondary or conservatory/school

of music teaching, but it is in fact the most common way in which people learn music throughout the world. From times immemorial to today, young people have learned music from simply hearing and imitating tunes and rhythms and songs that speak to them. But bringing back that practice and awareness is certainly a worthy mission with a lasting effect on the participants.

While there is a great deal of support for the idea to '[f]acilitate the mobility of young musicians and emerging talent, locally and abroad', there are many practical obstacles, particularly for young musicians from developing countries. These are economic, but often also political. Immigration regulations make mobility hard for many young musicians. Ethno USA proved exemplary in persisting to find ways of gathering musicians from all over the globe, with COVID-19 restrictions and requirements – which in the end prevented a number of young musicians from participating – as an additional barrier in 2021.

From the words of the participants, there is ample evidence that Ethno USA contributes to 'build confidence in young people's talents and inspire them to further their musical and creative development' in myriad ways. It is also a space that is conducive to '[g]row self-respect, self-awareness, and respect for others'. With its very small power distances and emphasis on the collective, Ethno USA was a strong platform to '[c]reate a democratic space for the creation and performance of music' while providing 'equal opportunities to musicians of all genders', enabling the project to '[c]elebrate young talent in an inclusive environment'.

Perhaps most strikingly, Ethno USA succeeded in its mission to '[u]tilise, develop, and promote learning and teaching methodologies by ear, making music learning accessible to all' through its choice of mentors and participants. By creating a platform for age-old practices of music transmission and creativity compatible with contemporary needs and possibilities, Ethno USA has been highly successful in creating a learning environment that provides a stimulating, often even transformational experience for young musicians from different cultures. Its insistence on diversity in participants, pedagogies, and materials – and to some extent arrangements – make it exemplary in demonstrating viable alternatives or additions to formal music education for both professional and amateur musicians, and possibly – with some adaptations – from Kindergarten to secondary schools (K–12).

As an organization, JM International seems to be able to coordinate many Ethnos around the world every year, without the risk of becoming too tight in controlling its 'franchises' on one hand, or on the other allowing them to be so loose or distant from its key principles that the essence of the approach is lost. Judging from conversations with fellow researchers and participants of other Ethno gatherings, Ethno USA stood out in its profoundly culturally diverse pool of participants, the intense interaction between all participants (which is easier to achieve with 30 than with 100 participants), and its very ambitious goals in

terms of outputs (two festival performances and a professionally produced album). While some aspects of Ethno USA invite continued watchfulness and close scrutiny in terms of representation, inclusivity, and artistic outcomes, overall it stands out as a shining example of learning music from a truly global perspective, which deserves to be continued in its present form, and may serve as an inspiration for other settings of music-making and learning across the world.

ACKNOWLEDGEMENTS

First of all, I would like to thank the team at the International Centre for Community Music of York St John University led by Professor Lee Higgins for providing me with the opportunity to conduct this research. Second, I would like to thank JMI/Ethno, in particular Suchet Malhotra, for his vigilant support and guidance of this project. Third, I would like to acknowledge Aengus Finnan and Jennifer Roe of Folk Alliance, who passionately and bravely faced the challenges of producing Ethno USA during a pandemic. With unobtrusive but decisive stewarding, Julie Moore ensured that there was a truly inspiring mix of participants and artistic mentors from different cultures within the United States and beyond. Finally, I'd like to thank all the participants and artistic mentors who so warmly and graciously welcomed me in their midst; I can't wait to see where your myriad musical paths will lead.

NOTE

1. Psudonyms have been used here.

REFERENCES

Balosso-Bardin, C. (2018). #NoBorders. Världens Band: Creating and performing music across borders. *The World of Music*, 7(1/2), 81–106.

Blacking, J. (1973). *How musical is man?* University of Washington Press.

Brown, R. (1995). World music: As it was in the beginning, in now, and really should be. In M. Lieth-Philipp & A. Gutzwiller (Eds.), *Teaching musics of the world* (pp. 7–18). Philipp Verlag.

Campbell, P. S. (1998). Culture bearers in the classroom: Scenarios from the Pacific Northwest. Lecture transcript.

Campbell, P. S., Drummond, J., Dunbar-Hall, P., Howard, K., Schippers. H., & Wiggins, T. (Eds.) (2005). *Cultural diversity in music education: Directions and challenges for the 21st century*. Australian Academic Press.

Choate, R. A. (1968). *Documentary report of the Tanglewood Symposium*. Music Educators National Conference.

Creech, A., Varvarigou, M., Lorenzino, L., & Čorić, A. (2021). *Pedagogy and professional development* [Research report]. International Centre for Community Music.

Ethno. (n.d.). Homepage. Accessed 5 February 2024, from https://ethno.world/

Ethno USA (2022). *Ethno USA* [Record album]. Jeunesses Musicales International.

Gibson, S.-J. (2020). *Ethno on the road*. International Centre for Community Music.

Gibson, S.-J., Higgins, L., & Humphrey R. (with L. Ellström, H. Reis, & L. Roosioja). (2021). *30 Years of Ethno*. International Centre for Community Music.

Green, L. (2002). *How popular musicians learn: A way ahead for music education*. Ashgate Publishers.

Hood, K. M. (1960). The challenge of bi-musicality. *Ethnomusicology 4*, 55–59.

Hood, M. (1995). The birthpangs of bimusicality. In M. Lieth-Philipp & A. Gutzwiller (Eds.), *Teaching musics of the world* (pp. 56–60). Philipp Verlag.

Jeunesses Musicales International. (2021). Ethno USA: Global Music Gatherings [brochure].

Jorgensen, E. (2003). *Transforming music education*. Indiana University Press.

Kunst, J. ([1934] 1973). *Music in Java: Its history, its theory, and its technique*. In E. Heins (Ed.). Martinus Nijhoff.

Laww, J. (2021). *Ethno USA 2021* [video]. Ethno World. https://ethno.world/ethno-media/ethno-usa-2021

Mantie, R., & Risk, L. (2020). *Framing Ethno-world: Intercultural music exchange, tradition and globalisation*. International Centre for Community Music.

Neuman, D. M. (1980). *The life of music in north India* (2nd ed.). University of Chicago Press.

Nzewi, M. (2003). Acquiring knowledge of the musical arts in traditional society. In A. Herbst, M. Nzewi, & K. Agawu (Eds.), *Musical arts in Africa: Theory, practice and education* (pp. 13–37). University of South Africa.

Rice, T. (1994). *May it fill your soul*. University of Chicago Press.

Rice, T. (2018). Bimusicality. In Laura Macy (Ed.), *Grove music online*. https://doi.org/10.1093/gmo/9781561592630.article.46455

Roosioja, L. (2018). *An ethnographic exploration of the phenomenon behind the international success of Ethno* [Master's thesis]. Estonian Academy of Music and Theatre.

Sacks, O. (2007). *Musicophilia: Tales of music and the brain*. Knopf Canada.

Saether, E. (2003). The oral university: Attitudes to music teaching and learning in the Gambia. *Studies in Music and Music Education, 6*. Malmö Academy of Music, University of Lund.

Schippers, H. (2010). *Facing the music: Shaping music education from a global perspective*. Oxford University Press.

Schippers, H. (2018). Community music: Contexts, dynamics and sustainability. In B. L. Bartleet & L. Higgins (Eds.), *The Oxford handbook of community music* (pp. 23–42). Oxford University Press.

Schippers, H., & Bartleet, B. (2013). The nine domains of community music: Exploring the crossroads of formal and informal music education. *International Journal of Music Education, 31*(4), 454–471.

Solis, T. (Ed.) (2004). *Performing ethnomusicology: Teaching and representation in world music ensembles*. University of California Press.

Taylor, T. (2007). *Beyond exoticism: Western music and the world*. Duke University Press.

Trimillos, R. (1989). Halau, hochschule, maestro, and ryu: Cultural approaches to music learning and teaching. *International Journal of Music Education, 14*, 32–42.

Volk, Teresa, M. (1998). *Music, education and multiculturalism: Foundations and principles*. Oxford University Press.

9

Reconceptualizing Ethno? Perceptions of the Ethno Gatherings in Bahia, Malawi, and the Solomon Islands

Sarah-Jane Gibson

A unique feature of Ethno Research has been the opportunity to engage with multiple sites of investigation and a large variety of musical traditions. Within this variety, Ethno Research became aware of the many ways in which participants and researchers perceive Ethno, music-making, and intercultural understanding. The 'Exploring new pathways' research package explored the perspectives of Ethno musicians and organizers from outside of central Europe and the Nordic regions, with the intention of interrogating how the Ethno approach may have adapted due to its growth in regions with different socio-economic situations to where it first originated in Sweden (Gibson, 2022).

The growth of Ethno gatherings outside of Europe increased rapidly from 2015. The purpose of this research package was to explore how the perspectives of Ethno may be changing as the programme develops globally. This chapter focuses on the perspectives of the organizers of three Ethno gatherings: Bahia, Solomon Islands, and Malawi, examining how they negotiate running an Ethno within their local context and whether they perceive Ethno in a similar manner to those of their 'Global North' counterparts. Through individual interviews and one focus group with these organizers, I explore their perspectives in relation to four themes that relate to both the current research project and the overall meta-analysis of Ethno: learning, performing, connecting, and valuing (Creech et al., 2021; Gibson, Higgins, & Schippers, 2022).

In acknowledgement of my own positionality as a white South African researcher based in a British university, I have approached this chapter with the intention of opening doors for further discussions surrounding epistemologies of music-making, recognizing that my conception of music, although influenced by

the local music traditions of the country of my birth, is rooted in the western musical system. As research findings were also drawn from three interviews and one focus group, there is potential for more conversation with each research participant to further elaborate on their perceptions. What follows is a 'conversation opener' about how Ethno could be reconceptualized as it becomes more globalized.

You say potato ...

One of the interesting tensions Ethno Research found was that Ethno participants celebrated both difference and similarity, with comments such as 'we are all the same' often counterbalanced with a love of 'the diversity of people' within the gatherings (Gibson, Higgins, Humphrey, Ellström, Reiss, & Roosioja, 2021). Unfortunately, the concept of 'universality' can be complicated by notions of western ethnocentrism. As Hess states, 'rather than recognising the multiplicity of epistemologies used readily by different groups, music educators frequently take a Western ethnocentric singular approach to education' (2021, p. 26). Within Ethno, this may happen because western music is a system that current research suggests most participants understand.[1] For example, the western ethnocentric approach may be applying the use of western classical 'elements' of music, such as melody, harmony, form, rhythm, or dynamics to musical systems that do not conceptualize music in this manner. As one Ethno organizer in this research project explained:

> At the Ethno we mostly teach by ear because most of the music is not transcribed. This is because we're using our local folk music, which is mostly learned or taught by ear. So [the process is] you see it, you try it, you hear it, you try it until you get it. But of course, because you have international participants, you also need to use a language that each one can easily get. So there are some aspects where you need to explain using musical notes. So, if we did have a guitarist we say, can you start in G, or someone on the keyboard, we say this song is like, ABCD. So we do combine that.

From the perspective of this organizer, combining two approaches, the local and the western musical notation system, is not in conflict, but rather complimentary: 'we take advantage of the international perspective and look at what we are doing, and the internationals learn from what we are already doing.' What is pivotal in this commentary is the recognition of two approaches: an international and a local. This is vital in any intercultural engagement. Nzewi, Anyahuru, and Ohiaraumunna explain: 'most ethnomusicologists have come to accept that the standard theories about the music of one human society are often inadequate for a cognitive understanding of the music of another, culturally differentiated society'

(2008, p. 1). Rather than a universalist approach, there is a call to recognize difference in music. They continue,

> A 'black' vocal technique would sing 'white' melodies with the cultural quintessence of 'black' musical aesthetic or 'pigmentation'. It is ethnocentric and arrogant to derogate Igbo musical or intellectual sensibility for not interpreting the chromatics in Brahm's songs as effectively (to a European classical ear) as a European concert-hall singer could do. A 'white' musical culturation interprets 'black' harmonies, intervals and rhythms with the cultural nuances of 'white' musical perception of 'pigmentation' and could even hear the tonal nuances of melorhythm as mere percussion without melodic essence irrespective of the acuteness of 'musicalear'.
>
> (Nwezi et al., 2008, pp. 10–11)

Nzewi, Anyahuru, and Ohiaraumunna (2008: p. 1) are emphatic in the importance of an 'investigative approach that elicits the concepts about music and the principles of music making inherent in the music of every different society'. This is highlighted in relation to the Ethno approach by Yachita (2019) in his analysis of Ethno Cambodia. Yachita (2019) noted an interesting response to the use of learning by ear in which musicians who learned orally in their everyday practice resorted to using notation to aid their learning of Ethno songs. The musicians' understanding of how and why they learn by ear and use notation appeared to be conceptually different to the way it was being used in Ethno. Yachita notes that fundamental concepts such as 'learning by ear' may need to be reconsidered when 'bringing Ethno into the non-Western world' (2019, p. 10).

It is within this research package that I have interrogated whether understandings of approaches used with Ethno could be considered 'universal' aiming to understand how differing approaches to music-making are incorporated into the programme. At the heart of this research is the intention that 'differing perspectives […] are not a source of disagreement, confusion or conflict; rather they are a source of enrichment' (Atleo, 2011, p. 2). What the research is highlighting is that everyone views music from a particular cultural lens. This includes how we understand and conceptualize music-making. Acknowledging this difference in perception can prevent Eurocentric dominance in hybrid music-making processes such as those that occur at Ethno. As Nwezi, Anyahuru, and Ohiaraumunna cautioned, 'there is a danger of prejudicial representation when we lack adequate terminologies from our stock of musical or language backgrounds to discuss unfamiliar musical arts manifestations' (2008, pp. 1–2). Likewise, there is danger in not acknowledging the plurality of musical identities by trying to attach singular labels to musicians or musical practices according to their cultural background. As Kabanda suggests,

we need to ask how we should recalibrate and sharpen our tools of engagement. We need to take time to understand cultural activities and how they can play a meaningful role in building a more secure and peaceful world amidst modern globalisation.

(2022, p. 41)

Colonial difference

The notion of similarity and difference is further complicated when it comes to considering where the Ethno gatherings in this research package take place. Typically, these regions are labelled the 'Global South'. This label comes with connotations that cause an ontological unease because it brings attention to economic, social, and cultural imbalances related to colonialism. The term 'Global South' emerged during the cold war within the United Nations as a political tool to identify countries across Africa, Latin America, and most of Asia (Haug et al., 2021). It was used as a common identifier in opposition to the 'developed world' or the 'North'. The term is also used in academic research to acknowledge the actors and spaces that have been neglected by mainstream social science research and to represent the decolonized nations located roughly South of the old colonial centres of power. This enables a recognition of the systemic inequalities stemming from colonialism. There are attempts to consider alternative terms for 'Global South', 'third world', or 'developing countries', all references that can be seen to define these regions in terms of what they lack, rather than what they are (Alam, 2008). Alam (2008) suggests the use of the term 'majority world' to highlight that the majority of humankind reside in these areas. This is also a term that has been coined by a person living within this region (Alam, 2008). However, it still generalizes a large region into one meta-category, which can be problematic.

Waisbich, Roychoudhury, and Haug argue that meta-categories become 'an identity shorthand that we simultaneously reject and need' (2021, p. 2088). Whilst meta-categories are attempts to make the global space palpable by dividing it into areas that share basic characteristics, the result is that countries are linked together by broad generalizations, creating categories that may be a useful short-hand but are also incomplete. For example, very different countries, such as the three case studies in the chapter become tied together as one singular identity. Furthermore, and perhaps most pertinently, the meta-category underplays structural inequalities within those regions, as in the case of Ethno Bahia, which takes place in a poorer region of Brazil and therefore experiences socio-economic issues that are different to that of Ethno Brazil, which takes place in the wealthier region of Sao Paolo. As Bradley explains, binaries such

as Global North and South, 'obscure the way the postcolonial world operates: through continuing entangled, hybrid and symbiotic relationships' (2012, p. 410). However, meta-categories also highlight global inequalities and aids in understanding concepts of subjectivity, positionally, and belonging in transnational spaces, particularly when people from the 'Global North' and 'South' engage with one another (Waisbichh et al., 2021).

Meta-categories themselves can be seen as a 'Eurocentric' viewpoint. We need to ask ourselves why we are highlighting inequalities and separating the 'North' from the 'South'. Furthermore, we need to interrogate whether this approach suggests one region may be 'better' or of more value than another. As Aman explains, when it comes to representation and 'encounters between two parties who have different ways of naming the world' there is also a situation of 'power in play between those parties whose representation carries the most weight' (2019, p. 172). Highlighting inequality only serves a good purpose when it is to bring about greater equity between regions, recognizing that there are 'power dynamics at work in how Europeans have represented their Others' (Aman, 2019, p. 175). Thus, differentiating between 'Global North and Global South' Ethno's in our research is done to better address the needs of Global South programmes in acknowledgement of socio-economic imbalances.

The risk of polarization between Global North and South in this research and the creation of binaries that in and of themselves speak to Euroecentrism (Agawu, 2003) are recognized. Ramnarine (2019) suggests, however, that dialogue between parties from the North and South are crucial to avoid such conceptual binaries. She writes, 'in sharing their practices, the musicians' dialogues hold the potential to dispel conceptual borders of west and east' (Ramnarine, 2019, pp. 117–118)

All the concerns that I have raised in this literature review relate to the question of understanding, or epistemology. In relation to intercultural encounters, Aman stresses that there may be 'unequal positions from which participants in an intercultural dialogue may encounter each other' (2019, p. 172). He continues by suggesting, much like Nwezi et al. (2008) in relation to musical systems, that 'depending on where (the geopolitics of knowledge) and by whom (the body politics of knowledge) interculturality itself may be thought about in different ways' (Aman, 2019, pp. 172–173). He stresses 'the importance of the geopolitical dimension of knowledge production and the potential pitfalls of not taking the colonial difference in consideration of interculturality' (Aman, 2019, p. 183) concluding that 'part of the challenge in achieving an intercultural dialogue [...] involves understanding the social-historical power relations that imbue knowledge production' (p. 184). Likewise, Bradley (2012, p. 429) argues that we need to 'approach all music, and all philosophies of music education, with an understanding of their contextually situated nature' (see also, Prest & Goble, 2012).

Nwezi et al. write 'words can never sufficiently convey what musical arts making communicates as a unique system of non-verbal discourse and human behaviour in a cultural-human setting' (2008, p. 2). Or, as was once quoted in another research project 'show me how you make music, so that I can make your music as best I can. I would like to be part of your understanding. And will you, through my music, be part of mine?' (Gibson, 1992, p. 44). Most musicians will recognize that there is a level of communication that goes beyond words when performing. What should be recognized is that there cannot be a generalized 'accepted standard' for music-making because music-making is contextual, based on the cultural values and opinions of the local community. As Freire emphasizes, 'one cannot expect positive results from an educational or political action programme which fails to respect the particular view of the world held by the people. Such a programme constitutes cultural invasion, good intentions notwithstanding' (2017, p. 68).

The following case studies reveal how Ethno has the ability to adapt to the cultural value system of local communities and also where there are tensions, not because of the Ethno programme, per se, but because of an inherent dominant power structure of the western musical system within which Ethno was founded. There is a tension as organizers negotiate creating music that is considered 'acceptable' for an international platform, such as Ethno Solomon Islands will describe, or seek funding for their programmes that may not align with Government cultural policy, such as Ethno Bahia experiences. Acknowledging that there are epistemic differences in music-making begins the process of exploring, discovering, and adjusting the power imbalances between musical systems. With regard to Ethno, this can further strengthen the programme as it encompasses a global identity.

Method

The organizers of Ethno Bahia, Malawi, and Solomon Islands agreed to be part of a focus group study and were also interviewed individually. Organizers also responded to follow-up questions via e-mail and were given the opportunity to respond to research findings. The organizers of Bahia and Solomon Islands were also participants in previous Ethno reports, whilst this was the first interaction with Ethno research for Malawi. The research was further supported by observing videos and photographs of performances that are available on the Facebook pages of each of the gatherings. Interactions with each organizer have continued through WhatsApp and e-mail communication to gain greater clarity on topics discussed during our focus group meetings.

Performing

Learning and performing within an Ethno gathering follows a general structure whereby for the opening half of the camp, participants are gathered together to share and learn each other's music in preparation for final public performances that take place towards the end of the camp. As discussed in previous chapters, this structure has been related to a 'liminal space' or a 'bubble' where participants are in a space that is a 'suspension of the everyday' and can focus on their music-making and engagement with fellow participants (Higgins, 2020; Gibson et al., 2021). Some of this structure relates to the performance frame of western music where musicians spend time rehearsing and learning music in preparation for performance to an audience (Turino, 2008). The rehearsals take place without an audience. During performances, the audience will listen to the music and respond with applause at the end of each piece.

The organizers of Bahia, Solomon Islands, and Malawi all found the concept of an Ethno 'bubble' did not easily relate to their Ethno gatherings. Much of this appeared to be due to the level of engagement members of the local communities had with participants during their 'rehearsal' period.

For example, the first Ethno Bahia 2018 took place at the Casa do Samba em Santa Amaro which is in the historic centre of Salvador, declared a centre of cultural heritage by UNESCO in 2005. During this Ethno, there were musicians visiting the centre, such as the Samba Chula Master Aurino de Maracangalha who plays a rare instrument called the viola machete and a group of *Jongo no Sudeste* musicians. These musicians conducted workshops with the group which allowed for 'cultural interchange' between local musicians and Ethno participants. However, the Ethno Bahia organizer reflects that this was difficult for the artistic mentors who were both from Germany. The artistic mentors had a 'vision to fulfil and succeed' and the 'spontaneous coming and going' from visiting musicians was making it difficult for the mentors to follow the typical Ethno method of rehearsing and arranging music in preparation for a final concert. One artistic mentor wanted to focus on the timescale, whilst the organizer felt that they

> could not reject the people who are coming. They're feeling something is going on and they want to share. This is our culture here in Bahia. In Germany, Sweden or Belgium they are closed in their venue and do a lot of work and then present the result. In Bahia, we cannot. We have to be open.
>
> (Ethno Bahia organizer)

Much like Ethno Bahia, the organizer of Ethno Malawi noted that 'there are moments that come that must be accommodated' such as someone who was not

invited but has heard about the Ethno and wants to share their music. The organizer of Ethno Malawi explains, 'you can't say no. You have to accommodate him and share what you are doing. And then you find that they bring very interesting stuff that becomes one of the highlights of the event that really enriches' (Ethno Malawi organizer).

Both Malawi and Bahia refer to needing to accommodate people who want to share their music. There is a sense of expanding the bubble of Ethno to welcome local musicians. Upon reflecting on the term 'Ethno Bubble', one of the organizers of the Ethno Solomon Islands responded:

> I've always known in New Zealand as the Ethno *kaupapa* which basically means the values of Ethno is to enable, to mingle, to be able to collaborate and if you're only limited to just the camp in the bubble, I think it will limiting the values to ourselves.

For Ethno Solomon Islands, the issue of a 'separate bubble' appeared to relate more to infrastructure. The organizer explains that people on the Solomon Islands already live in circumstances that could be considered 'camping' and it is not something that local participants would be interested in doing. There are also difficulties in securing residential accommodation due to the unreliability of funding from the Government. He explains,

> a lot of our programmes are not quite structured because we are dependent on other sources [...] So the way we organize our camps, the way we organize our venues, the way we organize, or try to get into festivals is really dependent on those organisations.

Thus, Ethno Solomon Islands do not always hold a residential gathering.[2] Instead, participants go home every day after the workshops. The concept of a 'camp' is also noted as an unusual one in Cambodian culture (Yachita, 2019). Yachita notes that the structure of a residential gathering fulfils a condition of being 'secluded from normal city life' but also speaks to European concepts of a long Summer holiday, whereas places geographically located in a warmer climate such may not include a longer Summer break as part of their annual calendar (2019, p. 6). Yachita (2019, p. 6) notes, in Cambodia, from example, it would be a 'summer' camp all year round. The author also highlights the need for residential gatherings to have dependable facilities and adequate security.[3]

If there is a need to be more adaptable and spontaneous during the Ethno gathering to accommodate local musicians or because of a reliance on other organizations, how do these Ethno's prepare for a successful final performance? What was interesting was the reference by each of the gatherings to participants

'constantly performing' which connects to a more participatory approach to music-making (Turino, 2008). The organizer of Ethno Bahia refers to musicians constantly performing, which appears to be like musicians from the Solomon Islands, who 'naturally play, they can collaborate anywhere, anytime'.

Ethno Bahia reflects on the concept of performance, explaining that it is a 'natural thing to perform, in the bar, on the corner, people are playing just for fun, but they are performing. They do music all the time in all situations, so it's absolutely no problem to have the final performance.' She reflects on how their Ethno went into the village every night where there was music being played by the local people, which is 'very natural in Bahia, this will be happening a lot'.

Ethno Malawi see the final performance as an opportunity to showcase Ethno to stakeholders, potential funders, and policymakers. It's their opportunity to promote Ethno more widely. However, the organizer also notes that there are performances during the entire week of Ethno. He says, 'in the evenings it's all music, it's all playing, people from the community come and join in and just a joy.' So, for the (final performance) we are okay because the performance is happening throughout.

This organizer sees value in the structure of working towards a final performance to reach out to 'people within the government and the private sector' but manages the need for flexibility with incorporating constant performances throughout the week. He notes however that the audience do participate during the final performances, explaining,

> When the participants are onstage and start performing, everyone sings along. Even if it is in a different language. When you leave the venue, all the village is singing the songs you created at Ethno. [...] When I got a chance to visit Europe and go to concerts, you wait until the song ends and then you can exclaim, but here, it's the moment when the song has just started if it speaks to you, you shout at that moment because that's what you feel.

Based on the organizer's description of the level of participation by the local community, including how young children stay and listen to the music during the whole day, even not going home for lunch, one can assume that by the time of the performance the local community are already familiar with the tunes that will be being performed. Thus, joining in is possible because they have already been engaging with the gathering throughout the week.

The organizer of Ethno Bahia also reflects on how international participants respond to this experience,

> the people from other countries [...] get driven by this energy here and get so much more out of themselves. There is something for everyone, even if you just play a little

tambourine. [...] There is a place for everyone from the little participation to a very special participation.

She recalls how one participant reflected on how Ethno Bahia is a 'little bit of both mentalities'. There is the concept and methodology of Ethno combined with

> [Bahia's] way to believe in miracles and do miracles [...] there is an energy in being together. Everybody is focusing not only on technical perfection but this special energy and feeling and emotion. Everybody gets involved and this is present. It's not something you can rehearse.

A blending of approaches is also important within Ethno Solomon Islands. The organizer of Solomon Islands is passionate about providing international opportunities and platforms for performance for the Ethno participants because there are 'no opportunities to showcase or even work' in Solomon Islands. So, he takes a somewhat different approach to Bahia and Malawi. To acknowledge and recognize the participants who have attended and participated in Ethno workshops during the week, he takes the details of any musicians who arrive unannounced and show an interest in Ethno and keeps in contact with them. He then follows up with them when the next Ethno comes up to see if they are still interested.

With regard to performance, he finds if he creates a 'disciplined and strict Eurocentric type of camp' he seems loose the spirit of their music. However, he sees Ethno as an opportunity for musicians to improve their musical skills and shape their music-making so that it is not as 'loose' as when they play in their communities and will be 'acceptable' (dare I use that, he laughs!).

These examples as described by the Ethno organizers allude to the versatility of the Ethno programme and how it can respond to the needs of their locality. Culturally, to have a gathering where people remain 'separate' for a rehearsal period goes against 'how people do things' in these three regions. This requires a level of 'spontaneity' and adaptability to enhance the music-making experience. The organizer of Ethno Bahia explains,

> There is more flexibility in everything: in the schedule and the cultural activities and the way of people relating to each other. It's important to realize that this is all part of the experience in Bahia because of the culture, because of where the people are. And because of the nature.

Kabanda suggests that 'non-Western societies have an advantage, as subjects tend to be a part of daily life in their cultures' (2018, p. 52) and that in order for greater interdisciplinary and multidisciplinary ways of thinking and learning,

there is a need to 'curb [the western model of education's] tendency to put subjects into boxes', or, as Atlea (2012) explains, there is an inter-relatedness within Indigenous musical systems. This is evident in the difficulty these Ethno organizers have with separating the local community from their Ethno gathering, or, musically speaking, separating 'rehearsal' from 'performance'. Within these Ethno's, the connection with the local community creates a vibrant music-making experience but from the descriptions of these organizers it does not appear to have the same 'suspension of the everyday' that I, as a researcher experienced during fieldwork in Ethno Sweden and New Zealand, and as has been described by previous research participants. As the organizer or Ethno Malawi explains, ultimately their Ethno becomes a community programme.

Valuing

One concern throughout the research into Global South has been the concern over differentiating Ethno's and their participants due to their location or cultural heritage. Some academic research challenges notions of difference as being implicitly Eurocentric, relating to the concept of 'Othering' or 'Exoticism', by highlighting difference to remain separate or suggest that a European approach is better. Analysis based on differentiation runs the risk of a 'perceived hierarchy' (Agawu, 2003, p. 22). This research project is revealing that when it comes to 'sameness', participants want to be recognized as equal regarding the value of their music, and their identity as musicians. So, for example, an Ethno participant from the Global South wants to be recognized as being 'on the same level' as one from the Global North. As Bradley (2012, p. 429) states, 'our goal should be to understand music's importance to identity construction – individual, collective, gender, racial, cultural, national [...] and the myriad other ways people understand themselves.'[4]

However, there is recognition that there is a difference in music-making traditions on a conceptual level. Thus, it is possible to argue that all music is the 'same' from the perspective of the value of all musical cultures. All musical cultures are the 'same' in that they have equal value, equal systems of practice, that may be different conceptually but need to be regarded on the same level as western systems. As Kabanda explains, 'culture is also about people's identity and dignity, which they have reason to value' (2018, p. 17).

A core tenet of Ethno pedagogy is that of 'valuing' (Creech et al., 2021). At Ethno Malawi Solomon Islands, and Bahia the gathering offers an opportunity to value local culture more deeply, where perhaps music has been 'devalued' due to colonization. The organizer of Ethno Solomon summarizes:

> A successful Ethno here in my view would be a balance of both foreign traditional and traditional music here so young people will not marginalise what we have but rather have pride in it. Ethno is an opportunity for people like us to revive and promote our already deteriorating culture through music.

This is also acknowledged by Ethno Malawi:

> It is a way of, you know, appreciating the diversity of cultures of the world, but also looking at ourselves. There's also a lot of diversity within the national borders, in terms of musical traditions. So, I think to raise that kind of awareness and appreciation of our own culture through our local music, it's quite motivating for me.

The organizer of Ethno Bahia wants the music of Bahia to be seen on the same level as classical music. She sees that Ethno helps people to recognize that. Bahia has a rich musical heritage of Afro-Bahian music which sees little recognition in academia or music education in Brazil (Döring, forthcoming). This problem has become more pressing with the current government regime and their public policies. Döring (forthcoming, p. 5) refers to one project, Orquestra Neojibá, noting that the project is 'based on Central European music and theoretical codes with no focus and methodology for black dance and music genres'. The Ethno Bahia organizer explains her motivation,

> It is to be on the same level, it's not to impose 'only this structure' is possible. [Ethno] gets closer to help be able to have all kinds of experience in music, in dance. This is what I want for all the youth.

Both Ethno Uganda and Solomon Islands note that the visiting international participants assist in developing an appreciate for local musical traditions. Ethno Malawi comments: 'Having participants coming from Uganda or from Congo gives another perspective of traditional music. And sometimes we confirm about our ourselves when we hear the kind of music from other countries.' Whilst in Solomon Islands, it's the boost the confidence that the locals have when they see Europeans Australians and New Zealanders turn up to the Solomons to learn to teach their songs and to learn their songs. The organizer describes it as 'a huge boost'.

The organizer of Ethno Malawi expands further by explaining:

> We're trying to deal with the people's attitudes, especially the local people. Because there has not been that amplified focus on the traditional instruments and the music, especially among the youth. So when they hear Ethno, they think it is something associated with primitiveness. So, we are trying to rejuvenate, that interest,

that pride in performing your own local instruments. So that is something that we are already struggling and working with. The young people would rather play a guitar, a bass guitar, or these drums and not be their local instruments but we see that now, we're getting a lot of interest from the people because of the publicity that we're doing.

The organizer continues to discuss the difficulties in locating traditional musical instruments:

We have a lot of folk songs that are collected that are sung everywhere. But the instruments are not available, because the people who make the instruments are mostly very far away in the remote areas. And there's those traditional musical instruments that are quite rare at the moment. So what these young people do is that they have the tunes, they have the music, they have the relics in their traditional format, but then they are using modern equipment. Or sometimes they use both modern equipment as well the local instruments that are available. So that gives us an angle where we're talking of Ethno, but in a way, we're in the contemporary environment.

He continues by explaining, much like what happens in Bahia, that people who are experts in local instruments and music will come and 'demonstrate and even teach some of these young people how they can play those [instruments]'. The result has been that Ethno participants 'have mastered playing local instruments now for having participated in Ethno Malawi and for us having invited elderly people to come and demonstrate and perform at Ethno'.[5]

In Malawi, there is also a feeling that Ethno has a 'duty to contribute to the promotion and preservation of the Malawian traditional music and musical instruments'. Ethno Malawi are the first project in Malawi to work around traditional music and they focus on reviving and generating interest among the Malawian youth so 'they can be happy about their culture through music'. The organizer explained that there was a national debate about the identity of Malawi and music and how their Ethno can contribute towards his discourse by identifying the musical instruments, folk songs, and Ethnic groups within the country. He continues to explain, however, that there are many connections between the culture and traditions of Mozambique, Tanzania, Zambia, and Zimbabwe, saying that the 'reality is that it's the music of the region and promoting a network of young people that are involved in traditional music'.

The traditional music of the Solomon Islands was heavily impacted by the growth of Christianity in the region. It became a belief that the traditional music of the Solomon Islands was not Christian and could therefore not be performed, marginalizing those people who chose to continue performing their traditional

music of the Solomon Islands. It has become important to the organizers of Ethno Solomon Islands to rebuild a sense of value in their traditional music. One of the organizers explains: Solomon Islands was colonized through Christianity so we grew up with a mindset that what is related to our culture are diabolical things.

The organizer of Ethno Solomon Islands reflected on his own personal journey towards performing traditional music and the need to value their traditional music. He explains,

> I realized, when I started going from festival to festival with my own band, that we have to value this music, it's a value that we don't see. […] When [another Ethno Solomon Island organizer] went to Australia to get the Ethno thing and he brought it back and he shared it with me, I jumped on board with him. I realized that this is at least one of the things, the physical evidence people can see and realize that yeah, it is valuable.

Mentioning 'primitiveness' or culture as 'diabolical' immediately draw attention to the legacy of Colonialism in these two regions and why these gatherings need to focus on reviving their local culture and building pride. What has been interesting for the Solomon Islands is how musicians who want to be reggae or rap artists have realized, once 'they come up with a good blend, a good collaboration and a good performance using traditional songs that's the music I like, that's the music I'm good at'. The organizer of Solomon Islands speaks with pride at how Ethno participants have realized that 'this music can go out to the world' and they can perform in festivals not only in Honiara but somewhere else in the world. 'It gives them that bit of courage and confidence'. Notably, the musicians selected by the Solomon Island government to represent that nation in Dubai World Expo 2021 were all Ethno musicians. This experience for Solomon Island musicians reflects Kabanda's argument regarding cultural policy, 'For all artists in growing countries, there is a need to expand their reach into both domestic and international markets. And the answer to the policy question here is clear: enablement' (2018, p. 123). Reviving an interest in traditional music-making appears to be creating a platform for musicians to perform internationally. Being part of an international network, for Ethno Malawi, also enables the opportunity to 'connect ourselves to the rest of the world through music and through Ethnos'. Whilst there has been some criticism of Ethno's role in reviving the folk tradition in music gatherings in 'the North', Ethno appears to be supporting revivals within Solomon Islands and Malawi. In some respects, these motivations are similar to founder Magnus Bäckström's desire for folk music to be recognized on the same level as classical music in Sweden.

Connecting

As discussed earlier, local connections and collaborations with members of the community appear to be strong with the Ethno's in this case study. However, all Ethno's also talk of the importance of the Global network and how it can support Ethno's where local governance and economy may not be reliable. Kabanda argues,

> There is a role for international agencies, national donor agencies and governments. The action of these agencies should be more than roles between 'actors' and 'enablers' they should espouse truly interactive and proactive roles that stimulate mutually inclusive public policy measures.
>
> (2018, p. 33)

Here, we broach the complex relational aspect between the 'North' and the 'South'.

Ethno Malawi appears to have been able to tap into the advantages of having international participants attend their Ethno. He elaborates:

> As organizers, it also adds a lot of value when we have participants coming from outside the country. That's very important. Because now when we go to influence the policy at the government level, we made mention of the interest coming from outside Malawi. And some of the policymakers who are not the musical, they start to get interest in what we are doing.

In Malawi, the Government is willing to support the organizers in fundraising activities, but do not provide any funding, and sometimes they have been unsuccessful in raising sufficient funds to support local participants attendance at the gathering.

Global support is also needed because of the levels of poverty. All three Ethno organizers explained that participants cannot afford the fees for an Ethno gathering but also that persuading governments to fund the endeavour is complicated. This is another area where organizers are forced to adjust at the last moment because funding that was promised does not arrive on time, or at all, and it has left two of the organizers needing to 'pay out of pocket' as a result. Ethno Solomon provides one example:

> The Ministry of Culture tourism says, Look, we're gonna give you this amount of money. And then we were so happy. We waited and waited and waited and waited. And the amounts keep changing. And so when the time arrived, the money wasn't coming yet. So I just couldn't let it go. We had New Zealand participants coming in, a lot of other people come in, so we went ahead with it. And my hope was, okay,

I'll use my own money at this stage and hopefully when that money from Ministry of Culture and Tourism it will clear up. And it did.[6]

All three Ethno's mentioned how the funding of international participants through the Ethno mobility grant has been a great support to their gatherings. Here, the financial value of being connected to an international network is evident. Ethno demonstrates Kabanda's (2018, p. 33) call for an 'interactive and proactive role' of collaboration with international agencies that can lead to 'creativity and innovation'. However, these organizers reflect that collaboration does not have to be purely financial. For example, one organizer felt support from within the network for writing funding grants would greatly help their programme. The challenge is clear: as an international network how can Ethno further demonstrate their ethos of collaboration and connection in supporting their global community?

Conclusion

One of the central tenets of Ethno is that of connection. The three Ethno gatherings highlighted in this chapter reveal how they further the concept of connection to include the local community. This research revealed connections with local communities that impacted the structure of the Ethno gatherings towards more inclusive spaces during rehearsal times. There did not appear to be a strong sense of separation between the Ethno gathering participants and the local communities suggesting a differing perspective surrounding the concept of the Ethno 'bubble'.

The Ethno 'bubble' is expanded to become more inclusive of the local surroundings and community. By expanding the 'bubble' certain approaches need to change, such as a requirement for greater spontaneity and a reconceptualization of 'performance' and 'rehearsal' as members of the local community arrive to share their music. Ethno typically involves a period of rehearsal for the final performance, however, due to guest performers and local musicians sharing of their music throughout the week, performance becomes a constant feature within the Ethno. Rather than rehearsals as a separate moment from the audience, these rehearsals become a performance in and of themselves.

Perhaps more complex are the issues relating to funding. Government funding is non-existent or unreliable, requiring innovative ways of raising the funds necessary for an Ethno gathering. Further to that, participants may not have the financial resources to attend a gathering or may have an expectation that they will be paid to attend an Ethno. Malawi have developed a good relationship and support for fundraising from their government but do not receive direct funding. Organizers from Bahia and the Solomon Islands have needed to pay out of pocket

due to delays in funding from their governments. This may speak to a particular area of socio-economic instability within these regions where governments can be less dependable when it comes to financial support.

These broadening perspectives on the use of terminology within Ethno draw attention to the concepts of similarity and difference within music-making, suggesting that 'sameness' is synonymous with equity: all musical systems have equal value and ought to be treated similarly. It becomes clear that whilst the epistemology of music-making may be different, all music-making systems are equal in value and these three case studies demonstrate how local and global approaches collide, connect, and can work together to create unique Ethno experiences. Respect for local music-making traditions is a focus, highlighting how organizers aim to develop pride in traditional music and see it as a potential opportunity for young musicians to perform on the global platform.

A global Ethno perspective needs to recognize international cultural difference as an opportunity to deepen intercultural encounters through music. Epistemic understanding of ideas such as the 'Ethno bubble' or 'Performance' gain different perspectives as the programme branches out. Some examples highlight the difference, questioning how a global network might support Ethno's that are not able to depend on local funding to run their gatherings. Or, how Ethno can create platforms for Indigenous traditional music where it can be recognized as 'acceptable' without needing to adapt to a Eurocentric system. Other examples suggest new ways of engaging with the structure of Ethno, exploring how approaches such as 'constantly performing' may impact western perspectives of performance and allow for greater local community engagement with Ethno's that take place within Europe. Acknowledging epistemic difference makes room for the richness of musical approaches developed outside of the 'western' system and strengthens Ethno's core pedagogical approach of 'valuing'.

ACKNOWLEDGEMENTS

I would like to thank the Ethno organizers who agreed to be part of this research.

NOTES

1. Nwezi, Anyahuru, and Ohiaraumunna define a system as 'a body of cultural artistic production that has geographical-cultural delimitation, and that is marked by features of sound, musical objects and performance organisation distinguishable from the musical arts of contiguous cultures' (2008, p. 1). This is the definition I shall be applying within this chapter.
2. They were able to host one gathering in a hotel.

3. This is also apparent in the organisation of Ethno India, which is held in a resort, rather than in New Delhi itself, due to concerns of security for the participants by the organizers.
4. See also Kabanda (2018, p. 40) who provides a personal reflection of being a musician from Uganda who plays the pipe organ and how his 'identity seems to be confined to one corner. Yet that borders on fiction that ignores the innate majesty of diverse art forms I adore.'
5. An older age bracket is noted in both Solomon Islands and Cambodia. In Cambodia due to the length of some apprenticeships in Japanese traditional music (Yachita, 2019). In Solomon Islands because musicians become interested in preserving or promoting traditional music at an older age.
6. Whilst this reflection describes how difficult it is to plan in advance for an Ethno, it must be noted that there are other Ethno's in Europe that struggle for funding. Thus this discrepancy may not necessarily be a Global North/South polarization.

REFERENCES

Agawu, K. (1992). *Representing African music: Postcolonial notes, queries, positions*. Routledge.

Agawu, K. (2003). Contesting difference: A critique of Africanist ethnomusicology. In M. Clayton, T. Herbert, & R. Middleton (Eds.), *The cultural study of music* (pp. 227–237). Routledge.

Alam, S. (2008). Majority world: Challenging the West's rhetoric of democracy. *Amerasia Journal*, 34(1), 88–98. https://doi.org/10.17953/AMER.34.1.L3176027K4Q614V5

Aman, R. (2019). Other knowledges, other interculturalities: The colonial difference in intercultural dialogue. In J. Cupples & R. Grosfoguel (Eds.), *Unsettling Eurocentrism in the westernised university* (pp. 171–186). Routledge.

Atleo, A. (2011). *Principles of Tsawalk: An indigenous approach to global crisis*. UBC Press.

Bradley, D. (2012). Good for what, good for whom? Decolonising music education philosophies. In W. Bowman & A. L. Frega (Eds.), *The Oxford handbook of philosophy in music education* (pp. 409–433). Oxford University Press.

Creech, A., Varvarigou, M., Lorenzino, L., & Čorić, A. (2021). *Pedagogy and professional development: Research report*. York St John University.

Döring, K. (forthcoming). Black neighbourhoods and music practice beyond the spotlights of carnival in Bahia. *IASPM*.

Freire, P. (2017). *Pedagogy of the oppressed*. Penguin Random House UK.

Gibson, S.-J. (2022). *Exploring new pathways*. York St John University.

Gibson, S.-J., Higgins, L., Humphrey, R., Ellström, L., Reiss, H., & Roosioja, L. (2021). *30 years of Ethno: The history of Ethno*. York St John University.

Gibson, S.-J., Higgins, L., & Schippers, H. (2022). *Understanding the magic of the Ethno experience*. York St John University.

Gibson, P. (1992). Music for the future: Dreams, schemes and reflections. *Proceedings of the Fourth International Educators Conference, Cape Town, South African Music Educators Symposium*.

Haug, S., Braveboy, J., & Maihold, G. (2021). The Global South in the study go world politics: Examining a meta category. *Third World Quarterly, 42*(9), 1923–1944. https://doi.org/10.1080/01436597.2021.1948831

Hess, J. (2021). Music education and the colonial project. In R. Wright, G. Johansen, P. A. Kanellopoulos, & P. Schmidt (Eds.), *The Routledge handbook to sociolog of music education* (pp. 23–39). Routledge.

Higgins, L. (2020). *Case study: Ethno Portugal. Crossing the threshold.* York St John University.

Kabanda, P. (2018). *The creative wealth of nations.* Cambridge University Press.

Nwezi, M., Anyaharu, I., & Ohiaraumunna, T. (2008). *Musical sense and musical meaning: An Indigenous African perception.* UNISA Press.

Prest, A., & Goble, J. S. (2012). Towards a sociology of music education informed by indigenous perspectives. In R. Wright, G. Johansen, P. A. Kanellopoulos, & P. Schmidt (Eds.), *The Routledge handbook to sociology of music education* (pp. 80–96). London.

Ramnarine, T. (2019). Dance, music and cultures of decolonisation in the Indian Diaspora: Towards a pluralist reading. *South Asian Diaspora, 11*(2), 109–125, https://doi.org/10.1080/19438192.2019.1568427

Turino, T. (2008). *Music as social life: The politics of participation.* University of Chicago Press.

Waisbich, L. T., Roychoudhury, S., & Haug, S. (2021). Beyond the single story: 'Global South' polyphonies. *Third World Quarterly, 42*(9), 2086–2095. https://doi.org/10.1080/01436597.2021.1948832

Yachita, M. (2019). *An analysis of Ethno Cambodia 2019: Youth, tradition and the unavoidable issue of ethnicity in Asia.* https://www.academia.edu/41696768/An_Analysis_of_Ethno_Cambodia_2019_Youth_Tradition_and_the_Unavoidable_Issue_of_Ethnicity_in_Asia

Contributors

MAGNUS BÄCKSTRÖM has been a folk musician, teacher, music producer, concert promoter, festival director, and concert hall director. In addition to Ethno, he has started and run the Giga record company, the folk and world music festival Falun Folk Music Festival, the music branch fair Norrsken, the magazine *Lira,* and the Uppsala International Sacred Music Festival. He is a co-founder of the international network Forum of Worldwide Music Festivals and was the artistic director of the music branch fair Womex 98. Magnus Bäckström worked for almost two decades as CEO and artistic director of newly opened concert halls, first in Gävle and later in Uppsala.

* * * * *

DAVE CAMLIN'S musical practice spans performance, composition, teaching, community music and research. He lectures in music education at the Royal College of Music and Trinity-Laban Conservatoire and was head of HE / Research at Sage Gateshead from 2010–19. His research interests include group singing; music, health, and wellbeing; and musician education. He has pioneered the use of Sensemaker® 'distributed ethnography' as a research method for understanding artistic and cultural experiences. His book *Music Making and Civic Imagination: A Holistic Philosophy* (2023, Intellect) explores the potential of musicing as both a complex adaptive system (CAS) and a global resource for sustainability.

* * * * *

ANA ČORIĆ is a lecturer at the Music Education Department, Academy of Music, University of Zagreb, where she graduated in 2012. She is a Ph.D. student in education at the Faculty of Humanities and Social Sciences, University of Zagreb. Her Ph.D. studies at the Faculty of Humanities and Social Sciences are related to higher music education, university civic mission, and civic dimension of musicians' professional identity. In practice and research, her interests are

community music, interdisciplinary approach in music education, children and female choirs, and youth studies. She has extensive experience in creating educational programs for children at the Croatian National Television and community music programmes that combine music and children's literature. Since 2019, she is involved in several international projects: Strengthening Music in the Society, MusiQuE and Power Relations in Higher Music Education (within the Association Européenne des Conservatoires, Académies de Musique et Musikhochschulen – AEC), Ethno Research Project (International Centre for Community Music, York St John University), and B-Air Infinity Radio – Creating Sound Art for Babies, Toddlers, and Vulnerable Groups (Creative Europe). Since 2022, she is a lecturer and performer at Storytelling Academy in Zagreb (Croatia) and a music mediator at the kULTRA Music Festival in Makarska.

ANDREA CREECH is professor of music pedagogy at the Schulich School of Music, McGill University. Following an international music performance career, Andrea was awarded a Ph.D. in psychology in education from the Institute of Education, University of London, where she subsequently was appointed reader in education. She returned to Canada in 2016, as Canada research chair in Music in Community at Université Laval. Andrea's research has covered a wide range of issues in formal and informal music education contexts, including interpersonal dynamics, informal learning, inclusion, lifelong learning, and music for positive youth development.

SARAH-JANE GIBSON is a music lecturer at York St John University in York, England where she also works as a research associate within the International Centre for Community Music. She was the post-doctoral researcher for Ethno Research. Her research interest is in intercultural understanding through music. Her most recent publication is the monograph *Building Choirs in the 21st Century – Re-imagining Identity Through Singing in Northern Ireland* (2023) part of Intellect's Music, Community, and Education series.

LEE HIGGINS is professor and director of the International Centre of Community Music based at York St John University, UK. He was the president of ISME (2016–18) and the senior editor for the *International Journal of Community Music*

(2007–21). He was the author of *Community Music: In Theory and in Practice* (2012, Oxford University Press), *Thinking Community Music* (2024, OUP), co-author of *Engagement in Community Music* (2017, Routledge), and co-editor of *The Oxford Handbook of Community Music* (2018).

* * * * *

LISA LORENZINO serves as the chair of the Music Education Department at the Schulich School of Music. Dr. Lorenzino received her Ph.D. from the University of Alberta in 2006 and is currently pursuing research that focuses on cross-cultural approaches to teaching music in both formal and informal settings. Her work has been published in *Research Studies in Music Education, Canadian Music Educator, Canadian Winds,* and *the National Flute Association Journal,* and will soon appear in the *Journal of Historical Research in Music Education.* Dr. Lorenzino is actively involved as a jazz/Latin flutist in the Montreal area.

* * * * *

KEEGAN MANSON-CURRY is a Ph.D. candidate in ethnomusicology at the University of Toronto. He holds a Certificate in Jazz performance (Humber College), a Bachelor of Arts (Honours) in comparative cultural studies (University of New Brunswick), and a Master of Arts in ethnomusicology (University of Toronto). Keegan's doctoral research, funded by the Social Sciences and Humanities Research Council of Canada, focuses on music, sound, and place along the Wolastoq (St. John River) in Atlantic Canada.

* * * * *

ROGER MANTIE is a professor, Department of Arts, Culture and Media at the University of Toronto Scarborough, with a graduate appointment at the Ontario Institute for Studies in Education. He enjoyed previous appointments at Arizona State University and Boston University. He is the author of *Music, Leisure, Education: Historical and Philosophical Perspectives* (2021, Oxford University Press), co-author of *Education, Music, and the Social Lives of Undergraduates: Collegiate A Cappella and the Pursuit of Happiness* (2020, Bloomsbury), co-editor of *The Oxford Handbook of Technology and Music Education* (2017) and *The Oxford Handbook of Music Making and Leisure* (2016), and is the senior editor of the *International Journal of Community Music.* Complete information at https://www.rogermantie.com

* * * * *

HELENA REIS is a musician and Ph.D. student of arts at Lisbon's University. She is currently developing projects in performance, theatre, and non-formal music education. The voice, especially in the context of female choirs, is a central part of her work.

* * * * *

LAURA RISK is assistant professor of music and culture in the Department of Arts, Culture and Media at the University of Toronto Scarborough, with a graduate cross-appointment at the Faculty of Music at the University of Toronto. Her research proactively builds out public archives in order to amplify unheard voices and critically interrogates the notion of tradition, with a focus on traditional music historiography in Quebec. She is also a fiddler.

* * * * *

HUIB SCHIPPERS is one of the world's leading scholars on the crossroads of music education, applied ethnomusicology, and cultural sustainability. With partially overlapping careers in performance, education, research, journalism, the record trade, arts policy, and project management, he founded the World Music School in Amsterdam (1990–96), worked with various conservatoires (1996–2003), and played a key role in realizing the World Music & Dance Centre in Rotterdam (2001–06). Next, he became director of the innovative Queensland Conservatorium Research Centre in Australia (2003–15) before moving to Washington DC as director/curator of the iconic label Smithsonian Folkways Recordings (2016–20). In 2021, he focused on writing and freelance research, and in 2022 he was invited to teach at UCLA after being awarded the prestigious title UC Regents' Professor. Among over 200 publications from his hand for scholarly and general audiences, the most noteworthy are *Facing the Music: Shaping Music Education from a Global Perspective* (2010, Oxford University Press; *Sustainable Futures for Music Cultures: An Ecological Perspective* (2016, Oxford University Press); and *Music, Communities, Sustainability: Developing Policies and Practices* (2022, Oxford University Press).

* * * * *

PEDRO TIRONI holds a Bachelor of Arts (music performance) from the University of Chile, a bachelor's in music therapy from the University of Salvador (Argentina), MA in music from the Catalunya College of Music, and Master of Teaching from the University of Toronto, Ontario Institute of Studies in Education. He works as an elementary music teacher in Toronto, Ontario.

MARIA VARVARIGOU is a lecturer in music education at Mary Immaculate College, Ireland. Maria has been researching the impact of music making on health and wellbeing across the lifecourse, effective music teaching and learning in higher and professional education and in primary school education, and intergenerational music making for many years. She is the co-author of the books: *Active Ageing with Music: Supporting Wellbeing in the Third and Fourth Ages* (2014) published by the IoE University Press; and *Contexts for Music Learning and Participation: Developing and Sustaining Musical Possible Selves Through Informal, Non-Formal and Formal Practices* (2020) published by Palgrave.

Index

A
accessible 8, 93–94, 128, 150, 176–77 *see also* inclusive
advocacy 118, 129
amateurs 17, 26, 29, 30, 62
ambiguity aversion 111
artistic citizenship 77
authenticity 168–69
authentic musical repertoire 93

C
careers 26, 63, 76–77, 81, 90, 137, 204
Cargill Philanthropies xviii, 26, 112
Christianity 193–94 *see also* religion, religious
climate emergency 114, 118, 129n2
co-creation 30, 58
concerts xii, xvii, 29–30, 59–61, 189
contact hypothesis 100
continuum transmission framework 149, 153, 175
colonialism 39, 124, 133, 143, 184, 194
commodifying 41
community music 2, 3, 21, 22, 29, 37, 49, 88, 155
community, sense of xxii, 16, 58, 94, 155
communitas 47, 55, 57, 66, 69, 71
consensus 82, 83, 92, 103
constructionist 50
cosmopolitanism 99, 108, 111

COVID-19 xviii, 112, 114–16, 118–21, 134, 177 *see also* pandemic
cultural bearers 29, 35, 93, 103, 150, 152
democracy 98
diversity 39, 43, 96, 99, 117, 149–50, 153, 155, 159, 164, 170
heritage xvii, 28, 76, 96, 114, 120–23, 143, 150, 176, 187, 191
preservation 36, 98, 174, 193

D
dancing 45
decolonized 184
decolonization 144
decontextualized 169
deterritorialization 98
dialogue 12, 16, 22, 34, 108, 185 *see also* intercultural
dissemination xxx, 124, 129, 150

E
ecological justice 114, 128, 130n2
education, formal 11, 61
non-formal xxx, 12
embodiment 99
empowerment 87
ethno bubble 107–08, 139, 188, 197
family 58
magic xix
method 83, 148, 150, 176, 187

ethno bubble *(Continued)*
 mobility programme 112, 114
 organizers xxx, 26–27, 43, 47–48, 51–54, 59, 64, 66–71, 98, 101, 108, 119, 121, 124, 190–91, 195
 as political project 106
 sound xxvi, 10, 104, 108–09, 167, 174
ethnocentrism 182
Ethnofonik 77, 88–89, 92, 103, 106
ethnography 115, 134, 201
 online 115
ethnomusicology 117, 120, 134, 137, 150–51, 155
ethics 40n4, 53, 135–36
ethnoscapes 98–99
ethnoverse 110, 112
Eurocentric 174, 183, 185, 190–91, 197
evaluating 19, 87, 91
excellence 162
exoticism 141, 143, 146, 191 *see also* Othering
experience, transformative 91
extramusical 9 *see also* paramusical

F
facilitation, definition of 4
 cooperative 8, 13
 multifaceted model of 2
Falun Folk Festival xv, 97
Festivals 29, 34, 152, 188, 194
friendship xii, 11, 57
fundraising 195–96

G
geopolitical 27, 43, 134, 185
Global North 34–35, 108, 110–11, 134, 145, 181, 185, 191, 198n6
Global South 30, 108, 110, 145, 184–85, 191
globalization xix, 133

H
Hope Sessions 115, 126
humanistic 18–19, 48, 71

I
identity, collective 44, 47, 62, 70, 108
 cultural 10, 63, 80, 108
 gender 10
 musical 19, 89, 92–93, 183
 professional 70, 201
 racial 27
 transnational 70, 122, 128 *see also* cosmopolitanism *see also* nation-based, music, identities in, transformation
identities 70, 83–86
inauthenticity 28, 169
inclusion ix, xxx, 18, 36, 94, 106, 115–16
inclusivity 119, 178
Indigenous xxx, 111, 159, 162
 communities 118, 126, 128
 cultures 123–24
 musical cultures xxxi, 115, 124
 music-making 117, 121
 music systems 191
 representation 171
 traditional music 197
intercultural competence 108
 dialogue xi, xvii, 26, 70, 97, 103, 108–09, 127, 142, 144, 150, 176, 185
 learning 8–10, 79, 85, 93, 96, 106, 153
 music exchange xix, 40n1, 56, 62, 97, 99, 101, 104, 112n1, 133
 understanding xxviii, 111, 126–27, 129, 181
interculturalism 99, 101, 106–07, 111 *see also* contact hypothesis
interdisciplinary 190
internet 81, 102, 110, 134, 136
interpersonal 4, 7, 70, 100

INDEX

J
jamming 3, 13, 16–18, 21, 85–87, 92, 158
JM International xviii

L
leadership skills xxv, 18, 82–83, 89, 92
learning by ear 3, 13–15, 21, 56, 63, 76, 183
 community-based 155
 expansive 12–13
 experiential 2, 7, 13, 21, 93, 176
 holistic 148, 156
 informal 19, 21, 76
 intercultural *see* intercultural
 nonformal 12, 21 *see also* pedagogies
 peer-to-peer xii, xvii, 15, 30, 97, 99, 148–49, 160–63
 self-directed 3, 7, 13, 18, 76, 93
 situated 16, 19–21, 76, 93
LGBTQI+ 164
liminality xix, 55, 187
listening 10, 14, 33, 45, 61, 82, 86, 90

M
magic moments 47, 55
mentoring 16 *see also* artistic mentors
monocultural 155, 174
motivation 8, 16, 36, 47–48, 71, 77, 92, 152, 192
multicultural 5, 8, 9, 21, 58, 62, 69, 83, 123–24, 155, 174
multidisciplinary 190
music curriculum 151
 ecosystem 28, 29, 39, 62, 97, 115
 education, cultural diversity in 150, 153
 education, formal xxv, 14, 16, 21, 22, 57, 78, 83, 88, 92, 148, 155, 177, 192
 education, intercultural 9
 education, non-formal 96, 150, 176
 education, philosophies of 185
 folk xii, 27–30, 34–35, 39, 77, 81, 88, 91, 97, 103, 108, 110, 117, 143, 148, 150, 152, 182, 194
 as holistic practice 44, 153
 identities-in 47, 71
 in-identities 47
 intercultural *see also* intercultural music exchange
 microcultures 9
 online 54, 81, 92, 115, 121, 125–28, 134, 146
 performances xxvii, 25, 30, 127, 148, 159, 163, 166, 178, 186–87, 189
 praxis 45
 subcultures 9
 teachers 2, 11, 12, 29, 40n3, 78, 83, 86, 88, 152, 155, 163
 traditional 25–39, 61, 84, 88, 90, 96, 103, 108, 138, 142, 167, 192–97
 transmission 29, 153, 176–77
 world 41n10, 85, 90, 91, 143, 151, 174
musical
 nationalism xix
 possible selves 78–9, 83–93
 heritage 114, 117, 122, 192
 notation 182
 instruments 84, 124, 193
 system, western 182, 186
musicking 45, 47, 50, 55–57, 65–67, 69–71, 115, 119–21, 167

N
narrative data 50, 54–55
nationalism 28, 97, 143
nation-based 26–27, 108, 194
nation 28, 31, 33, 35, 38–39, 99
non-human 117–18

209

O

orchestras 151
Othering 191
ownership 14, 19, 122, 135, 140

P

pandemic xxxii, 81, 92, 134, 138, 140 *see also* COVID-19
paramusical 44–45, 57
peacebuilding xxxiin5
pedagogic leadership 1
pedagogy
 ethno- xviii, 1, 191
pedagogies
 signature 2–3, 9, 11, 15, 20–22, 76
 non-formal xvii, xxx, 11, 13, 15, 19, 97
personal authenticity 27–32, 39
phenomenological 43, 50
politics 38, 106, 173
policymakers 189, 195
polymorphic concept 58
power distance 153, 160–62
professional
 development xviii, 76–82, 88–93, 153
 networks 69, 79, 81–82, 89, 92–93
 recording 159, 166

R

racism 173, 143
recontextualization 169–70
refugees 89, 126
rehearsing 45, 61, 83, 159, 187
religions 9
religious xxx, 106, 159
repertoire choice xxxi, 156
 nationally associated 25, 26, 28, 31, 37–40
 shared 76, 103–04
 new xxviii

residential xv, 86, 188
resilience 69
resistance 4, 11
responsibility 1, 3, 10, 12, 17, 19, 20, 37, 58, 60, 109
reverberations xviii
ritual 64, 106
revival xix, 27–28, 34, 122, 124, 143, 148, 150

S

safeguarding xxxiin5, 128
scholarships xviii, 25
school system 83
self confidence xxii, xxiii, 14, 15, 79–85, 91, 93, 96, 122, 150, 176–77, 192, 194
 determination theory 47
 efficacy 81
 knowledge 77, 80, 82–83, 88, 91–93
Sensemaker 43–44
sexuality xxx, 111
sexism 105
Sistema-inspired 83
social impact 48, 51, 59
socializing through music 77
solfege 158
songwriting 83, 85, 93
spirituality xi, 121, 159
sustainability 114, 116, 119, 127–28, 168, 174
system 197n1

T

Tandem Festival 34
teamwork 82, 83, 92
teaching, co- 12
togetherness xxvii, 127
touring 25
transactional 48, 70, 108
transcultural 155, 174

transformation xix, 89, 90
 identity 47, 70, 71
transferable skills xxxi, 77, 80, 82–83, 91–93
transnational ecosystem 62
 lives 38
 spaces 185
translations 145
training xviii, xxx, 2, 9, 29, 56, 77, 92–93, 103, 110, 112, 127
 classical 88
 voluntary 83, 88

U
Ubuntu 162
UNESCO xi, 98, 117, 187
universality 182

V
valued xxxi, 9, 13, 19, 20, 44, 81, 159
Världens Band 174
vulnerability 8, 119

W
wellbeing xxxiin5
welcome 20, 59, 99, 138–39, 188

Y
youth development 96

Printed in the USA
CPSIA information can be obtained
at www.ICGtesting.com
CBHW062112181024
15831CB00017BA/51